WORKBOOK

Photography > Fall 2012

Publisher/Owner	>	**BILL DANIELS**
Advertising Sales Director	>	**SUZANNE SEMNACHER**
Advertising Sales	>	**LINDA LEVY**
		MARY PREUSSEL
		LORI WATSON
Design Director	>	**ANITA ATENCIO**
Director of Production	>	**PAUL SEMNACHER**
Online Portfolio Manager	>	**KIRSTEN LARSON**
Social Media Manager	>	**WILL DANIELS**
Directory Manager	>	**ANGELICA VINTHER**
Directory Marketing Manager	>	**JOHN NIXON**
Directory Verifiers	>	**AURELIO FARRELL II**
		JORDAN LACEY
		DAVID PAVAO
		ANGELA PERKINS
Technology	>	**JIM HUDAK**
		STEPHEN CHIANG
		RYAN ADLAF
Finance	>	**ALLAN GALLANT**
		EDUARDO CHEVEZ
Security	>	**MR. "T"**

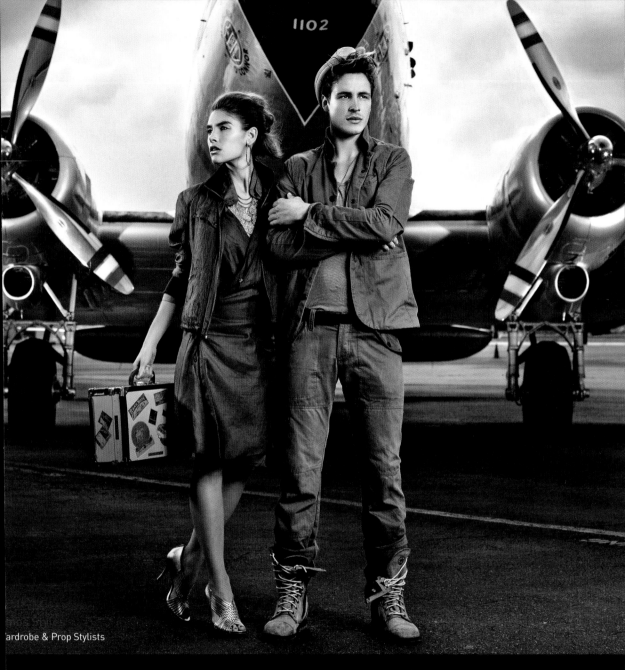

Where Talent Meets. With Stunning Results.

Featuring Portfolios from Producers, Location Finders, Stylists, CGI Services & Retouchers.

workbook.com/production

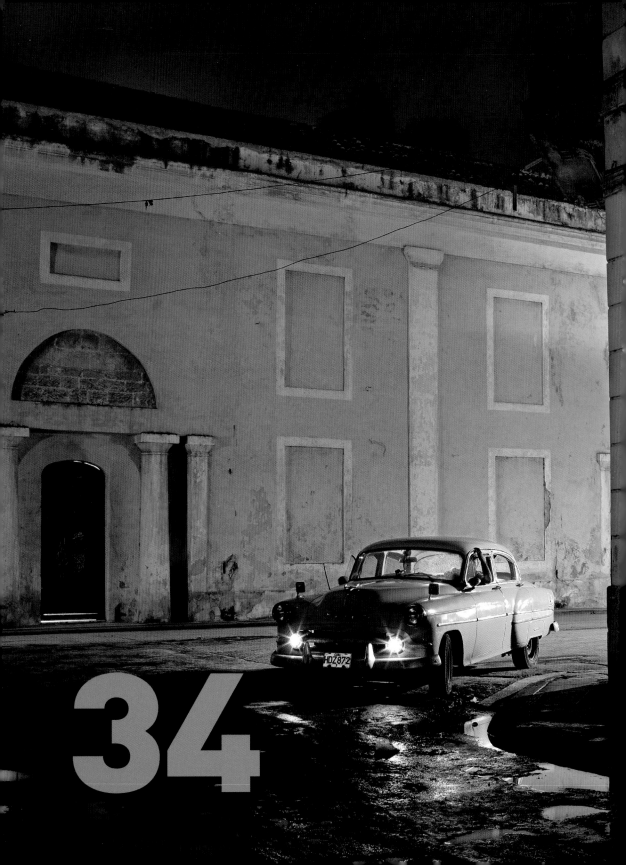

34

> **Contents**

*Artist's Representative

*Artist's Representative

> Index

*Artist's Representative

> Index

*Artist's Representative

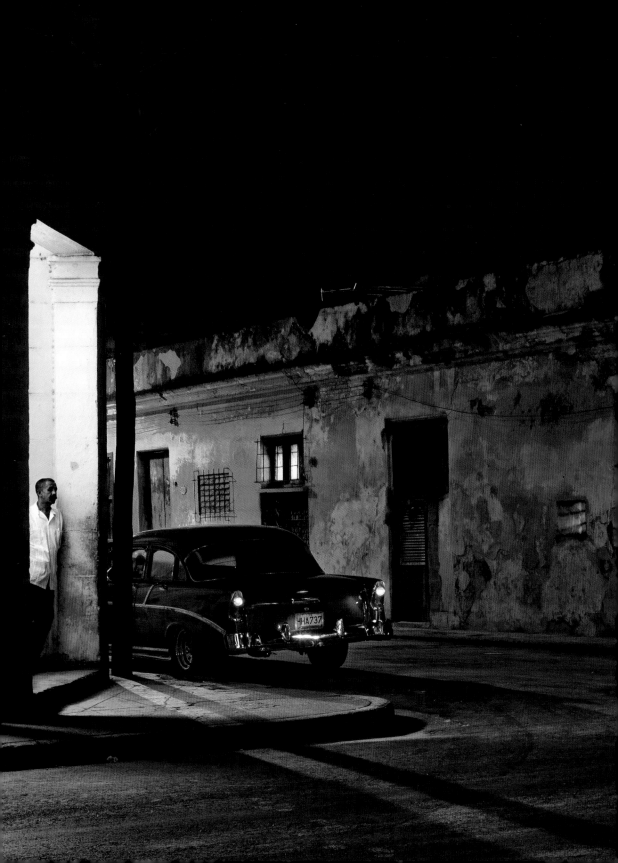

> **Photography**

POBY

PHOTOGRAPHER DIRECTOR

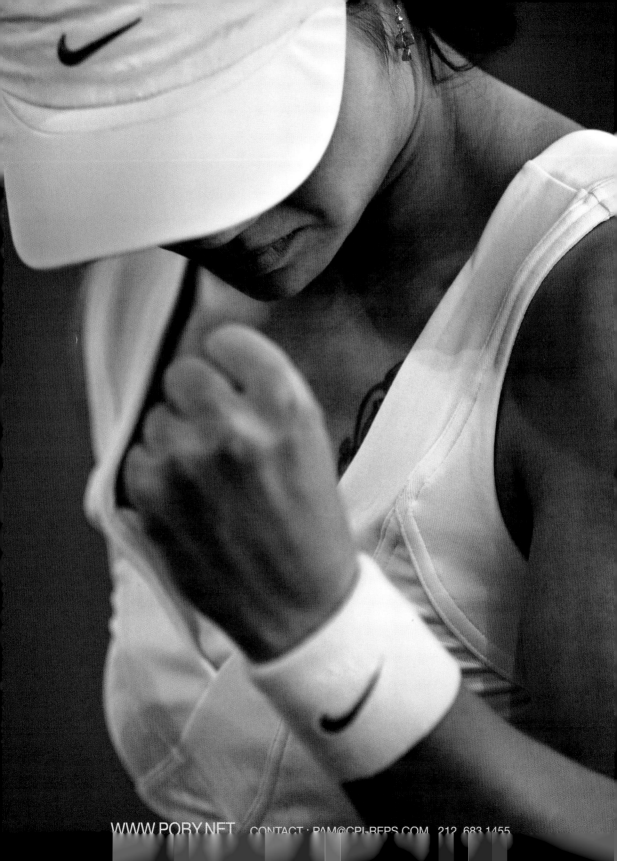

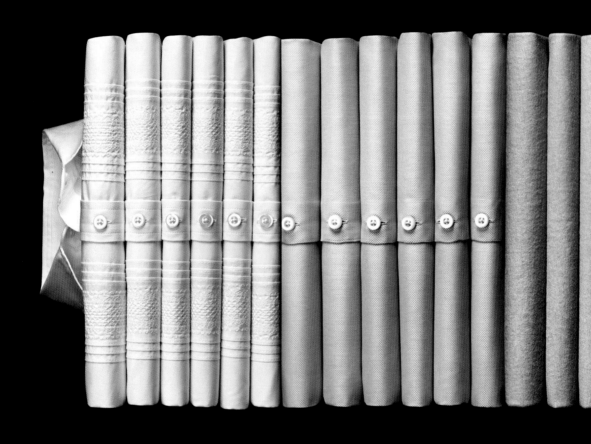

maren caruso

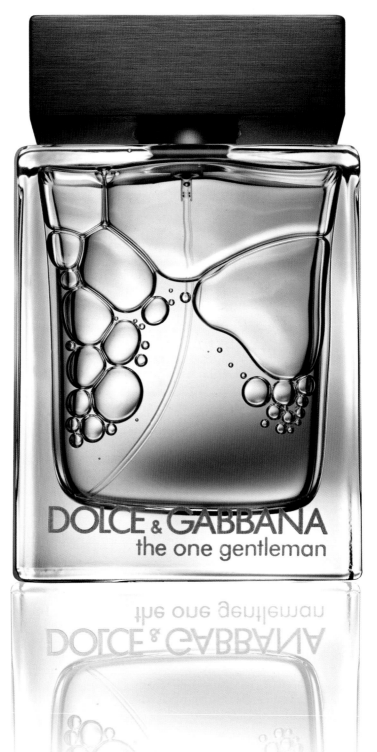

Contact Deb Schwartz at DSREPS LA office 626.441.2224 NY office 646.619.1269

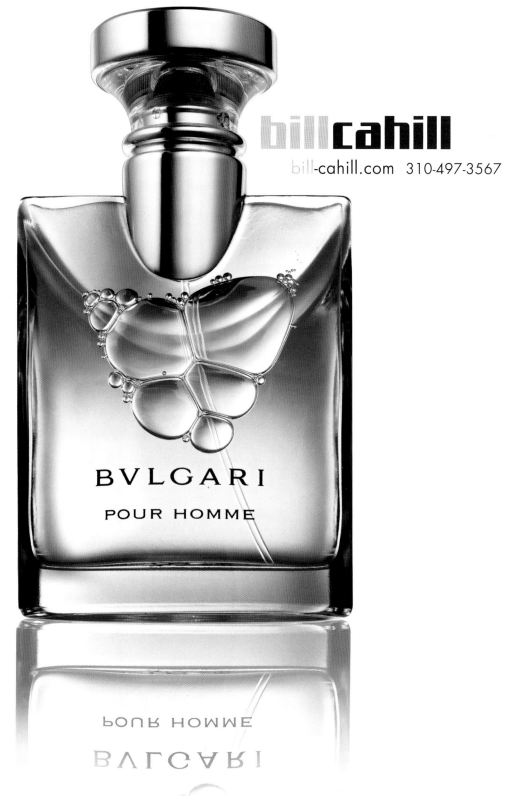

BVLGARI

POUR HOMME

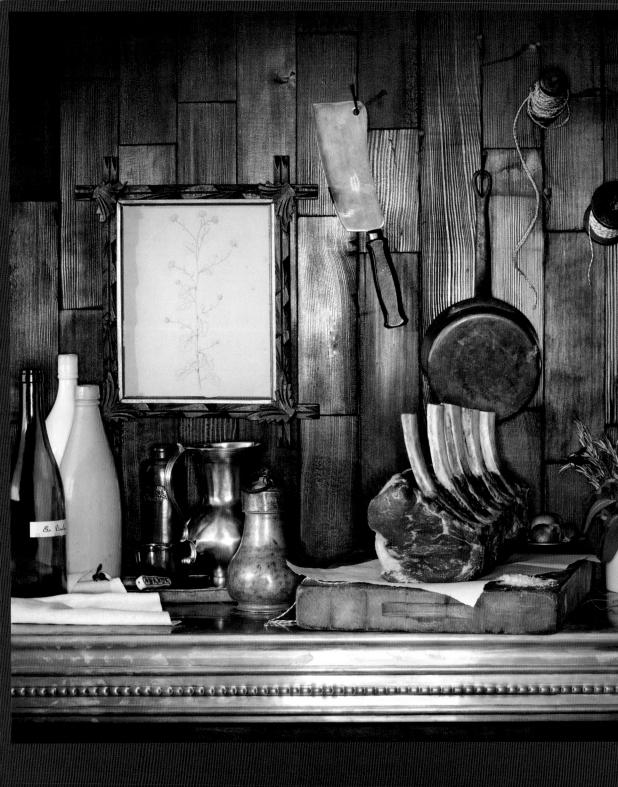

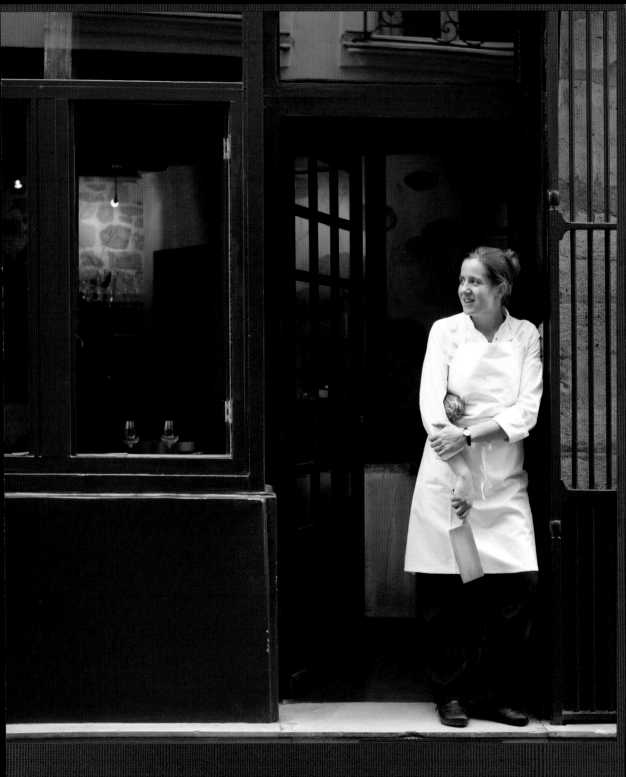

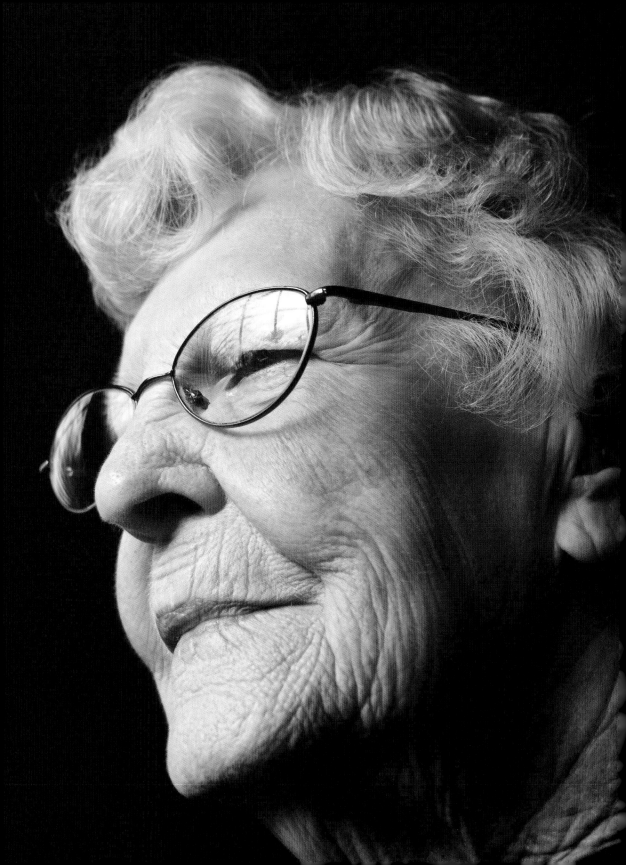

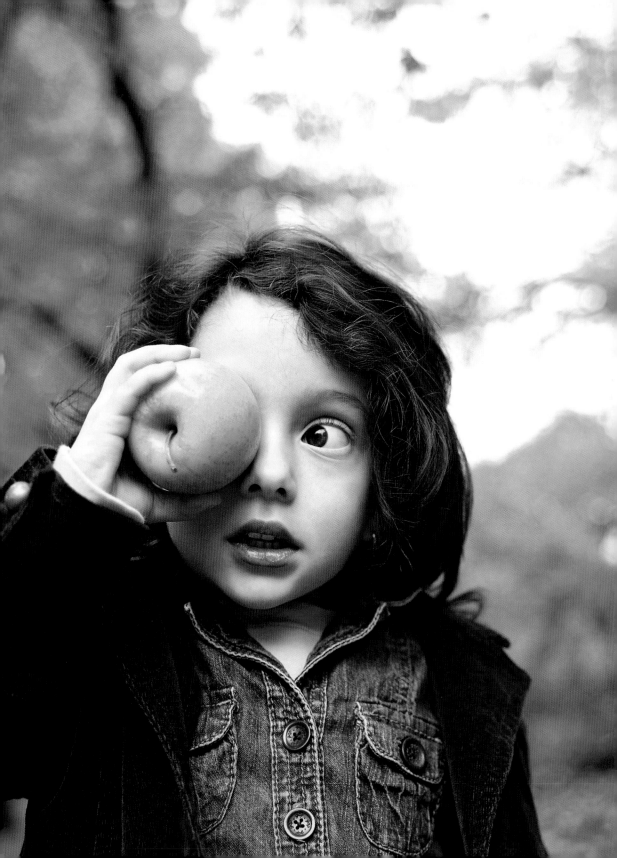

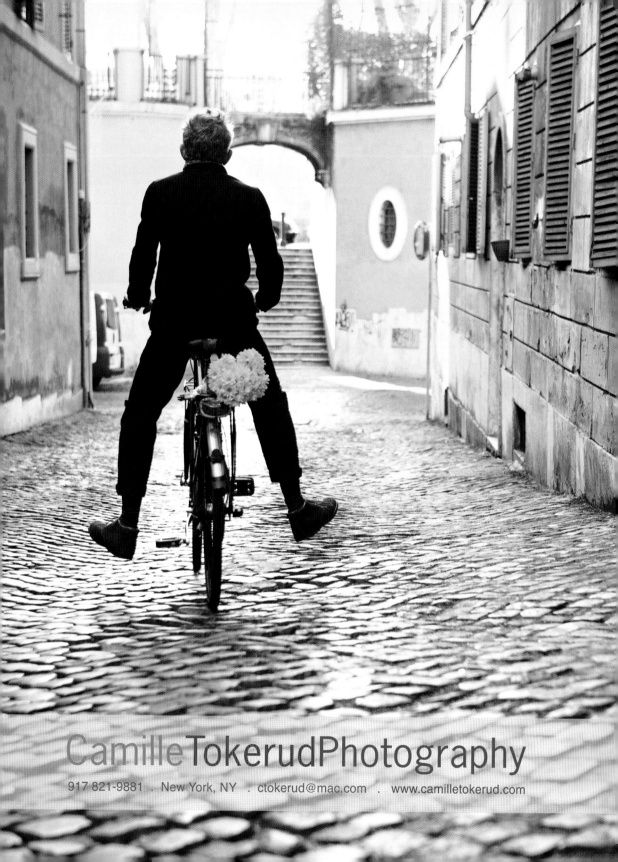

MICHAEL BOONE

PHOTOGRAPHY

312-890-3171

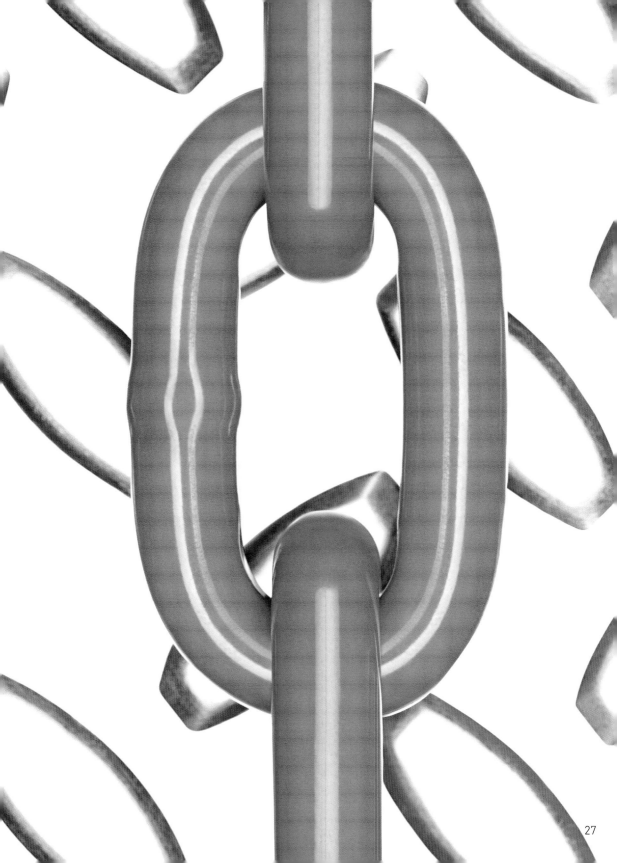

Kevin Twomey

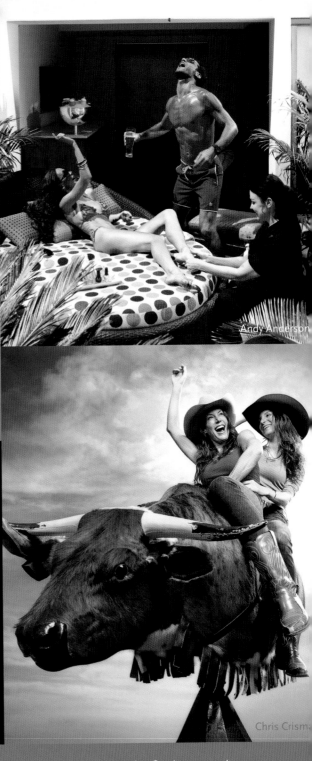

Andy Anderson

Hunter Freeman

Chris Crisman

David Martinez

Leigh Beisch

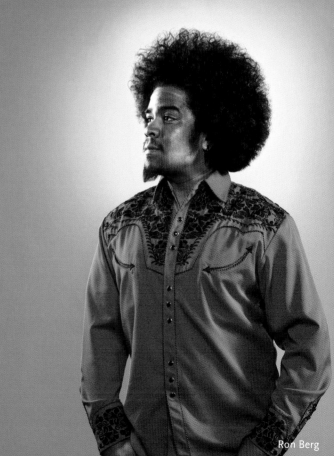

Ron Berg

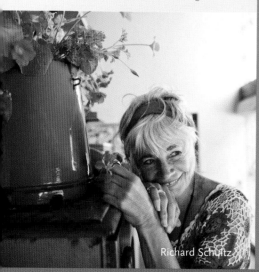

Richard Schultz

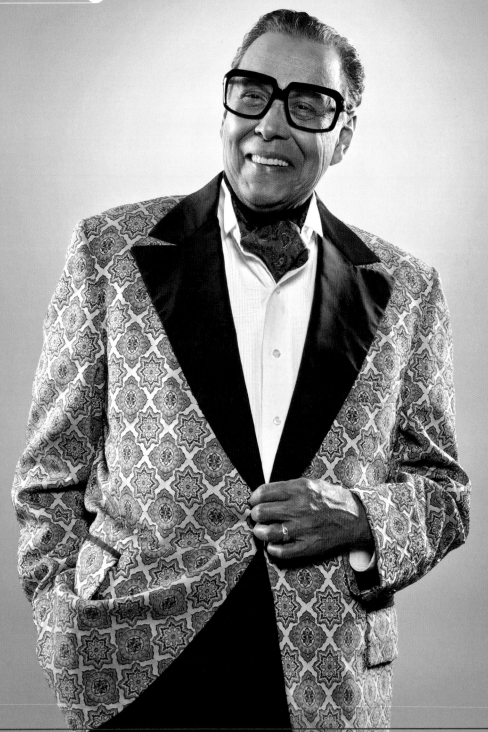

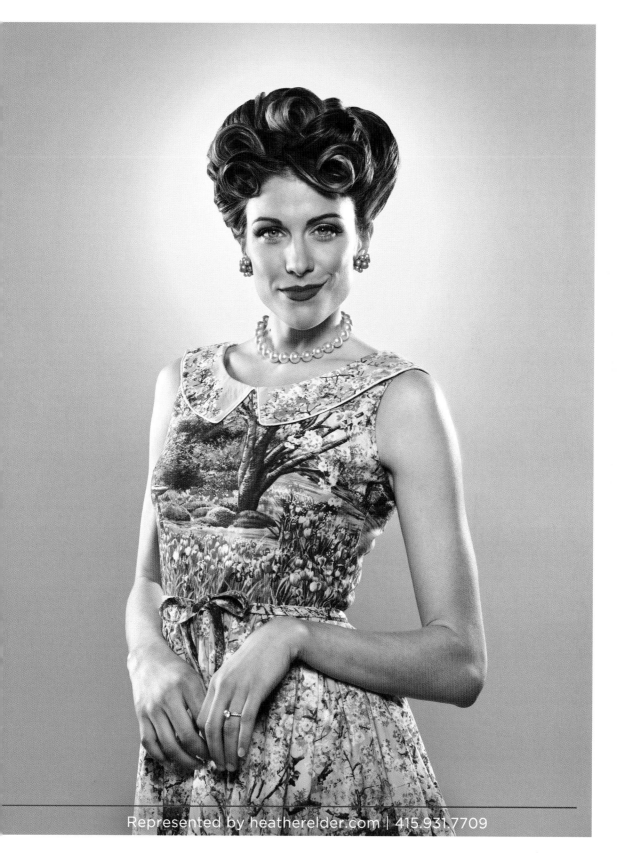

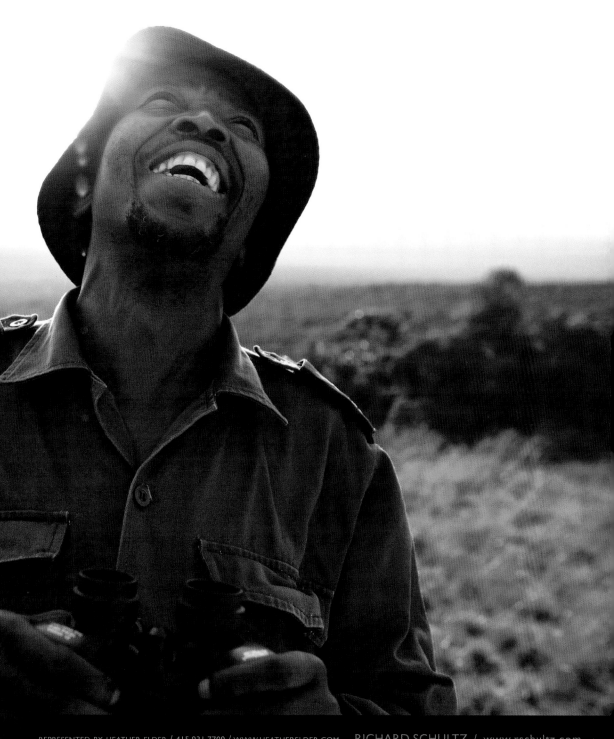

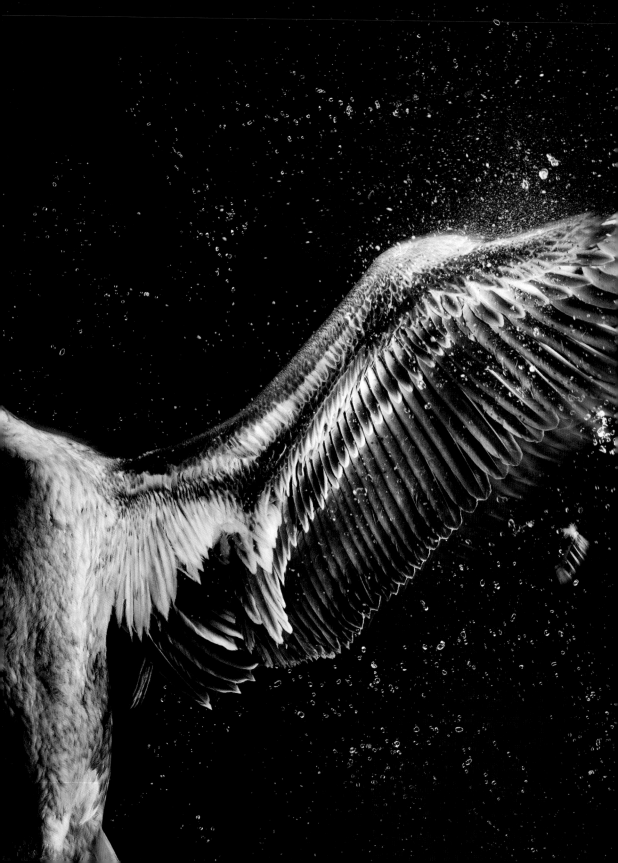

heather elder

(2ME) KEVIN TWOMEY : 415-517-6489 / KEVIN@KEVINTWOMEY.COM
REP : HEATHER ELDER / 415-931-7709 / OFFICE@HEATHERELDER.COM

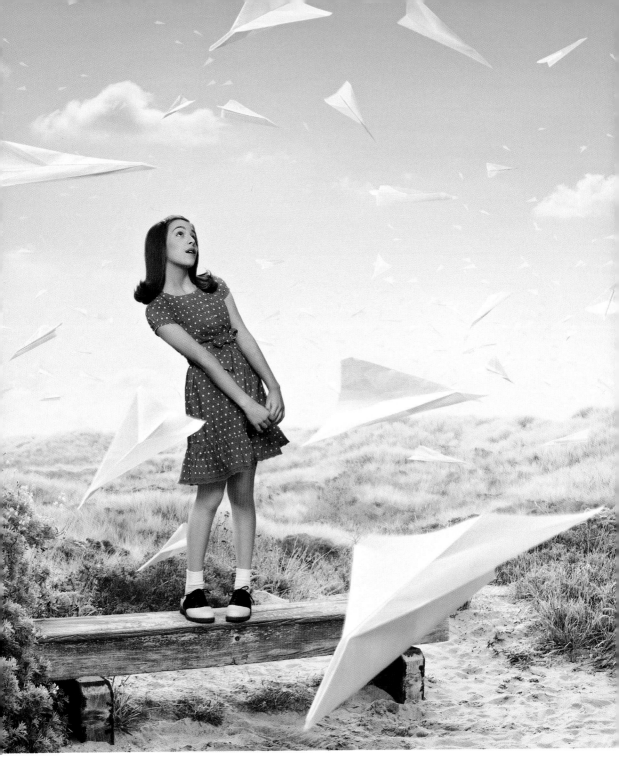

CHRIS CRISMAN

Photographer

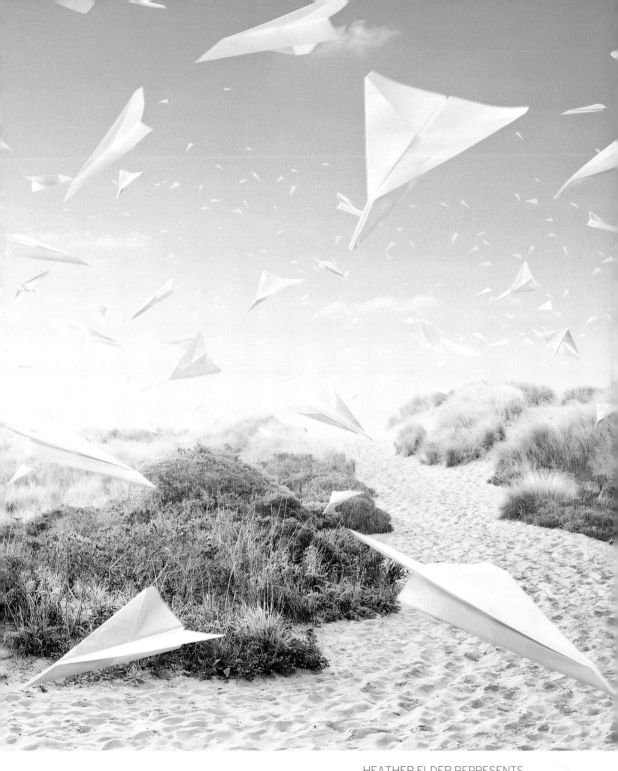

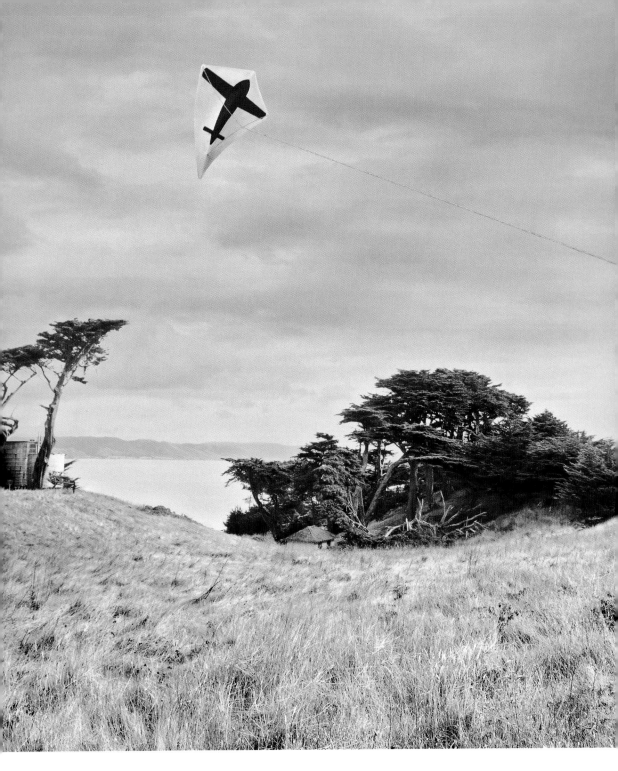

CHRIS CRISMAN
Photographer

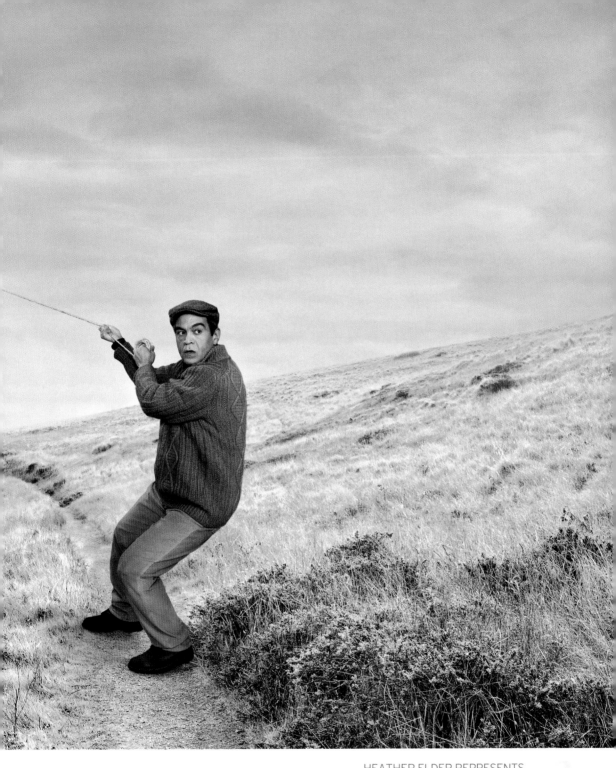

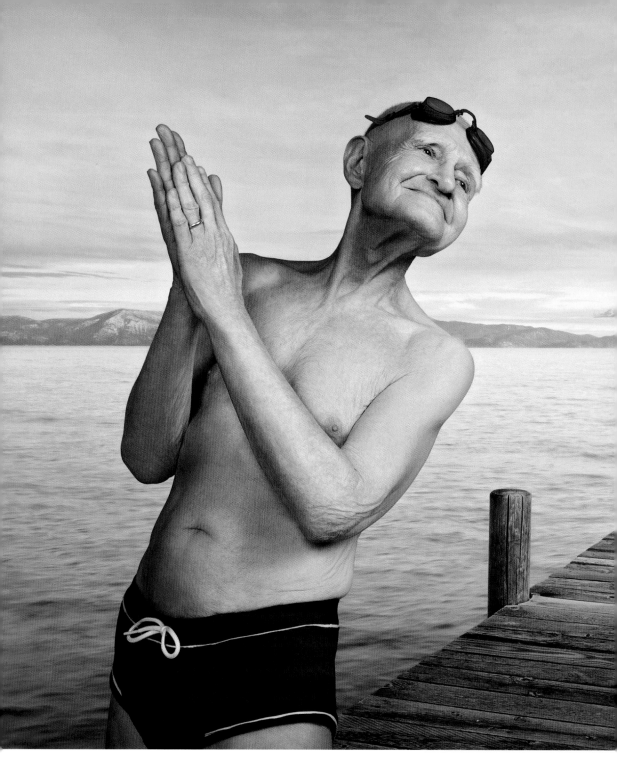

CHRIS CRISMAN

Photographer

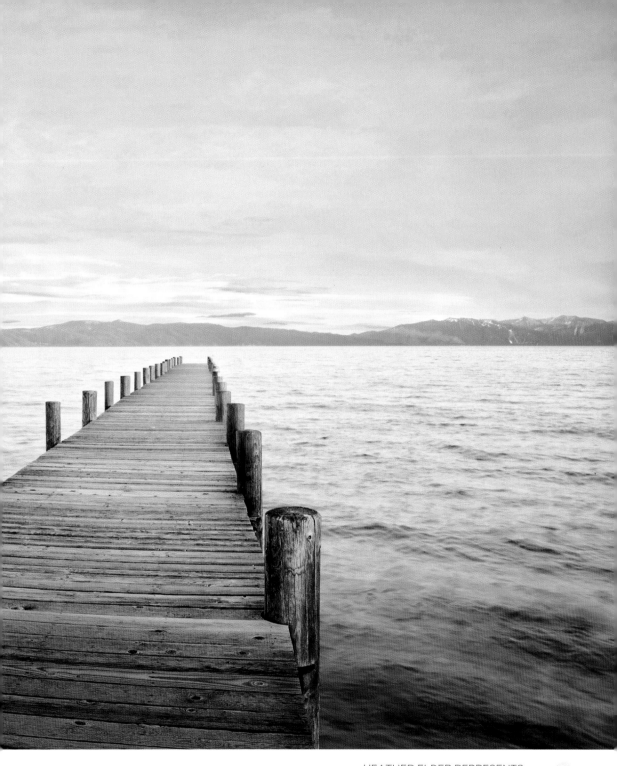

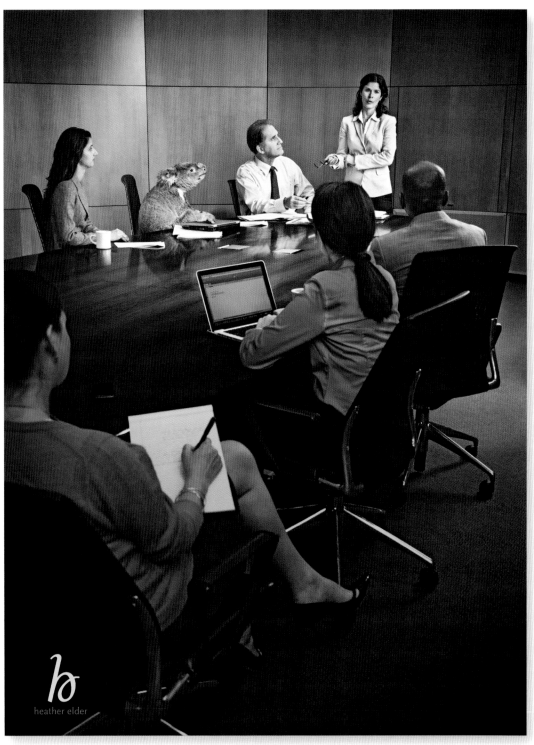

Represented by Healther Elder www.heatherelder.com 415.931.7709 office@heatherelder.com

HunterFreeman

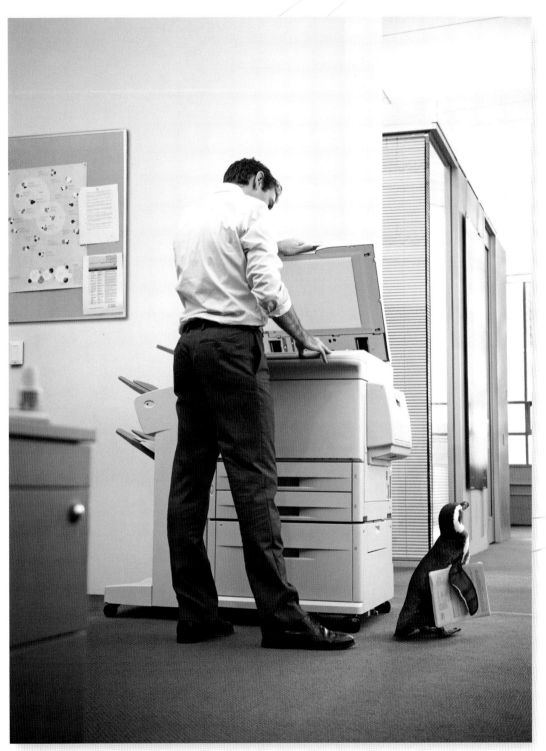

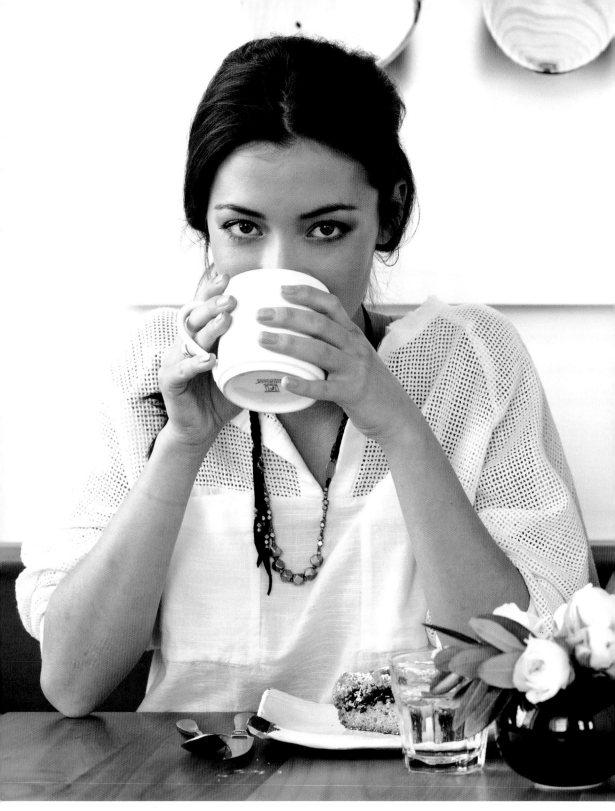

david Martinez

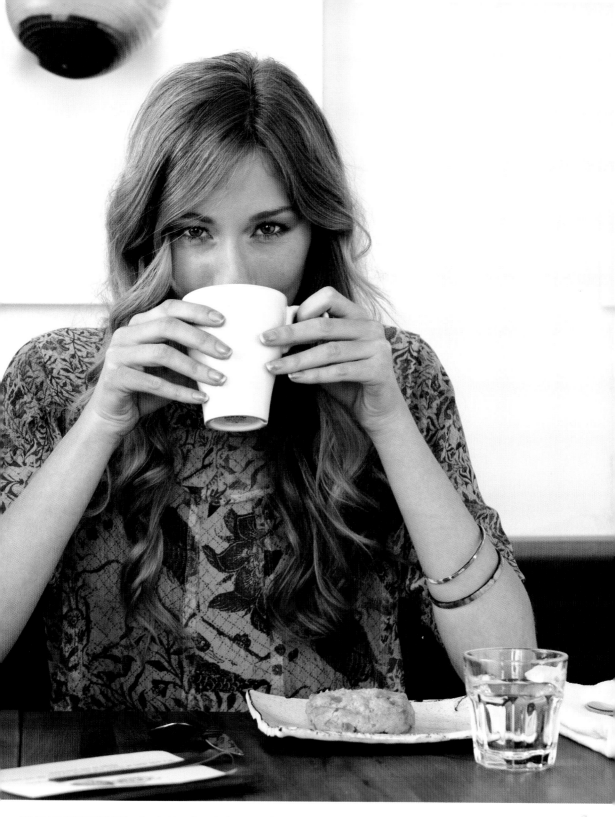

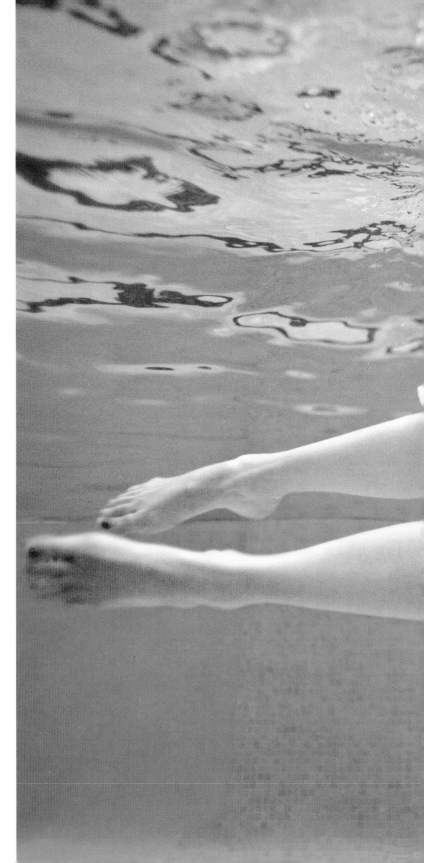

ANDY
ANDERSON

PHOTO.COM

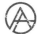

ANDY ANDERSON
www.andyandersonphoto.com
andy@andyandersonphoto.com
208.587.3161

Represented by Heather Elder
www.heatherelder.com
heather@heatherelder.com
415.285.7709

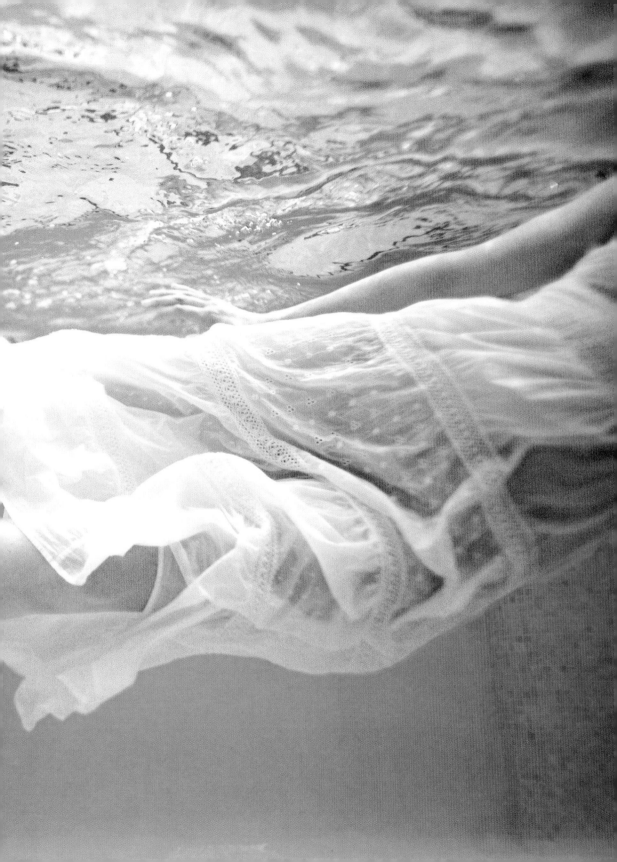

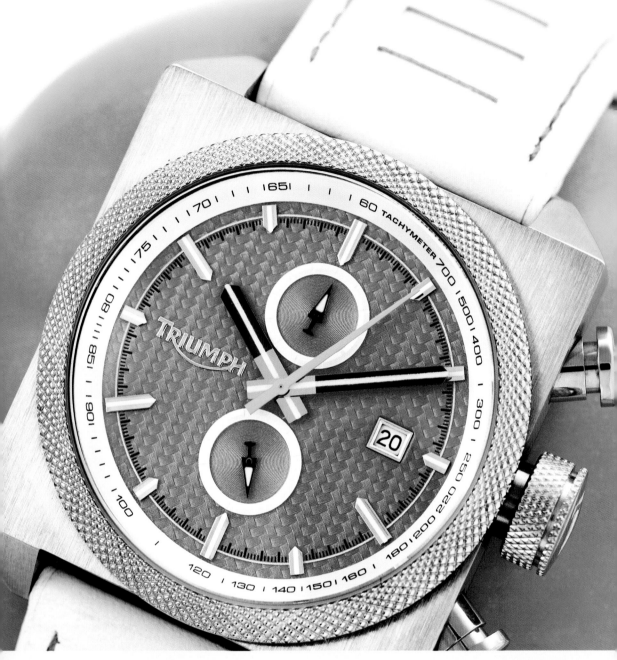

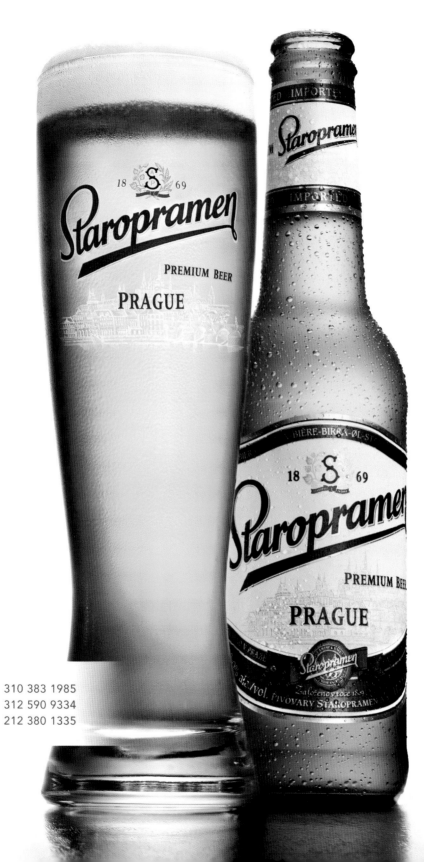

Lesley Zahara / LA 310 383 1985
Virginia Plasz / CHI 312 590 9334
Scott Evarts / NYC 212 380 1335

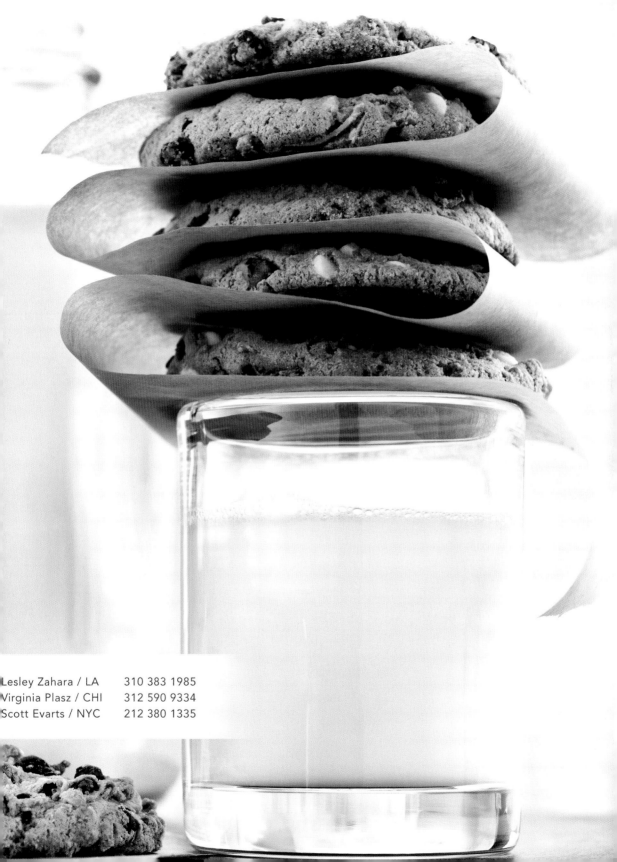

Lesley Zahara / LA 310 383 1985
Virginia Plasz / CHI 312 590 9334
Scott Evarts / NYC 212 380 1335

M REPRESENTS, INC. 212 840 8100
ALAN MAHON/Athletes JASON KNOTT/Lifestyle ACT 2|UM/cgi
FERNANDO MILANI/Beauty, Skin & Body JENNY RISHER/Beauty
JAMES PORTO/Photo-Illustration DENIS WAUGH/Landscapes
GARY SALTER/Conceptual & Humor RAY MASSEY/Liquids-Splash
ALICE BLUE/CGI & Illustration CONRAD PIEPENBURG/Automotive
LaCOPPOLA+MEIER/Lifestyle/ralph@mrepresents.com MREPRESENTS.COM

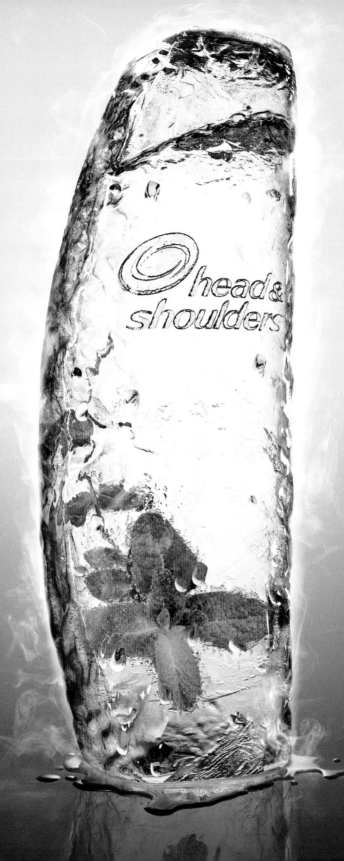

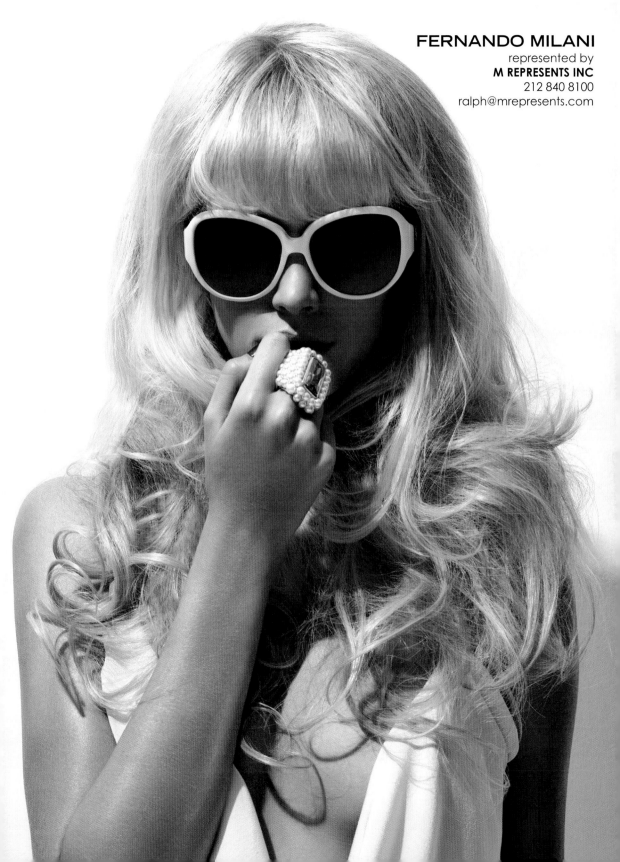

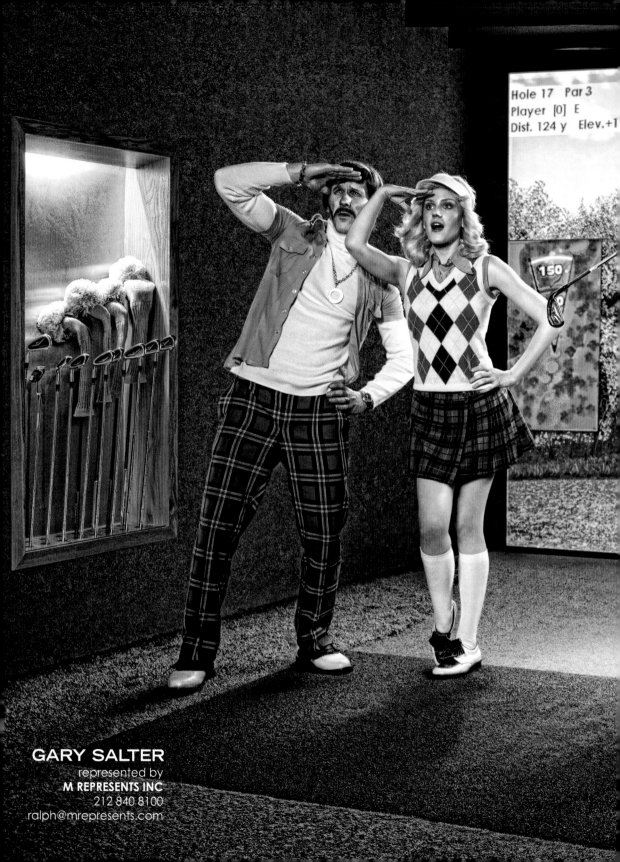

Hole 17 Par 3
Player [0] E
Dist. 124 y Elev. +1

GARY SALTER
represented by
M REPRESENTS INC
212 840 8100
ralph@mrepresents.com

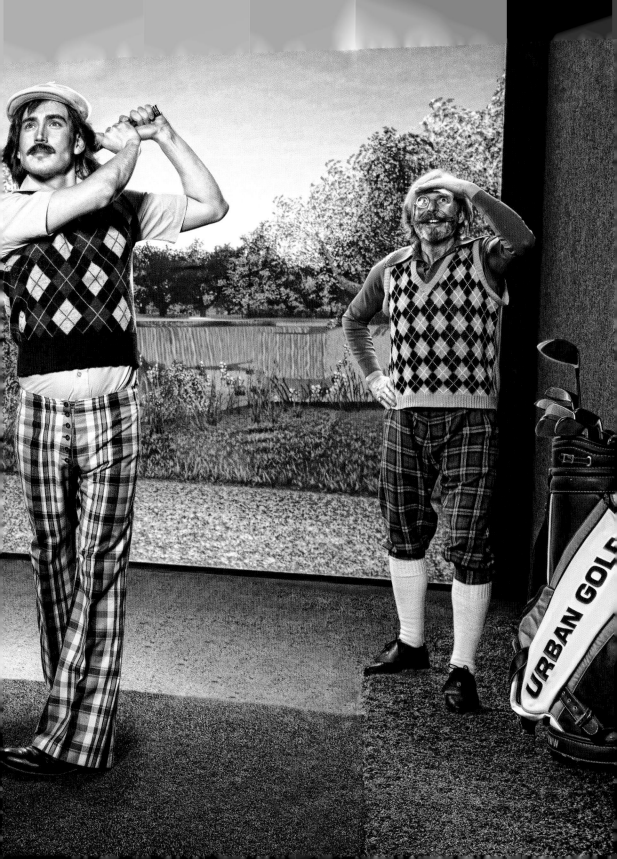

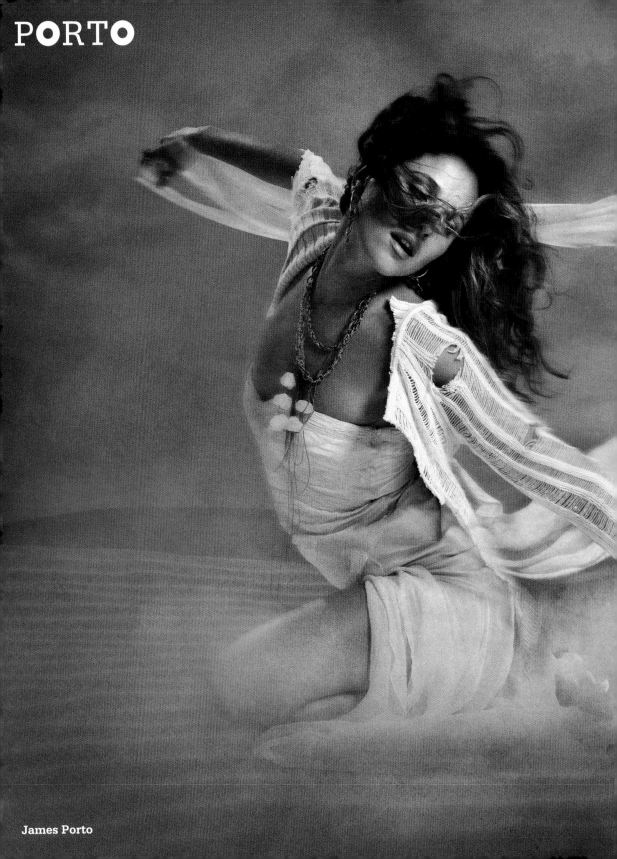

PORTO

James Porto

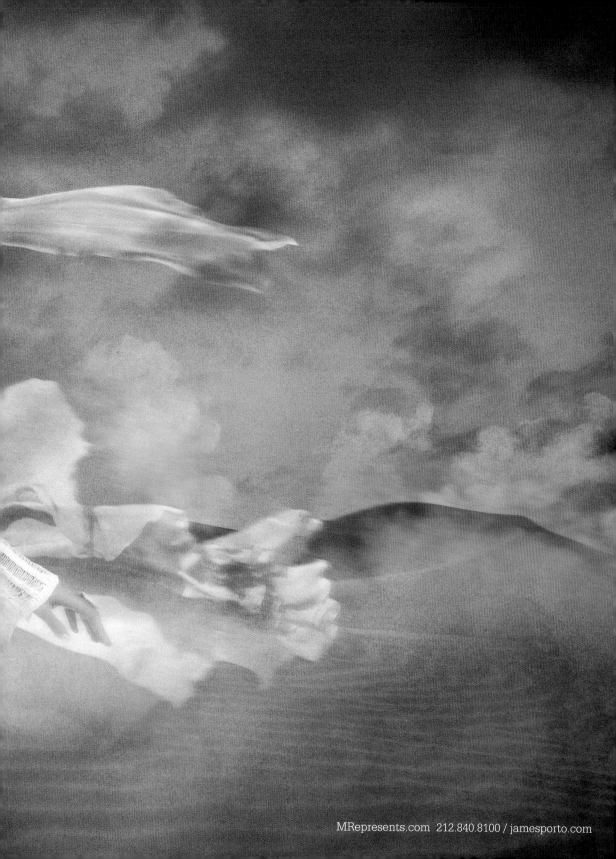

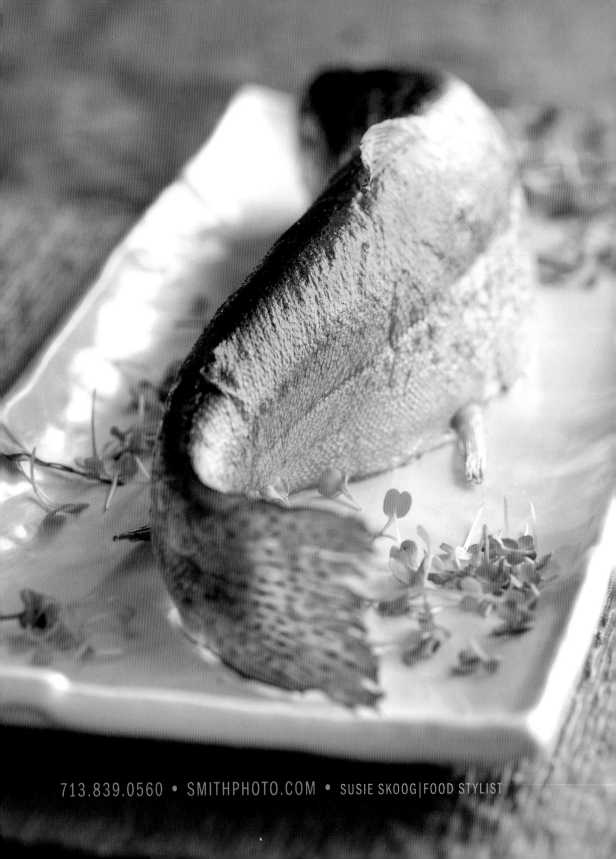

RALPH SMITH

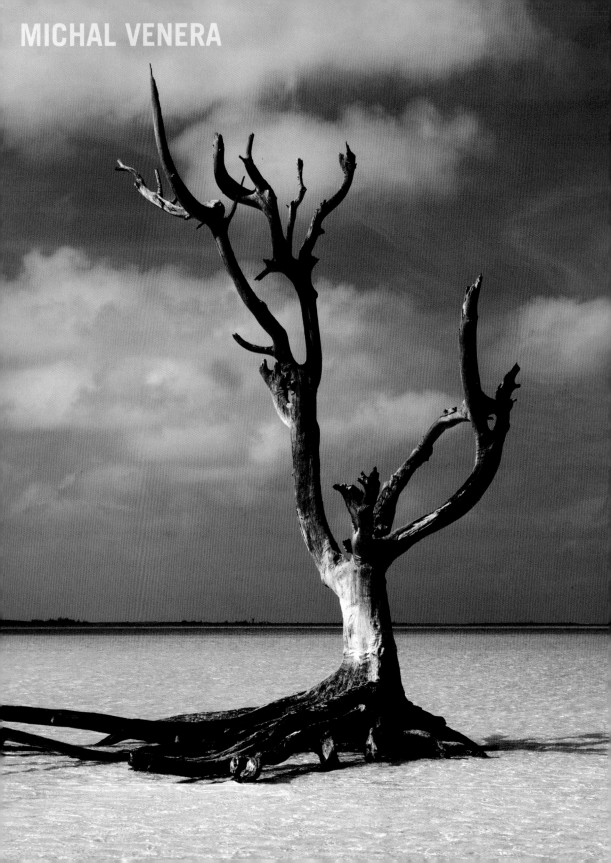

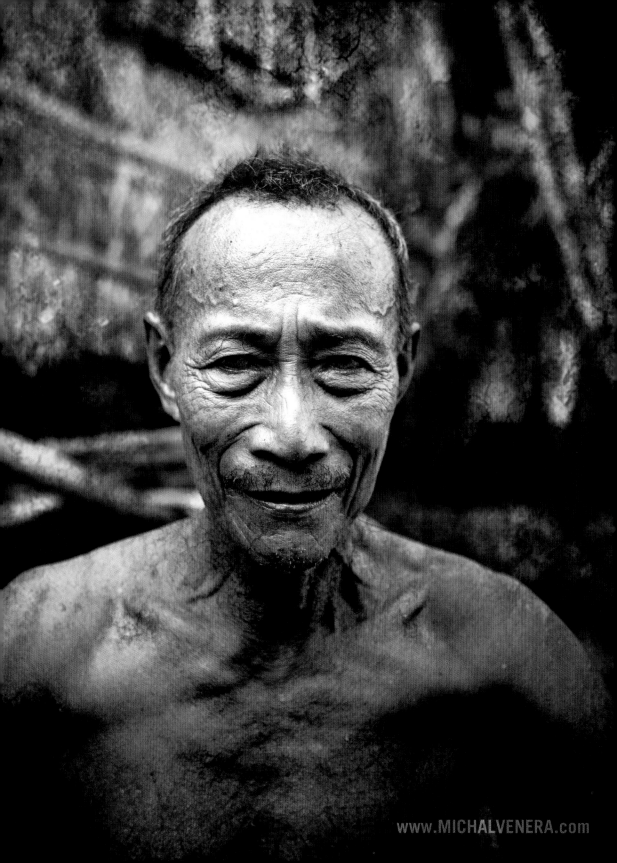

GLEN WEXLER STUDIO

glenwexler.com 323 465.0268 | representation: seminara artists 917 494.6736

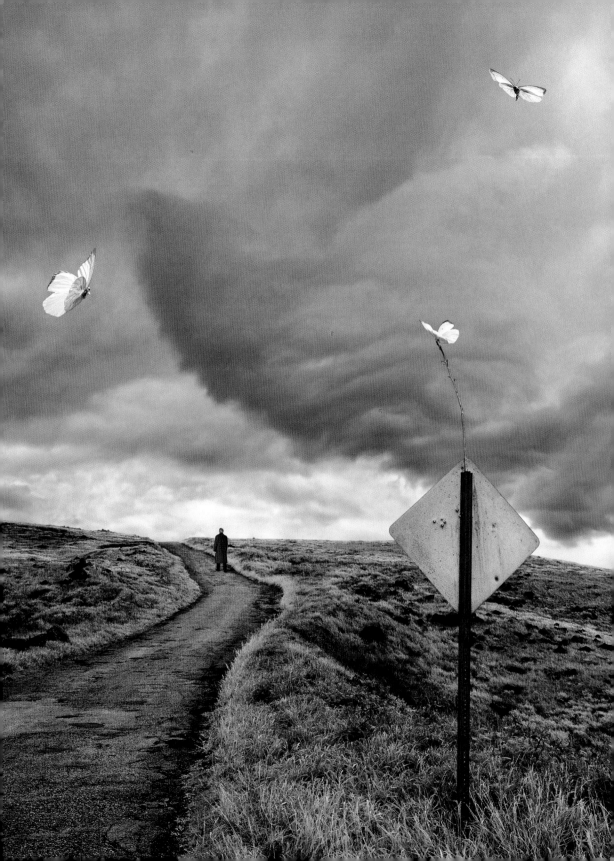

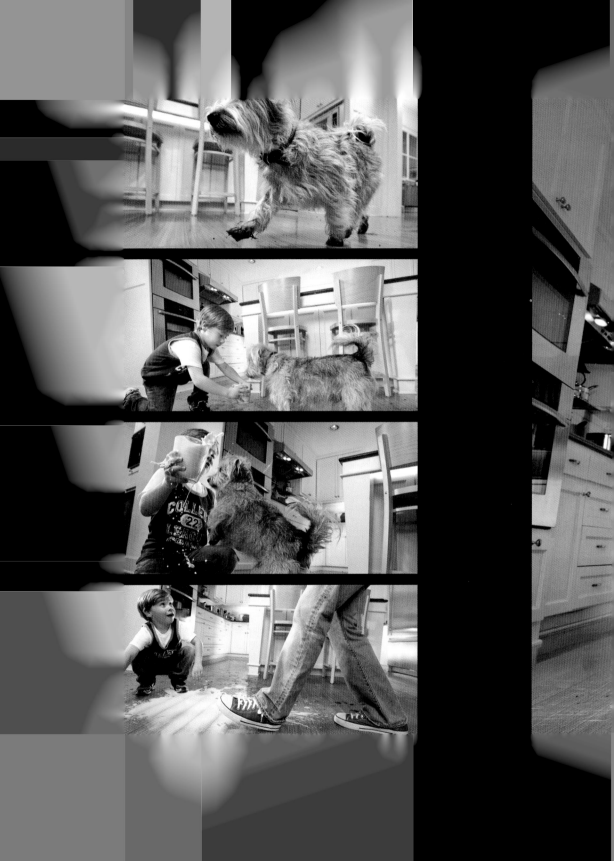

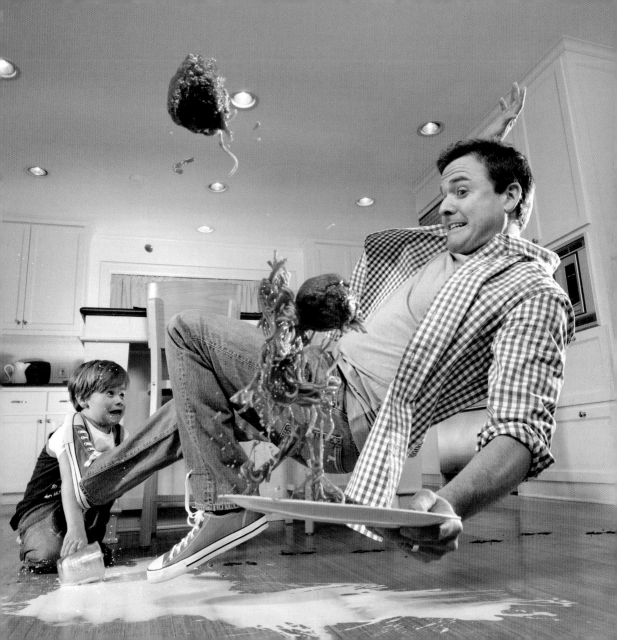

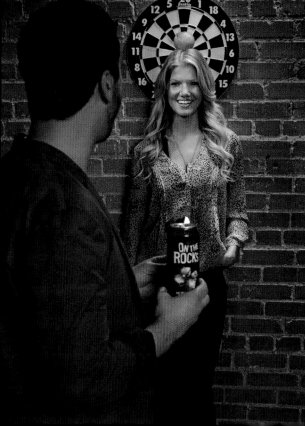

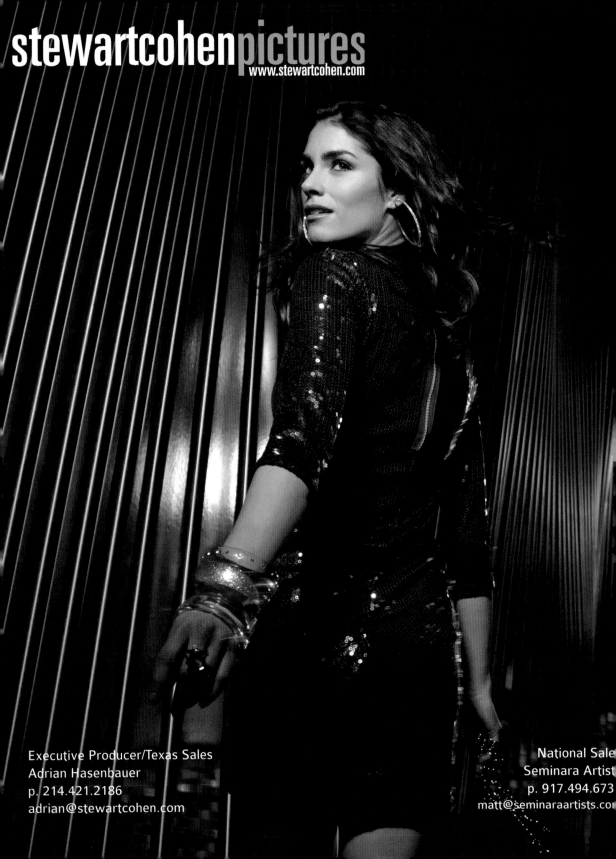

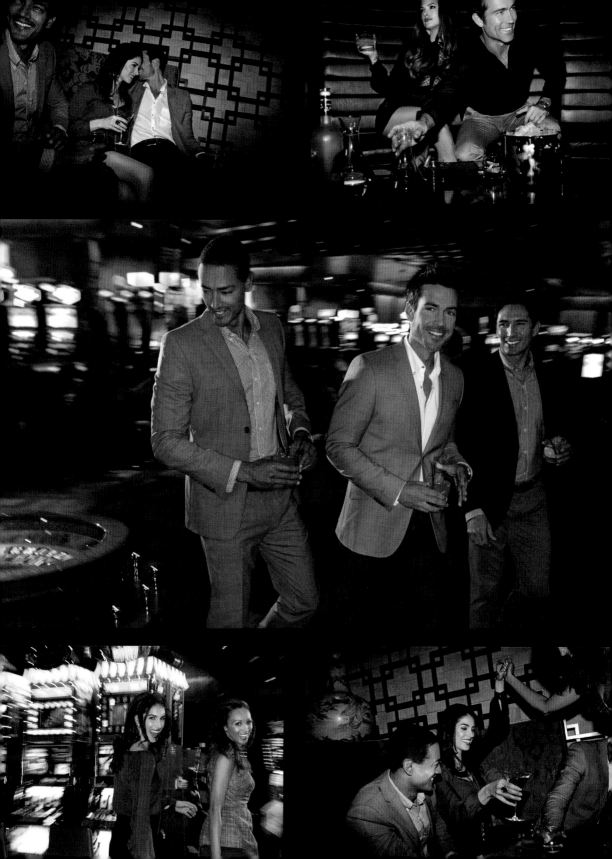

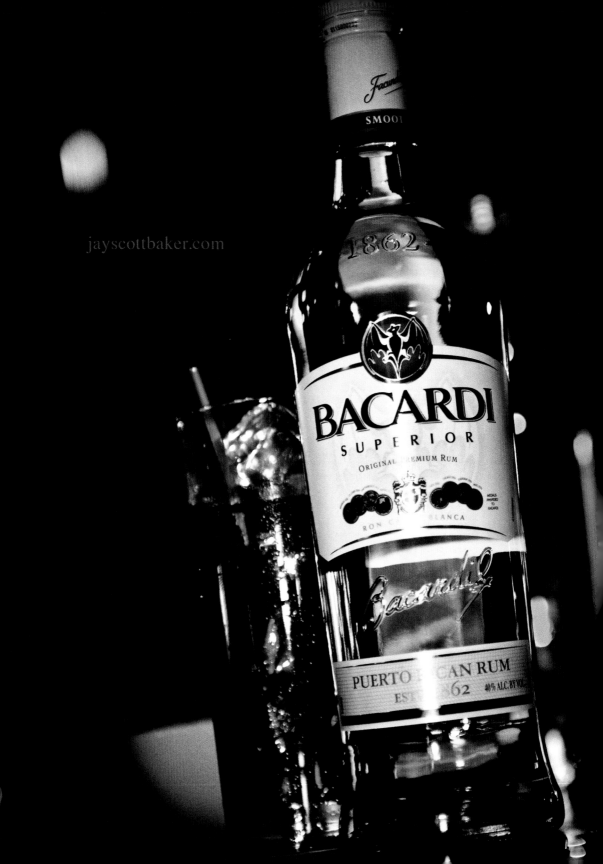

JAY SCOTT BAKER

represented by

Teenuh Foster

314.941.4250
fosterreps.com

ETCCREATIVEINC.COM

MW / WEST

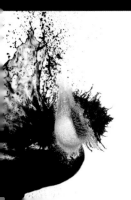

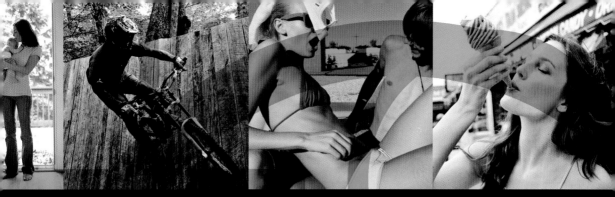

ETCCREATIVEINC.COM

EAST

JOE LOMBARDO - 347-409-9973 - JOE@ETCCREATIVEINC.COM

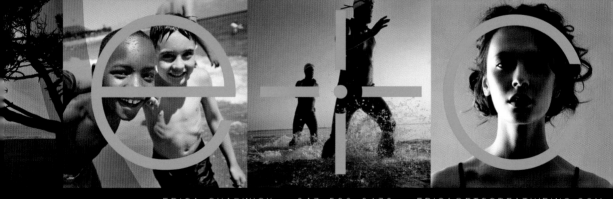

ERICA CHADWICK - 847-563-8178 - ERICA@ETCCREATIVEINC.COM

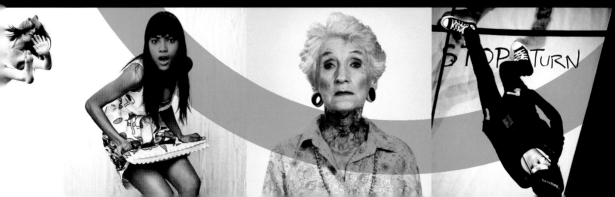

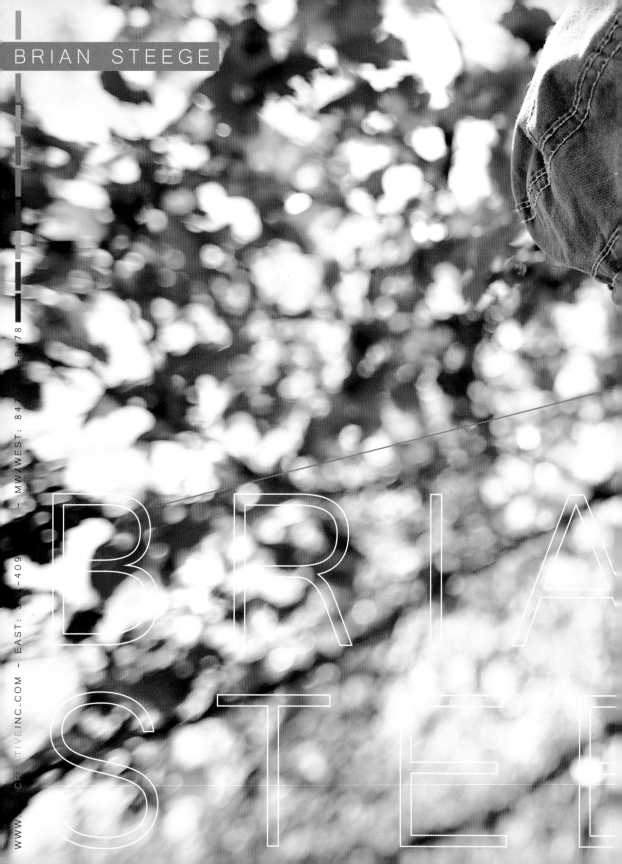

BRIAN STEEGE

MW/WEST: 847- -8178

EAST: 3 -409

CREATIVEINC.COM

WWW.

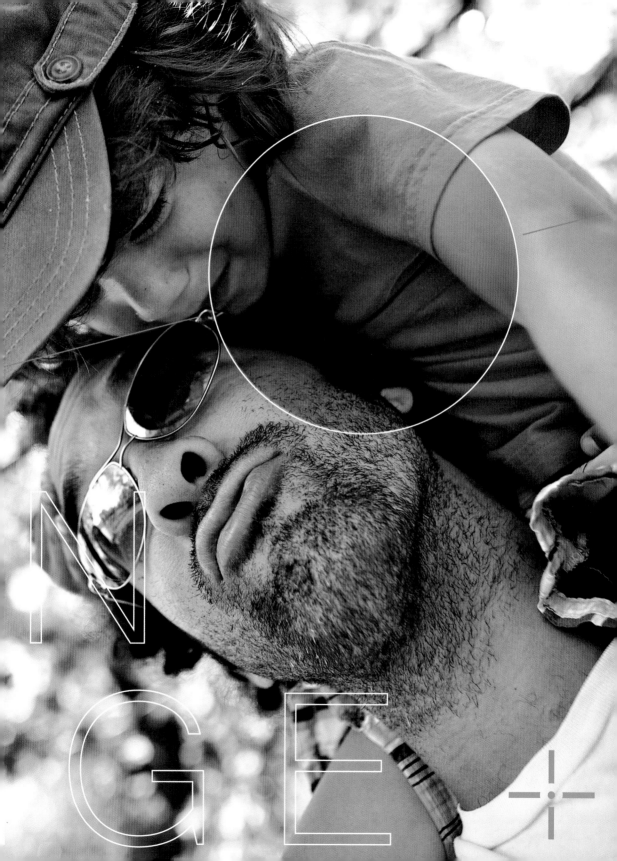

CLIN
BLO

CLIN
BLO

WWW.ETCCREATIVEINC.COM – EAST: 347-409-9973 – MW/WEST: 847-563-8178

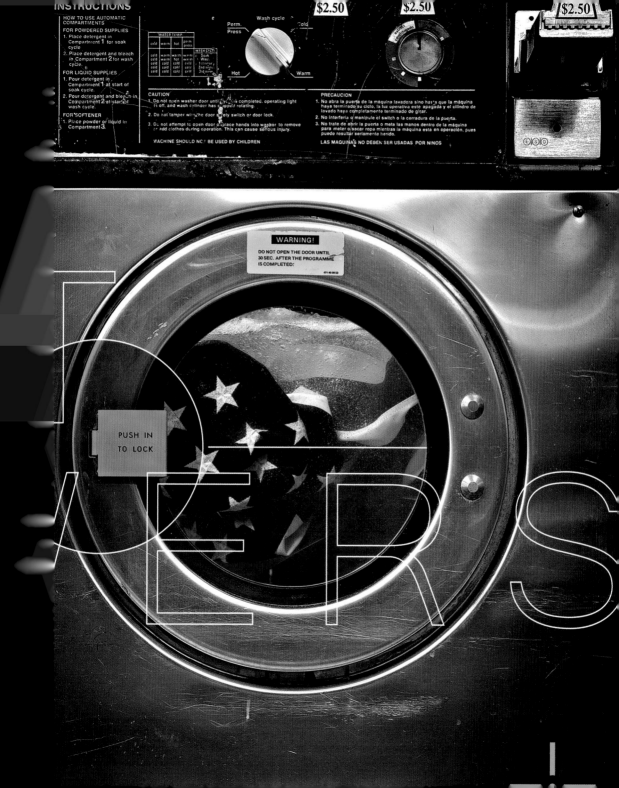

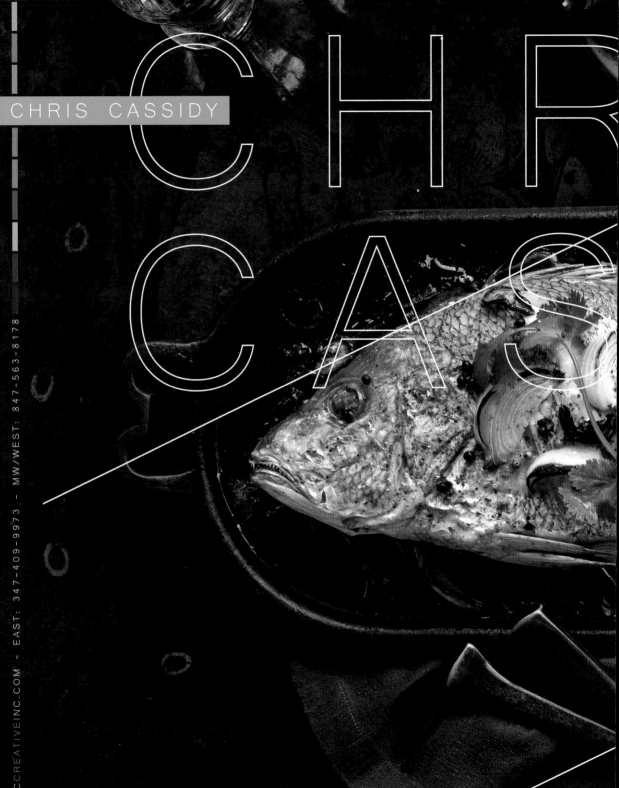

CHRIS CASSIDY

CHR
CAS

CCREATIVEINC.COM – EAST: 347-409-9973 – MW/WEST: 847-563-8178

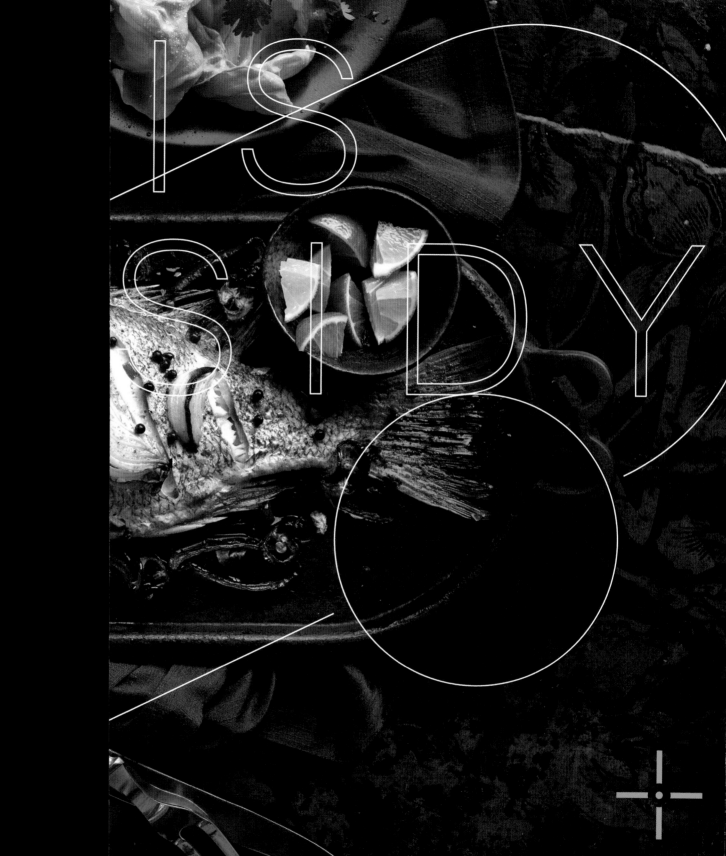

IS
SI
DY

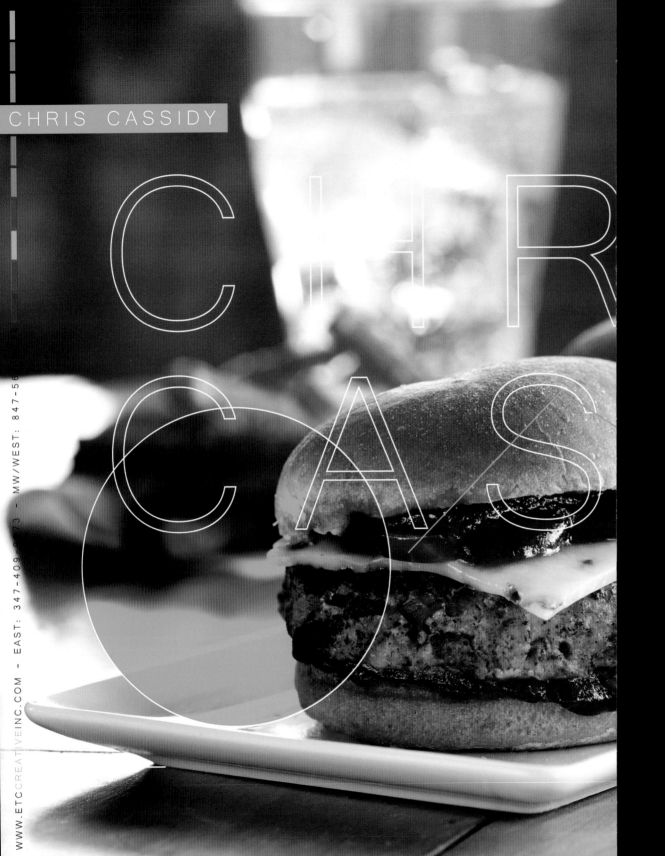

CHRIS CASSIDY

WWW.ETCCREATIVEINC.COM - EAST: 347-409-0173 - MW/WEST: 847-56

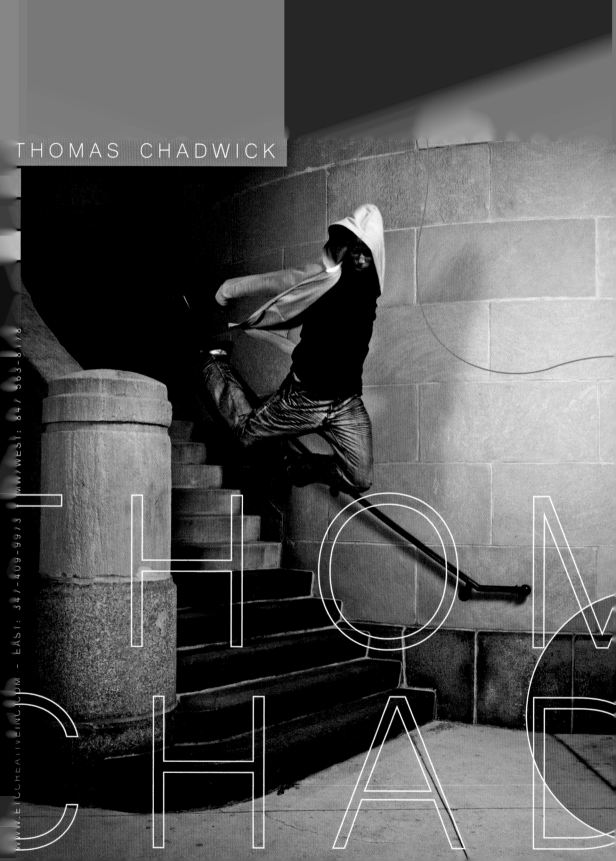

THOMAS CHADWICK

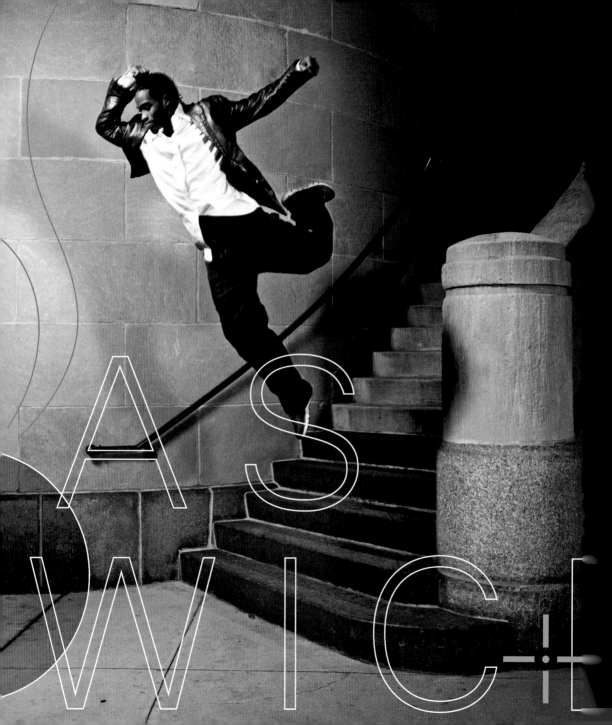

WWW.ETCCREATIVEINC.COM - EAST: 347-409-9973 - MW/WEST: 847-563-8178

T HOM
C HAD

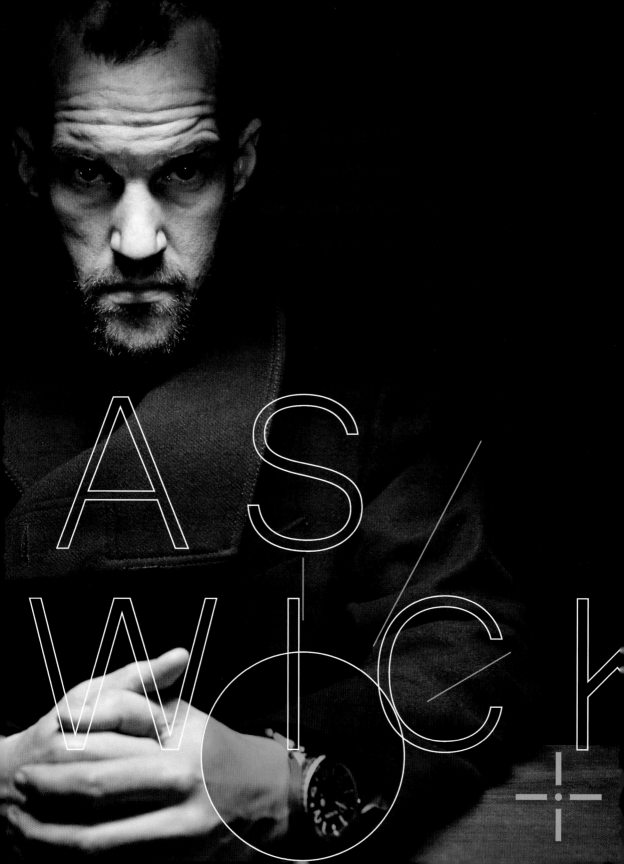

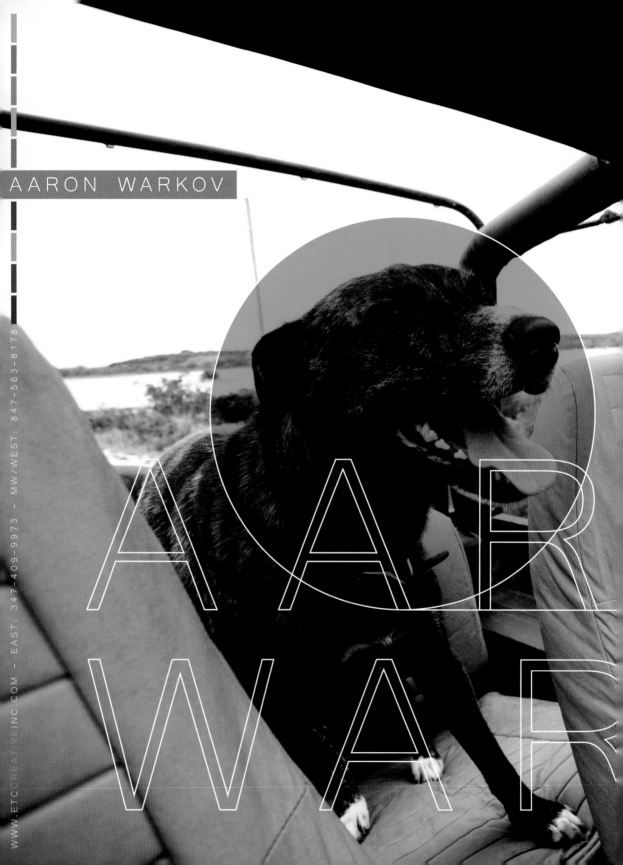

AARON WARKOV

WWW.ETCCREATIVEINC.COM – EAST: 347-409-9973 – MW/WEST: 847-563-8178

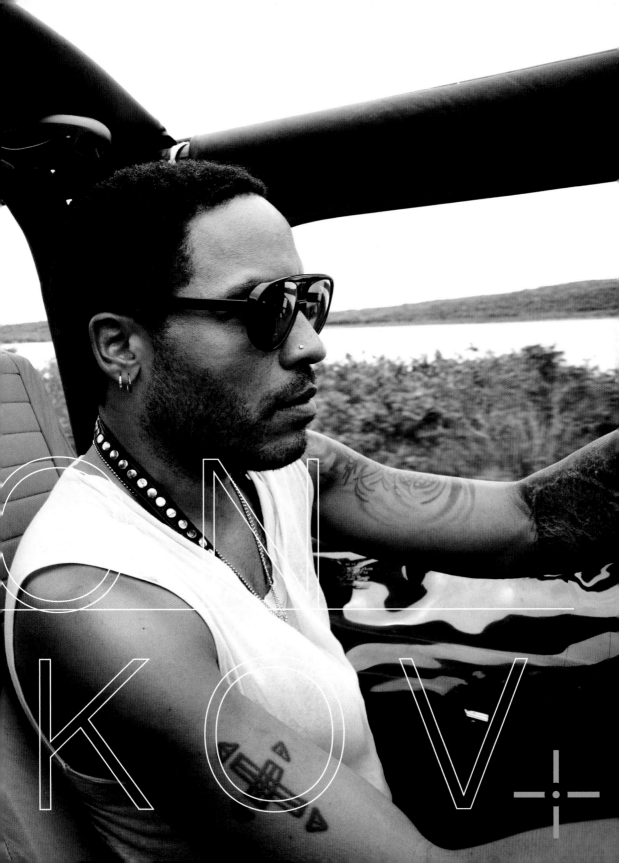

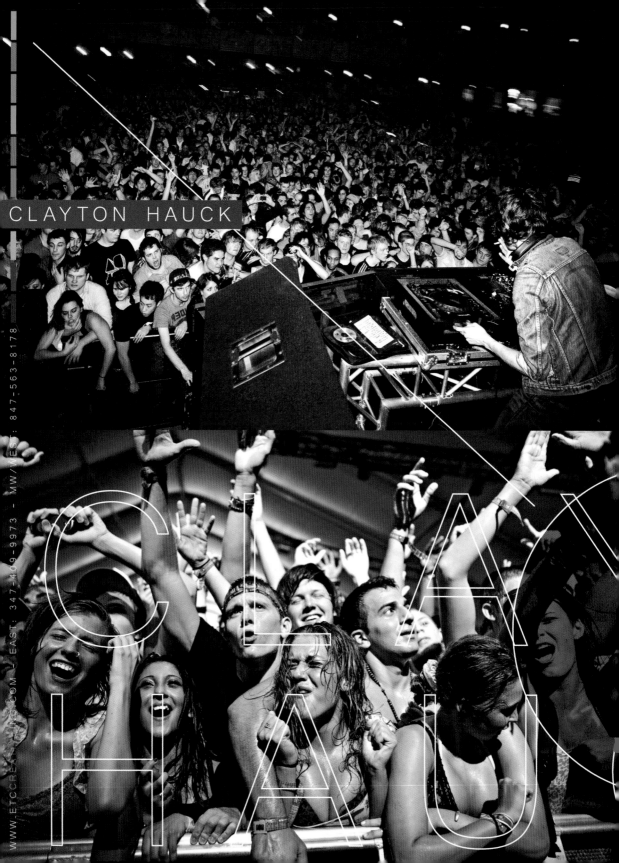

CLAYTON HAUCK

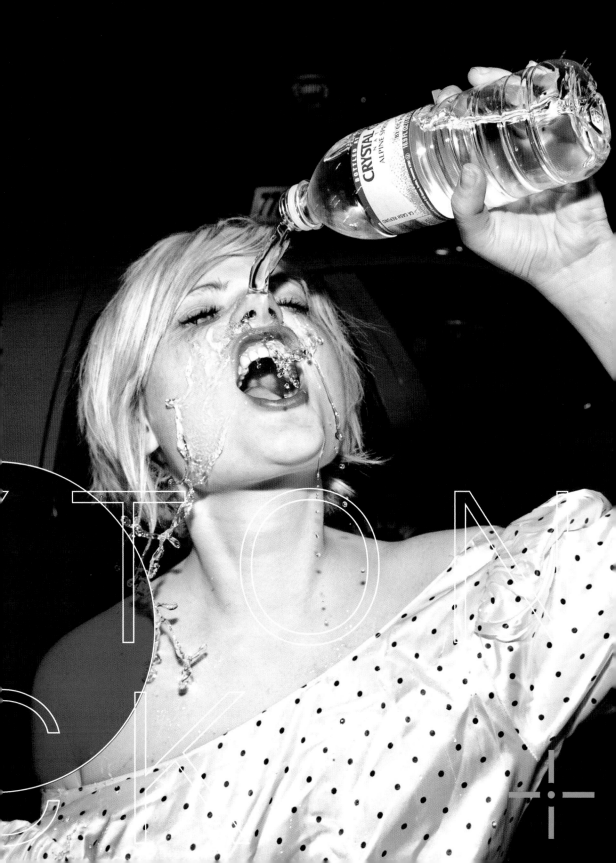

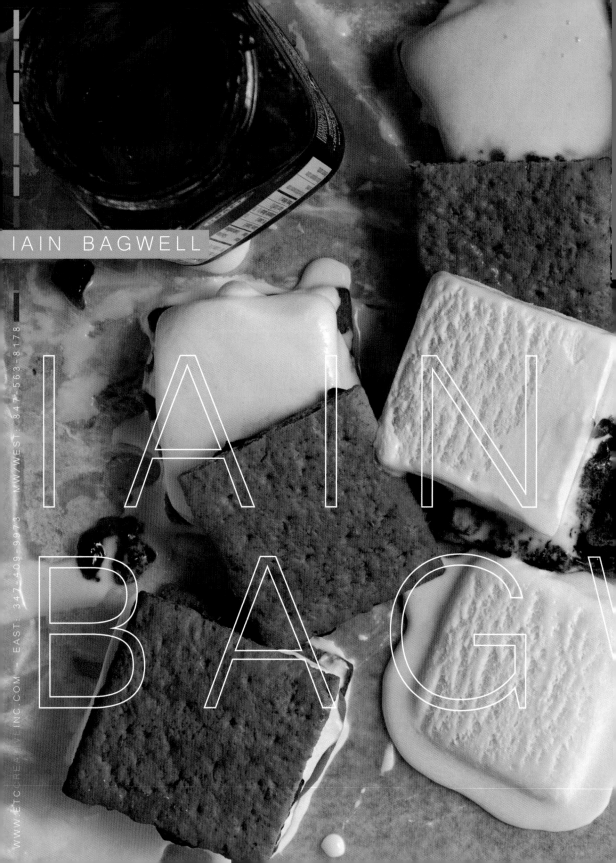

IAIN BAGWELL

IAIN
BAG

WWW.ETCCREATIVEINC.COM — EAST: 347-409-9973 — MW/WEST: 847-563-8178

TOSCA RADIGONDA

TOSCA
RADIGON

WWW.ETCCREATIVENC.COM – EAST: 347-409-9973 – MW/WEST: 847-563-8178

NOZICKA

STEVE NOZICKA PHOTOGRAPHY 314 WEST INSTITUTE PLACE CHICAGO, IL 60610

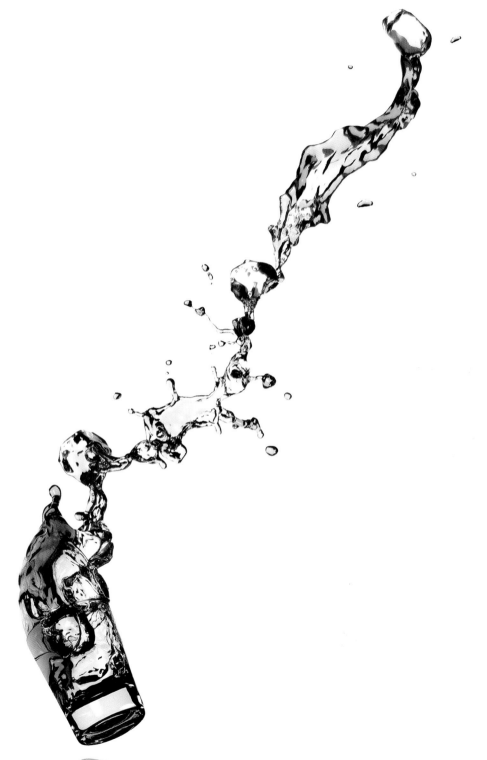

P)312-787-8925 nozicka.com nozickas@aol.com

vgpictures.com 214.284.0018
Represented by Those 3 Reps 800.579.0807

Vanessa Gavalya
PICTURES

Henrique Bagulho

Siri Berting

David Bishop

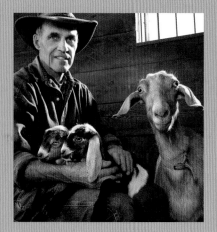

Robert Randall

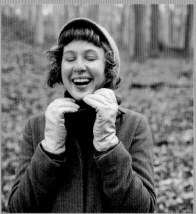

Zave Smith

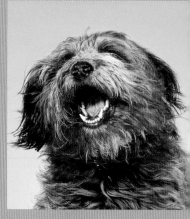

Gandee Vasan

Darrell Eager

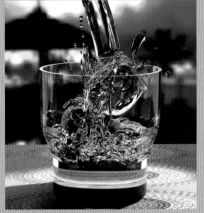

Kan Nakai

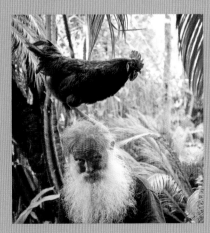

Michael Weschler

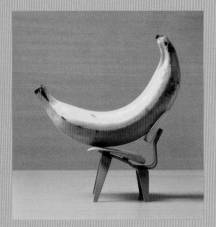

Bret Wills

107

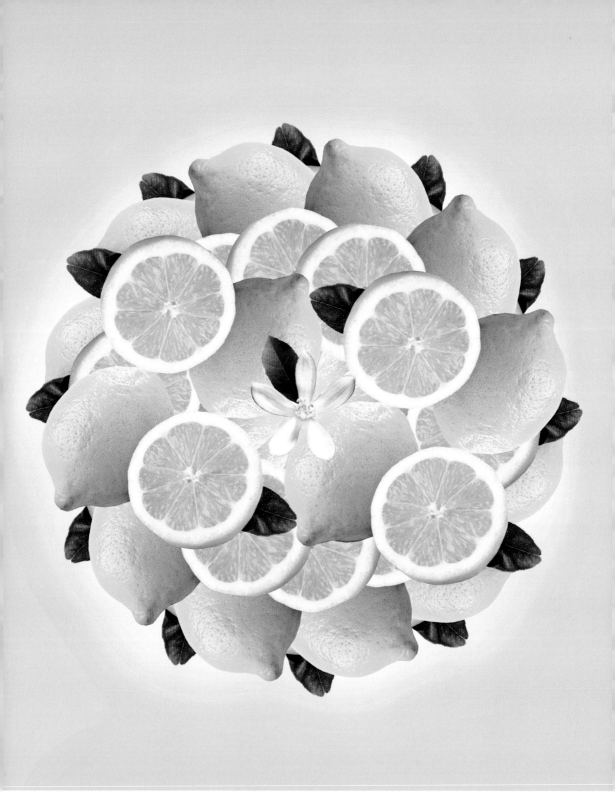

WSW creative 212-431-4480 | wswcreative.com

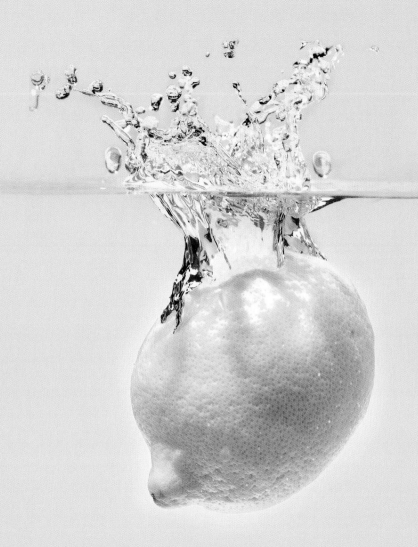

HENRIQUE BAGULHO

WSW creative | 212-431-4480 | wswcreative.com | midwest: annealbrecht.com | 312-315-005

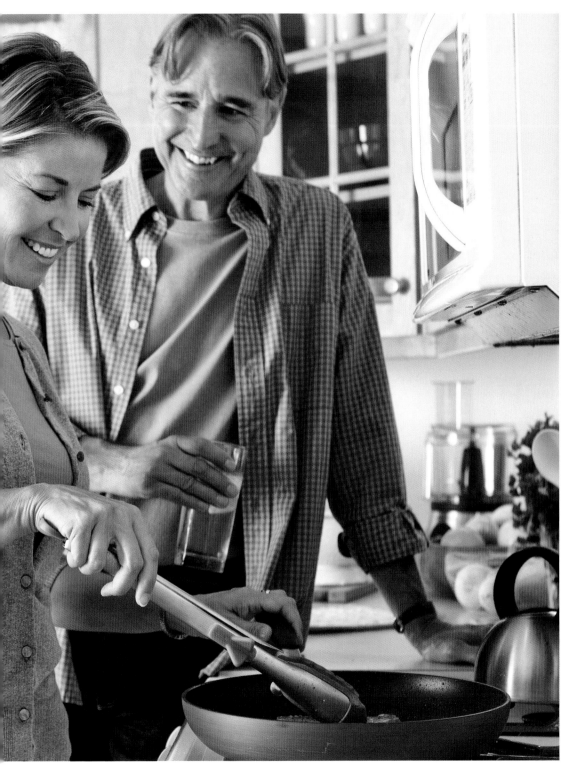

MICHAEL WESCHLER

DAVID BISHOP

ZAVE SMITH

WSW creative 212-431-4480 | wswcreative.com | midwest: annealbrecht.com | 312-315-005

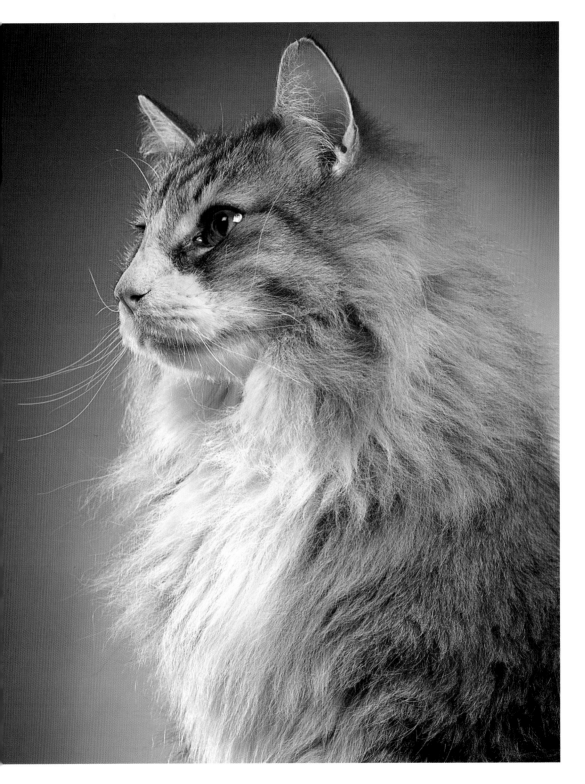

GANDEE VASAN

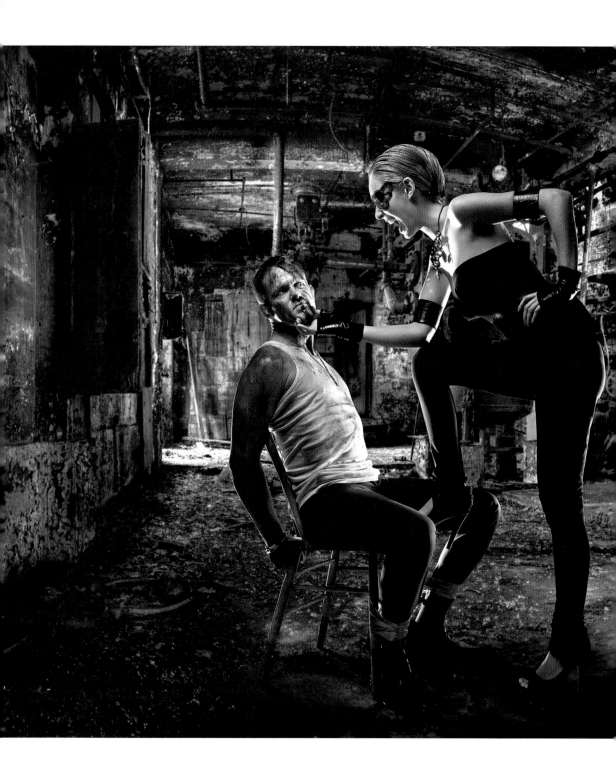

WSW creative 212-431-4480 | WSW Creative

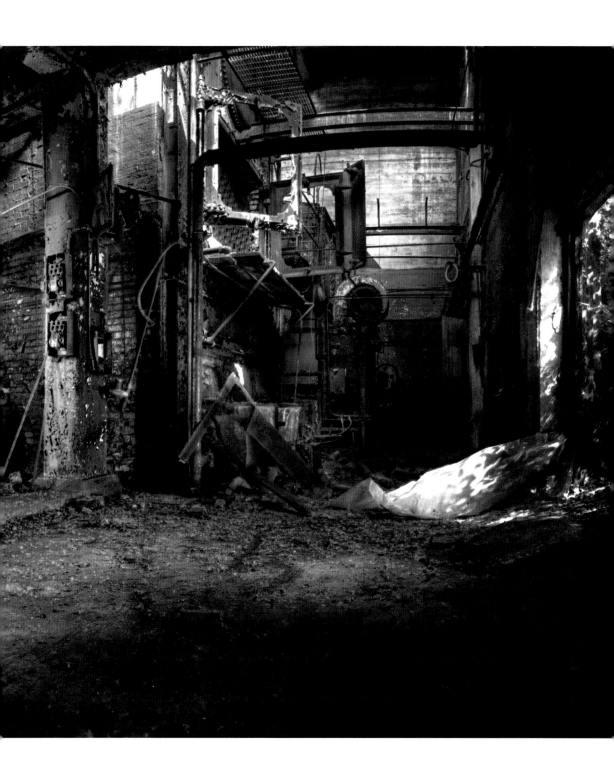

ROBERT RANDALL

HURS

DANAHURSEYPHOTOGRAPHY 626 345 9996 HURSEY.COM

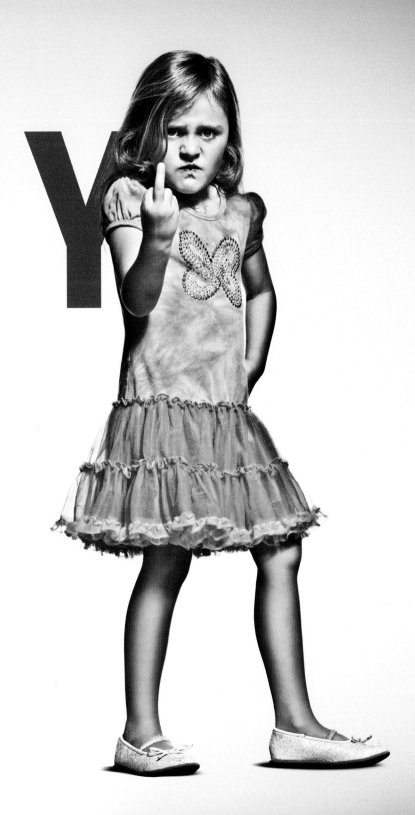

EY

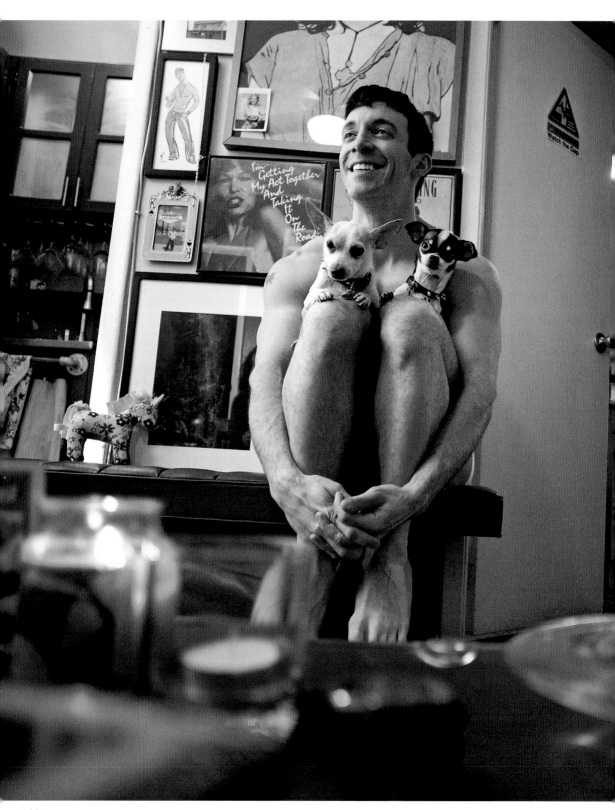

STEVE LESNICK

PHOTOGRAPHY

stevelesnick.com
agent:dougtruppe.com

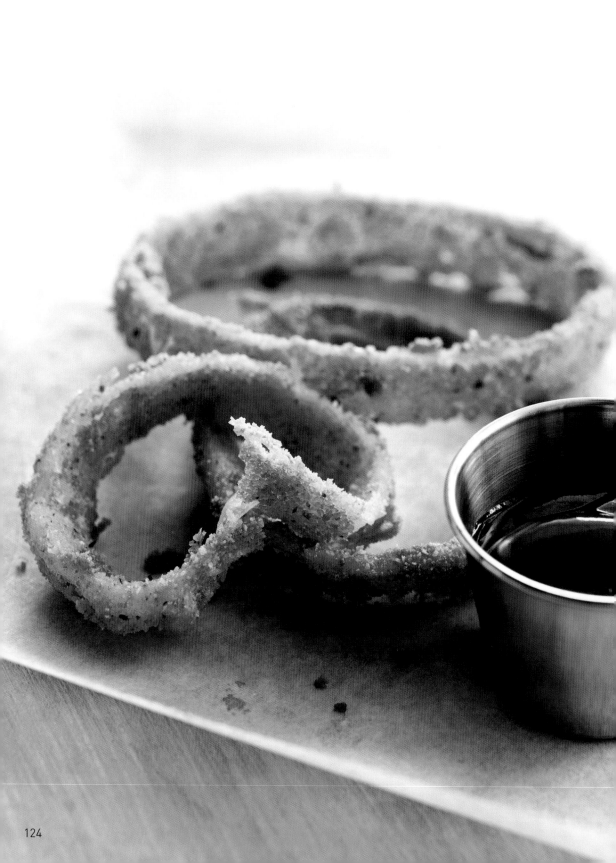

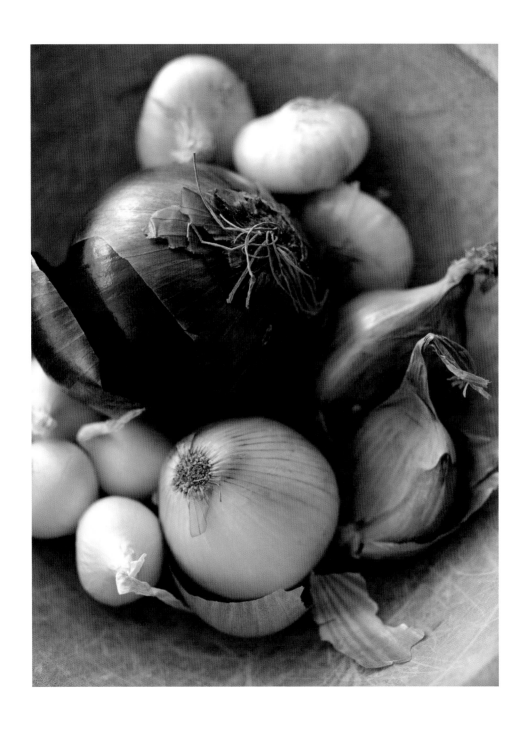

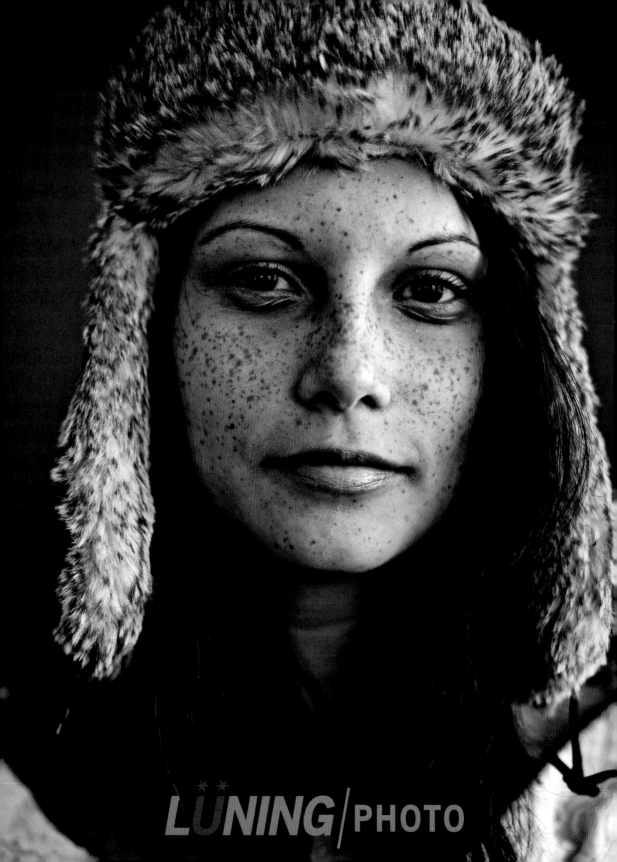

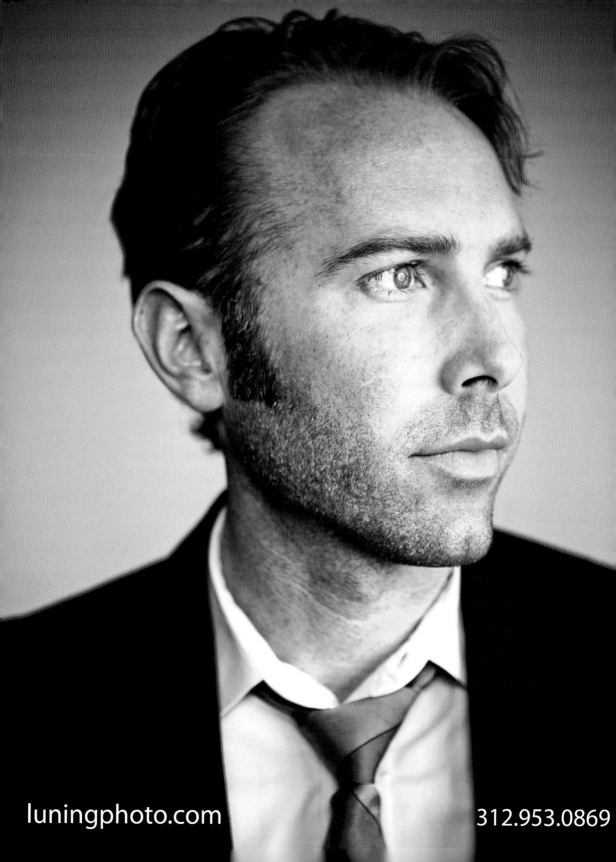

emissary

photography

MICHAEL COGLIANTRY
DAN GOLDBERG
MARK LUINENBURG
ANDREW REILLY
WALTER SMITH
TIM TADDER
WINKLER + NOAH

EMISSARYARTISTS.COM
773.489.9888

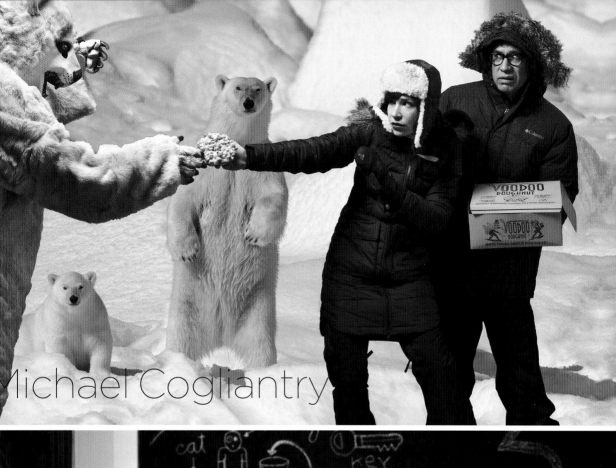
Michael Cogliantry

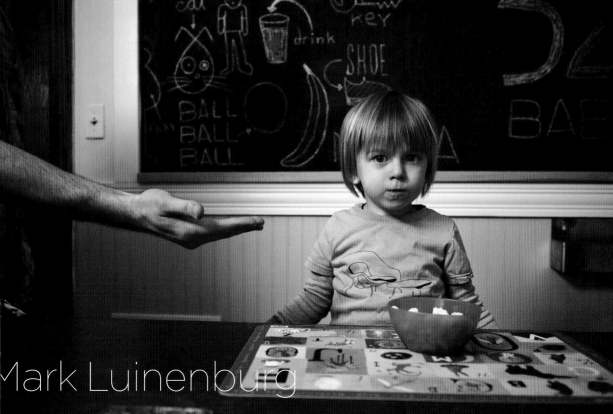
Mark Luinenburg

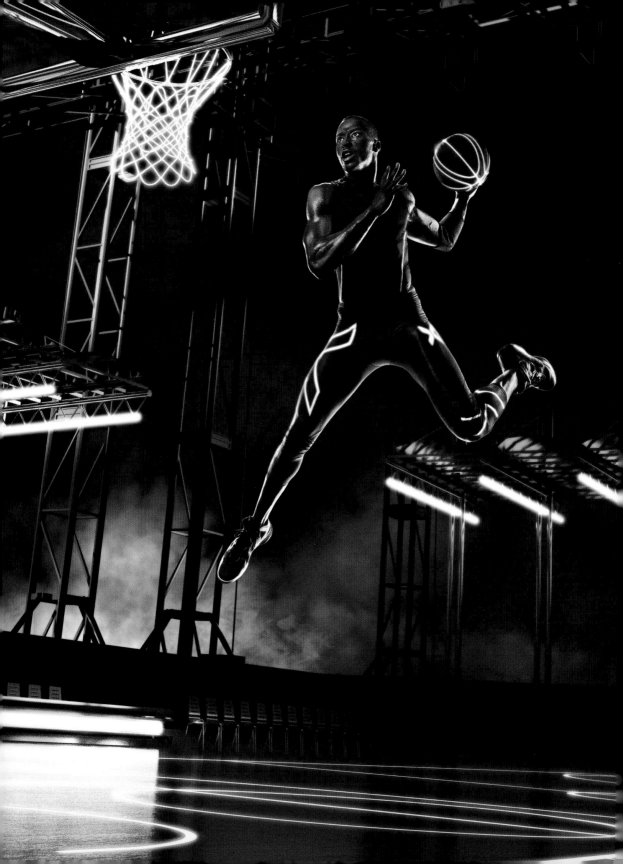

Tim Tadder

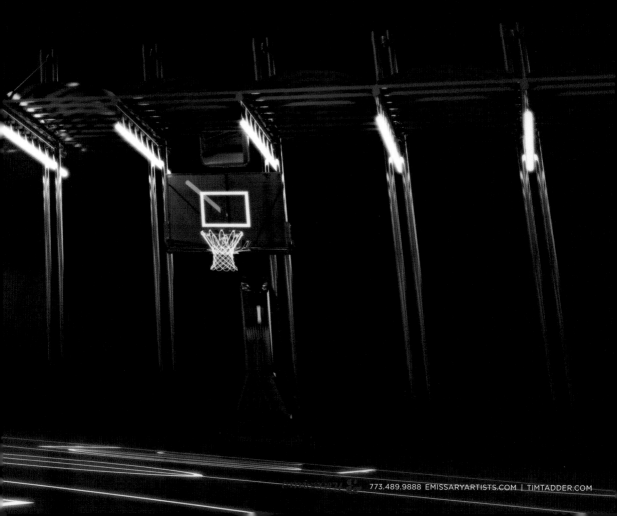

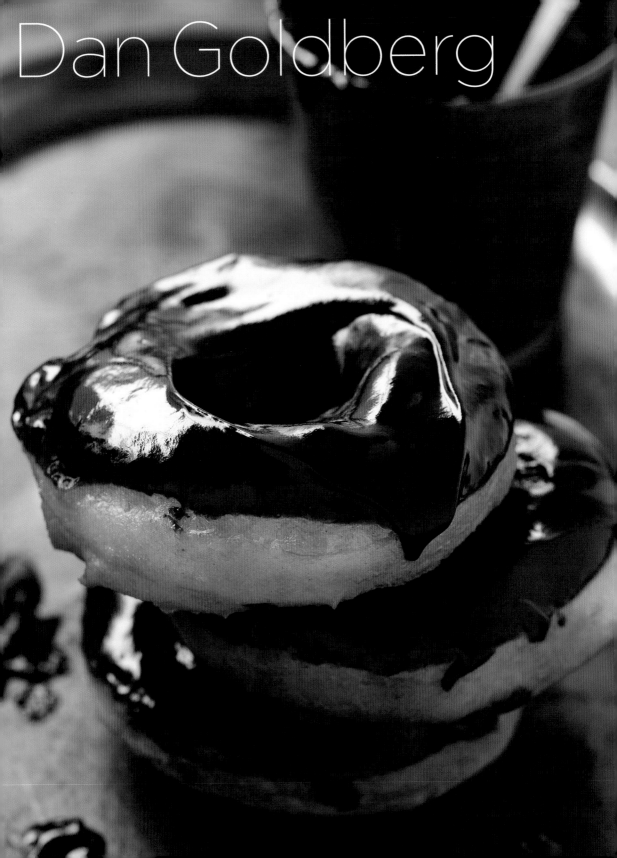

Dan Goldberg

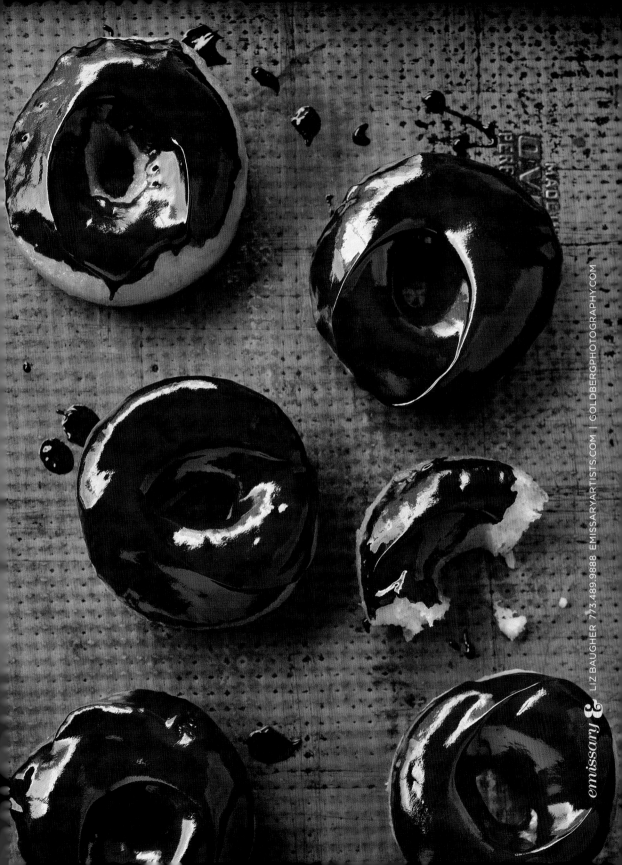

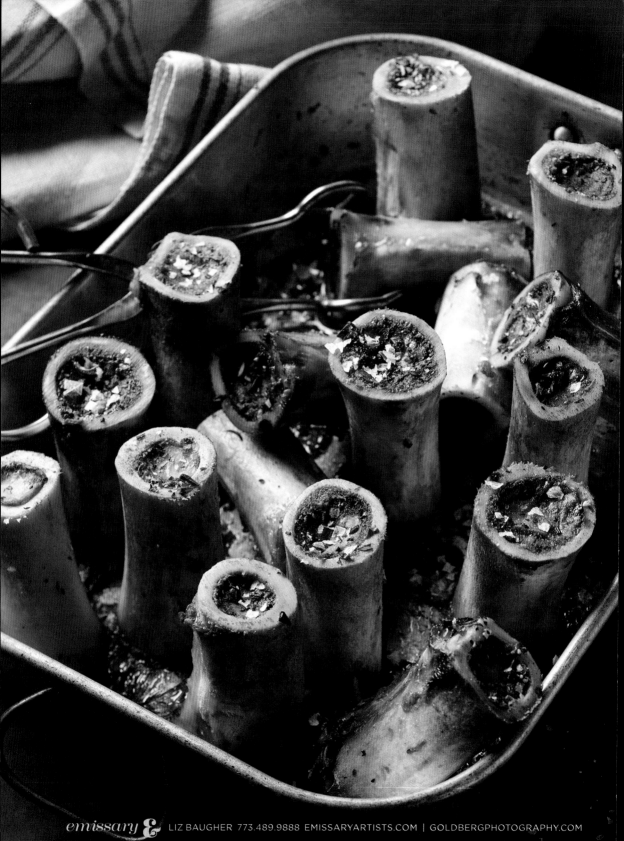

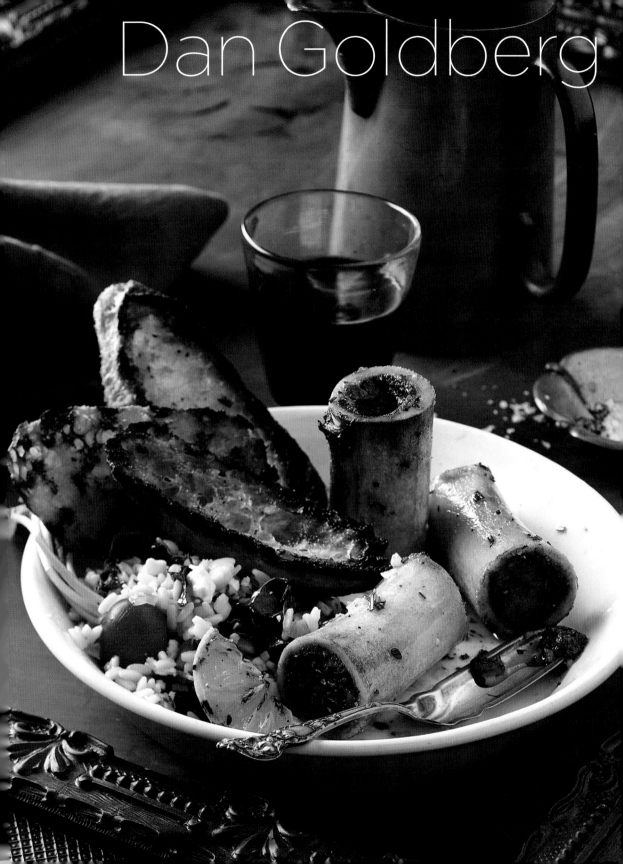

Dan Goldberg

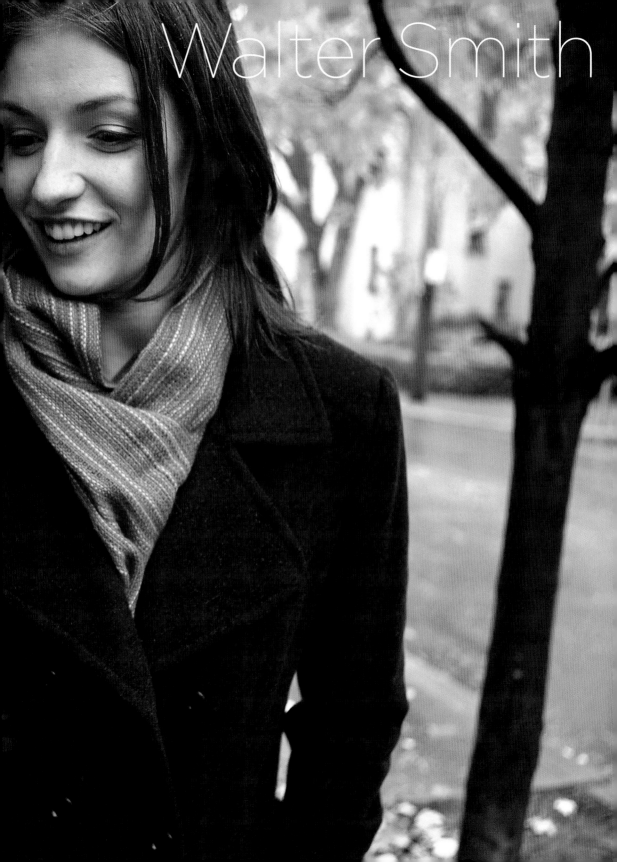

Walter Smith

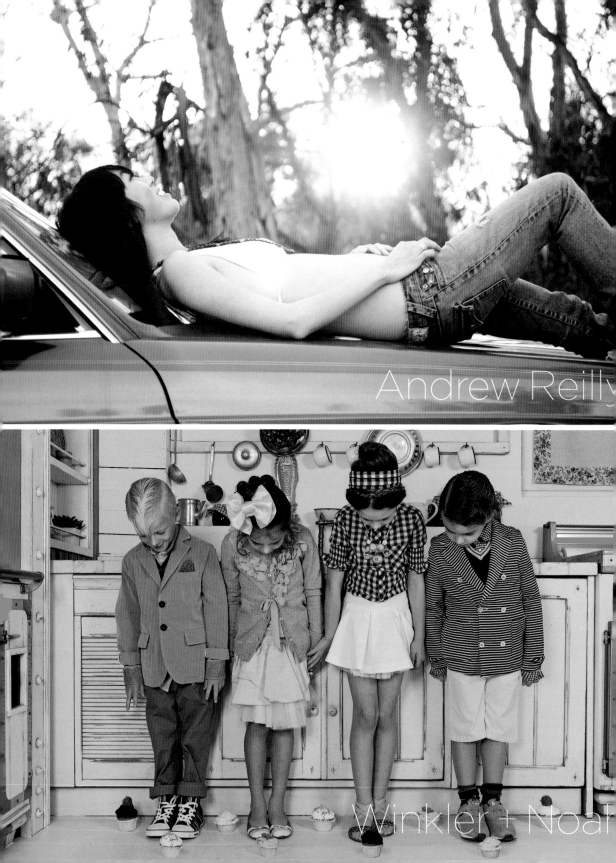

Andrew Reilly

Winkler + Noa

emissary

photography
MICHAEL COGLIANTRY
DAN GOLDBERG
MARK LUINENBURG
ANDREW REILLY
WALTER SMITH
TIM TADDER
WINKLER + NOAH

EMISSARYARTISTS.COM
773.489.9888

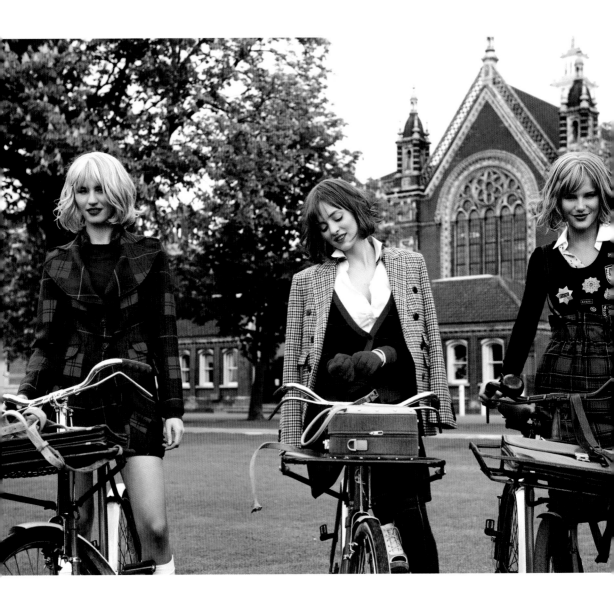

William Garrett

Belinda Sage
One Photographic Ltd
66 - 68 Margaret St
London
W1W 8SR
Tel.+44 20 746 1400
Cell. +44 7836 556362
Email.belinda@onephotographic.com

Kathrin Hohberg
GmbH & Co.KG
Klenzestraße 38
80469 München
Tel. 089.544173-13
Fax. 089.544173-20
email. monika@kathrin-hohberg.de
Internet. http://www.kathrin-hohberg.de

BRADGUICE
PHOTO

CARLIDAVIDSON
PHOTO

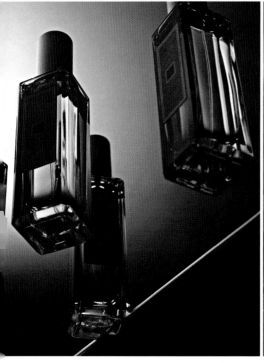

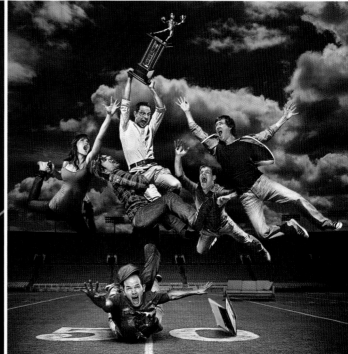

ROBERTTARDIO
PHOTO

PAULARESU
PHOTO / MOTION

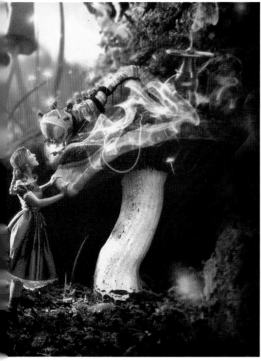

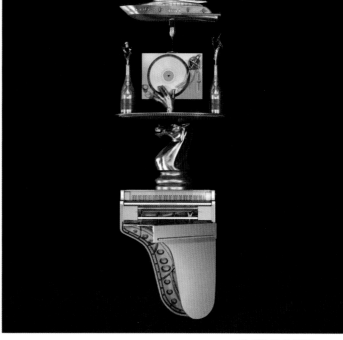

ALTER
CGI / MOTION / PHOTO

2FAKE
CGI / MOTION

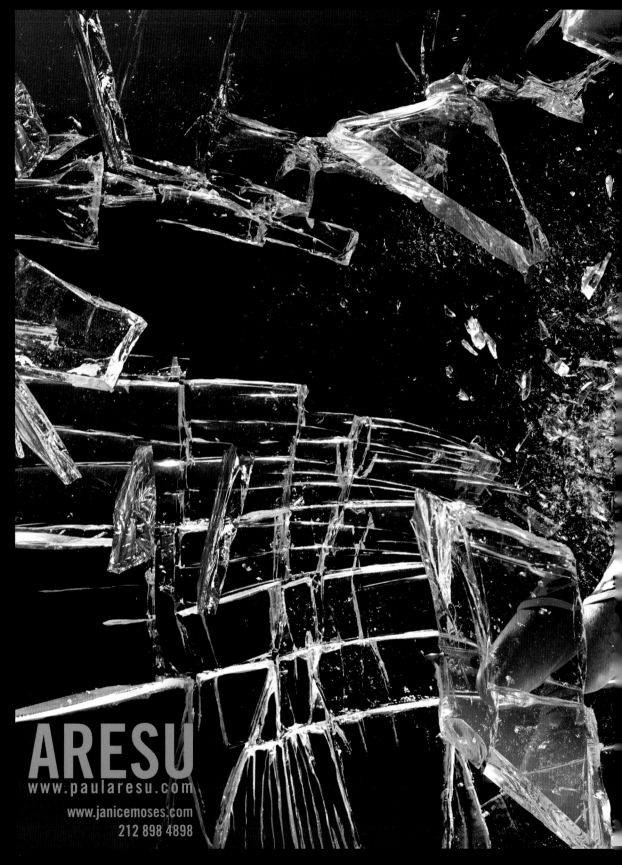

ARESU
www.paularesu.com

www.janicemoses.com
212 898 4898

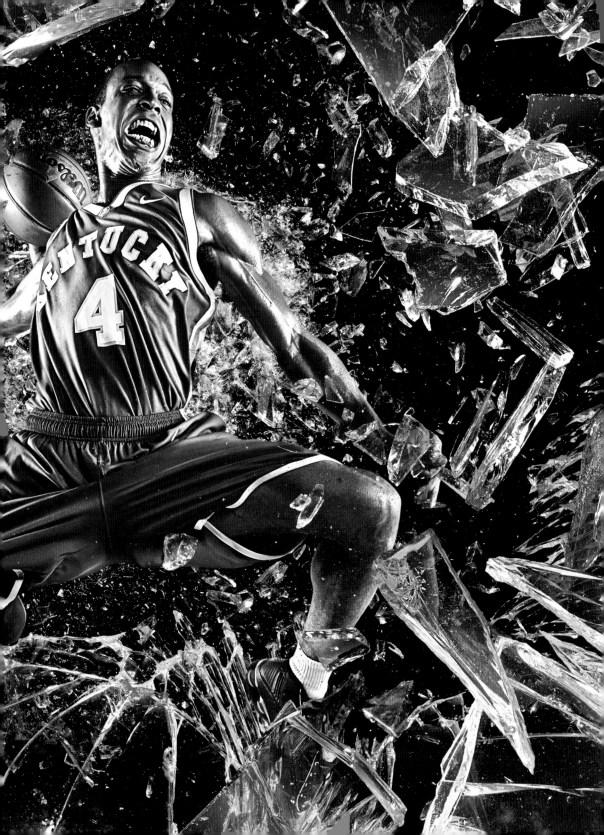

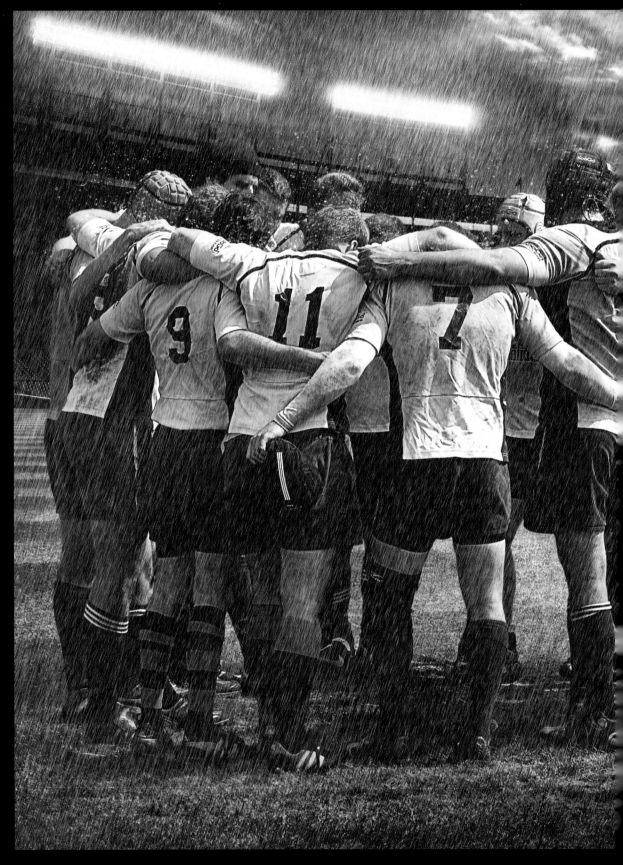

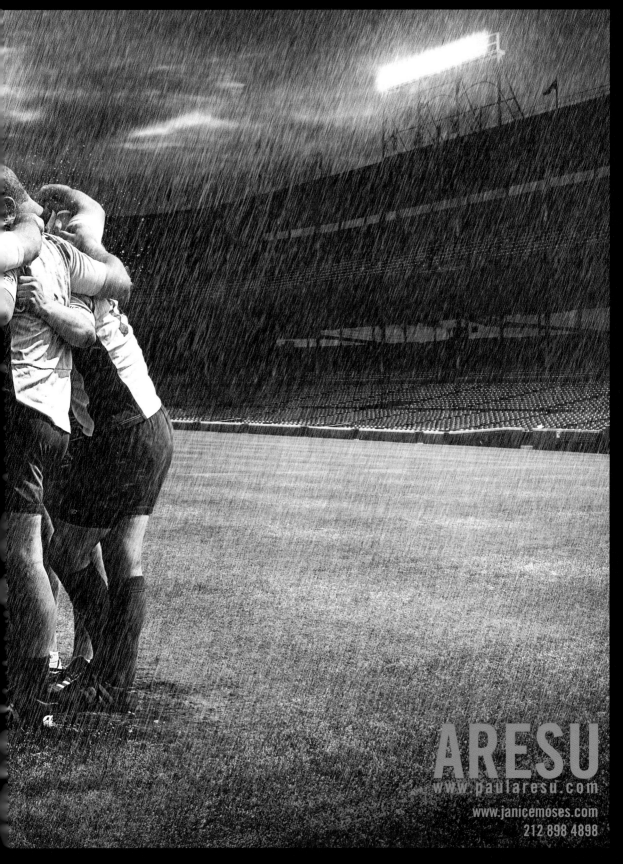

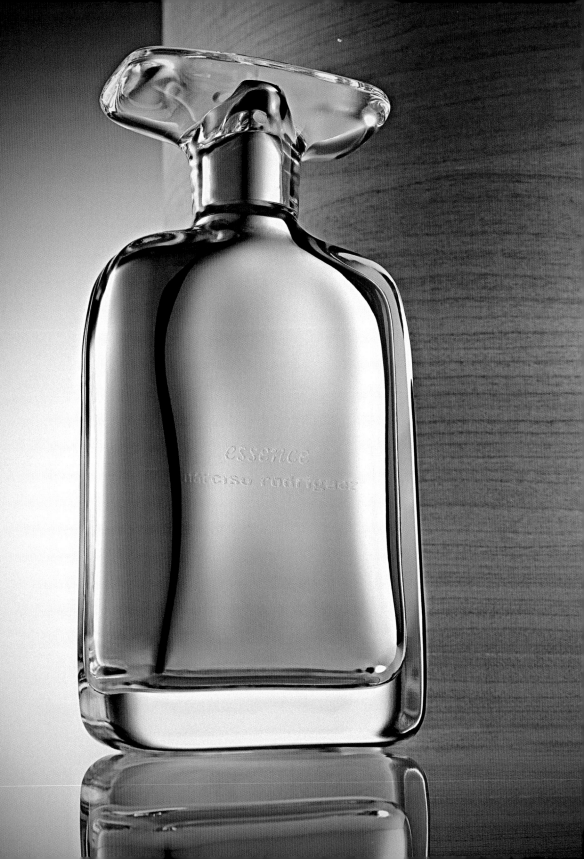

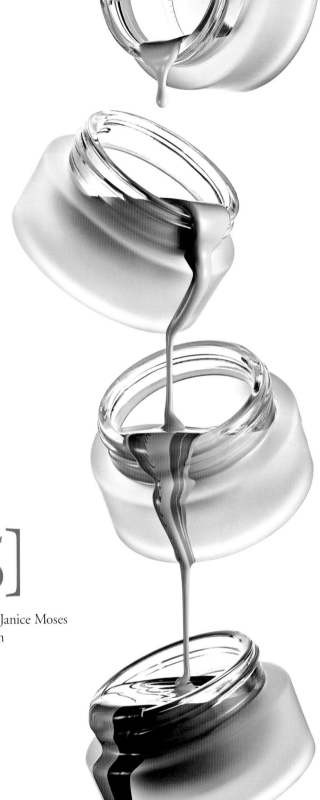

[ROBERT TARDIO]

RobertTardio.com

Represented by Janice Moses
janicemoses.com
212.898.4898

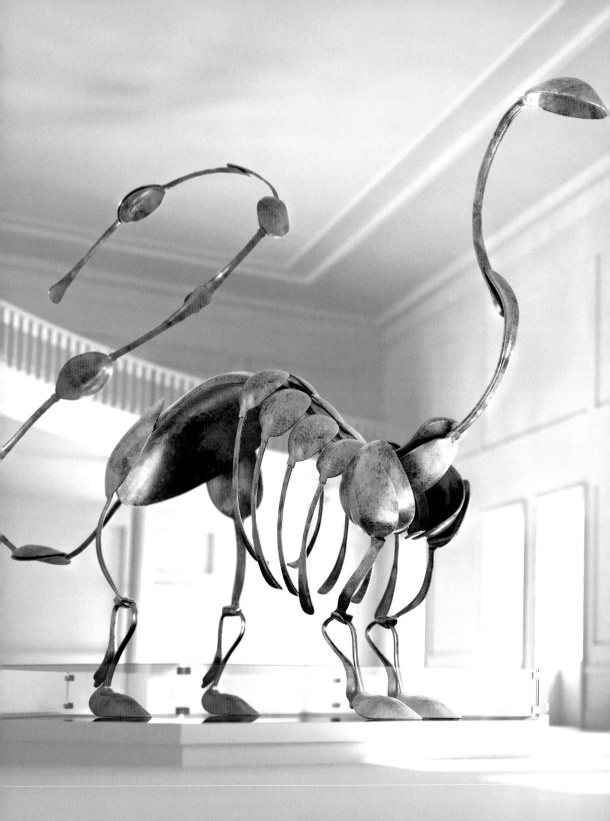

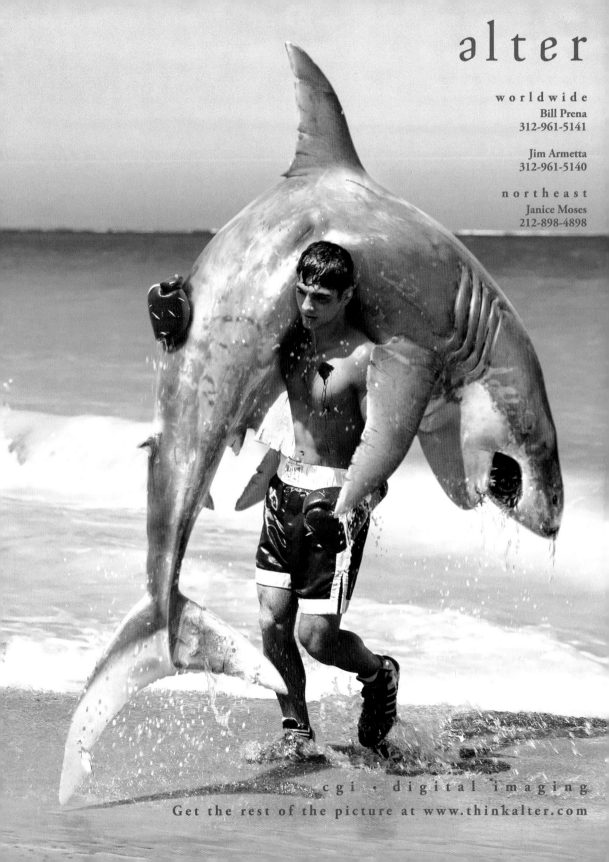

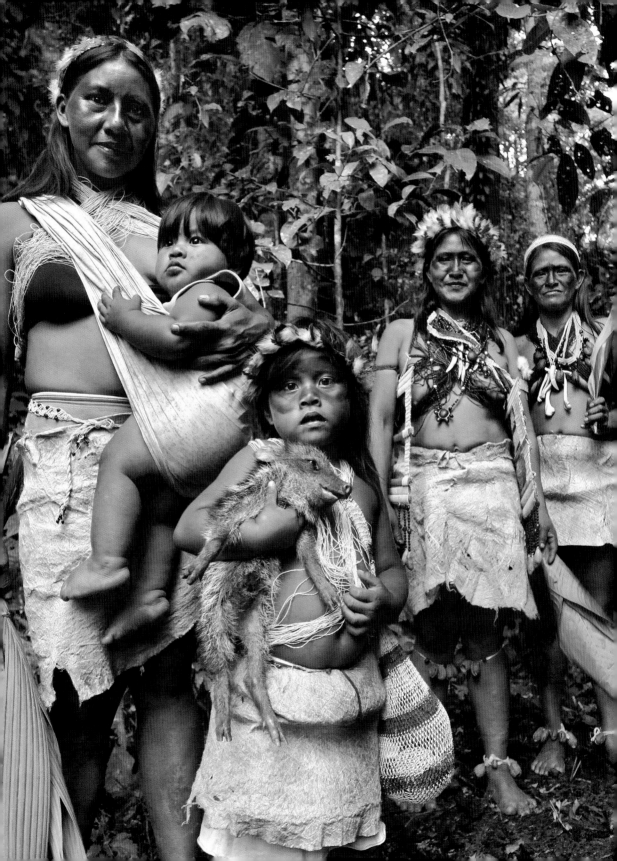

JILL BROUSSARD
PHOTOGRAPHY

The Photo Division 214.763.5887 m@thephotodivision.com

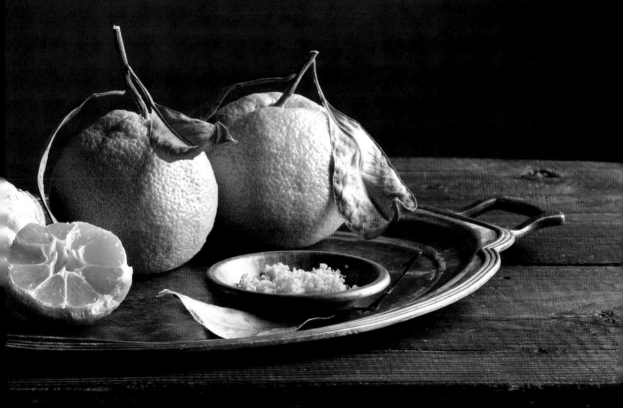

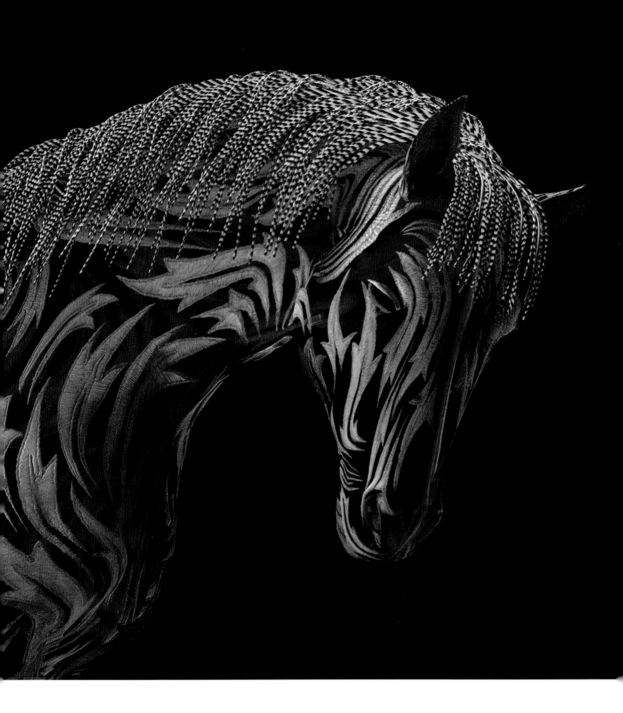

RAYGUN STUDIO

RAYGUNSTUDIO.COM

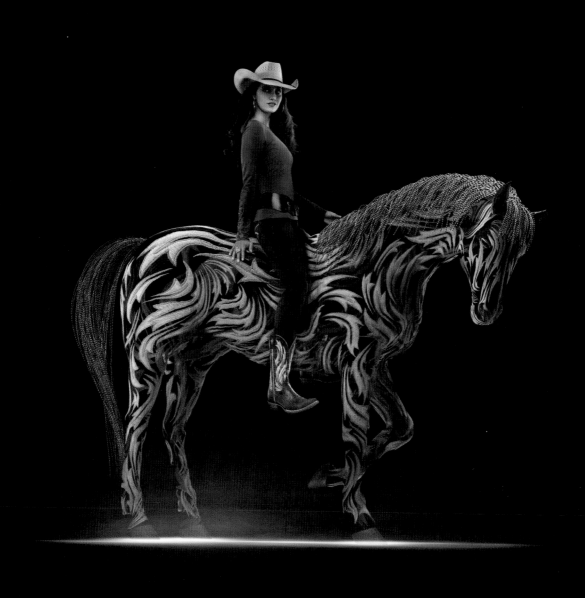

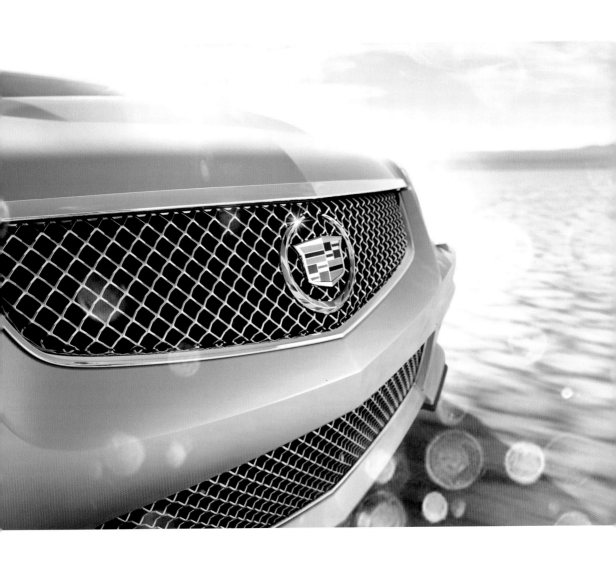

BILL CASH

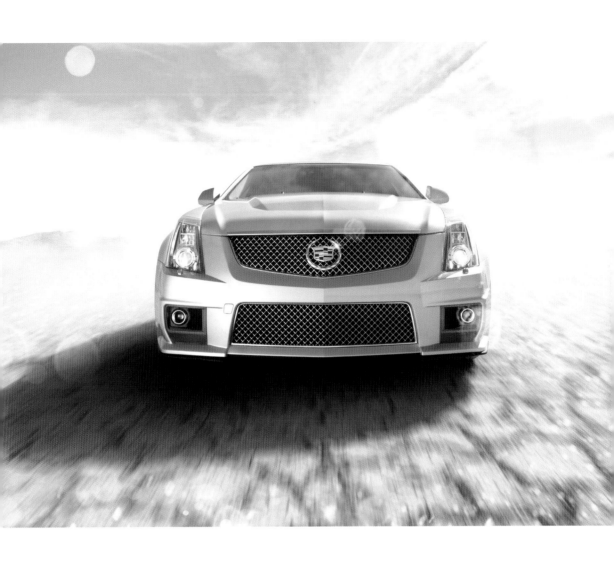

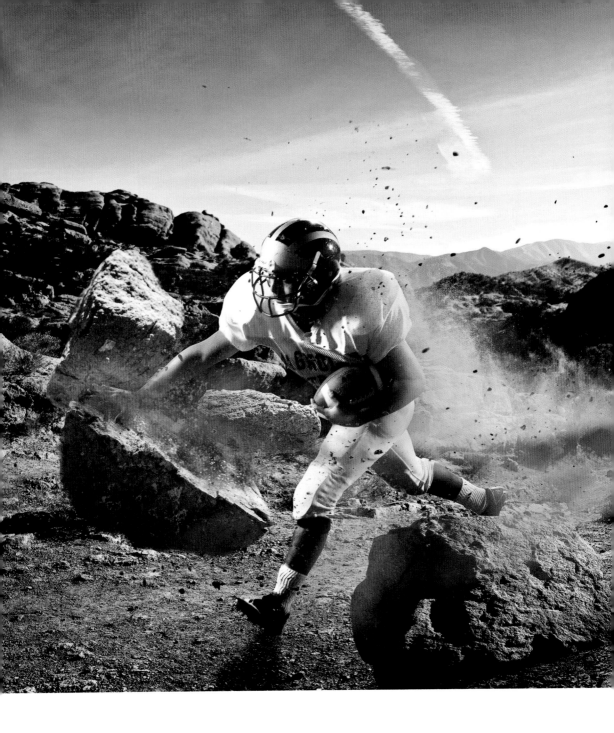

VEGARD BREIE

VEGARDPHOTO.COM

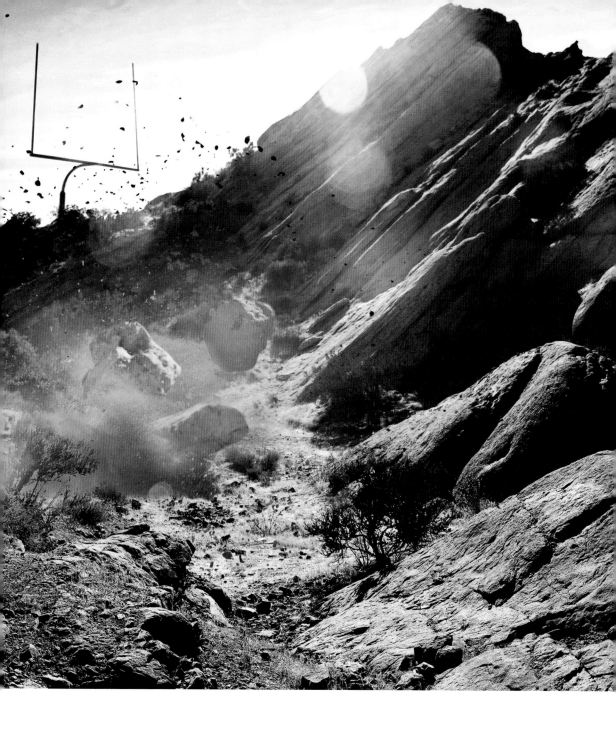

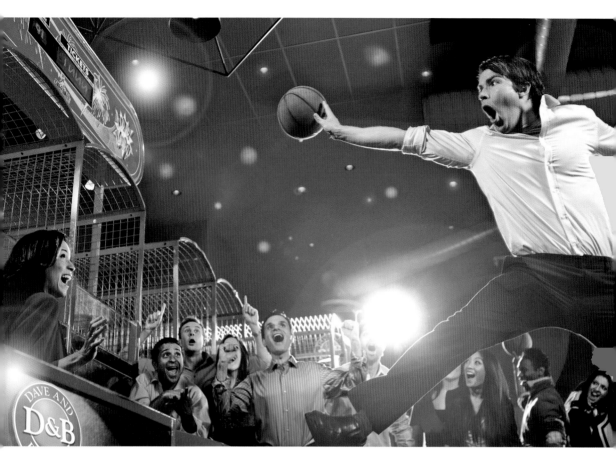

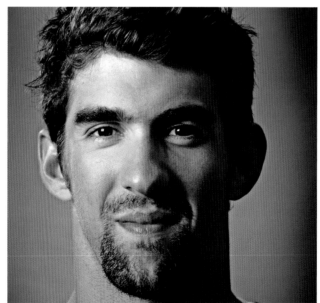

SILVERMAN

P R O D U C T I O N S

JAY SILVERMAN

PHOTOGRAPHER & DIRECTOR

(323) 466-6030

HOLLYWOOD, CA

JAYSILVERMAN.COM

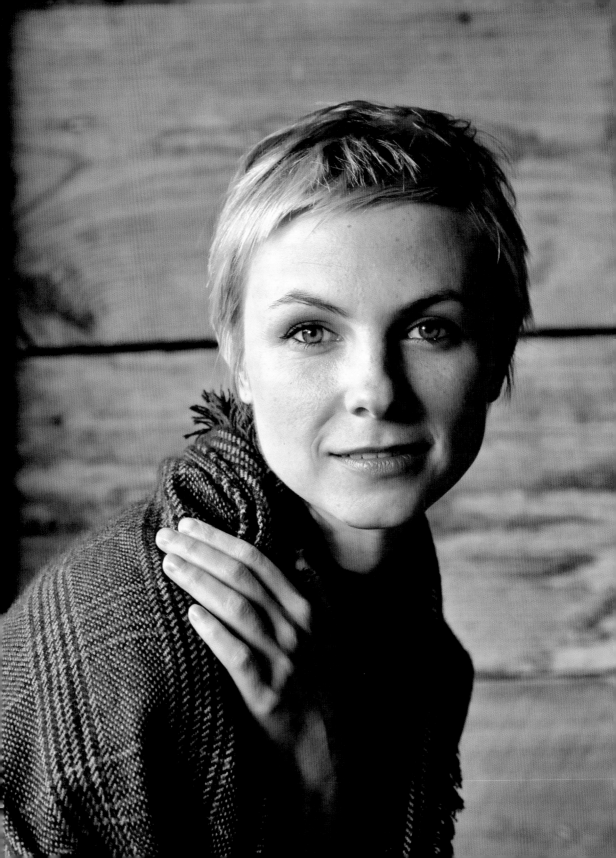

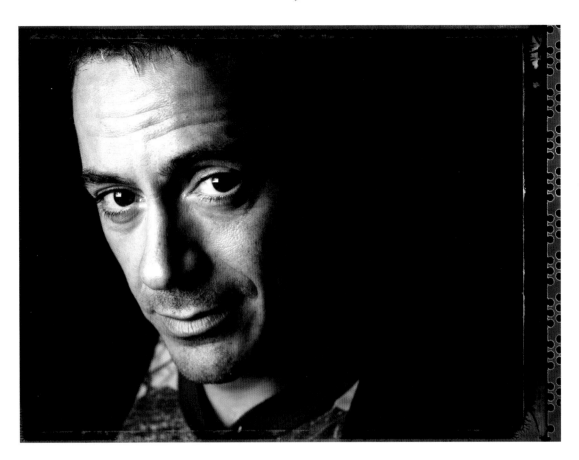

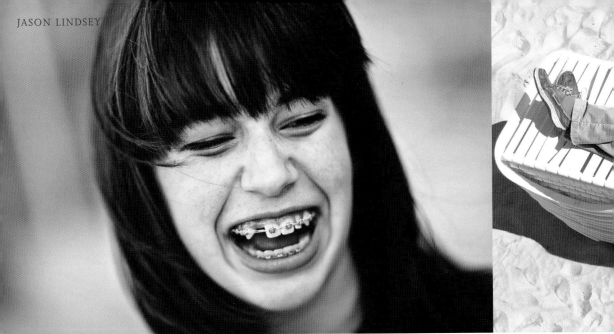

JASON LINDSEY

STEPHEN HAMILTON

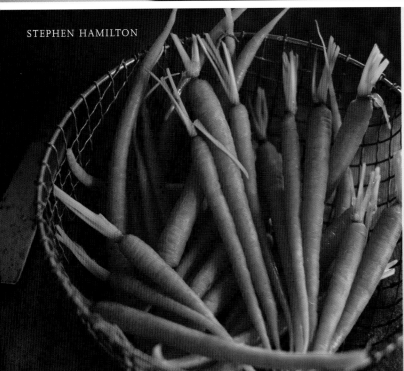

SANDRO

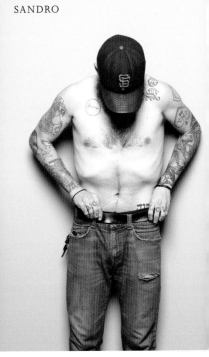

S/&/C

170

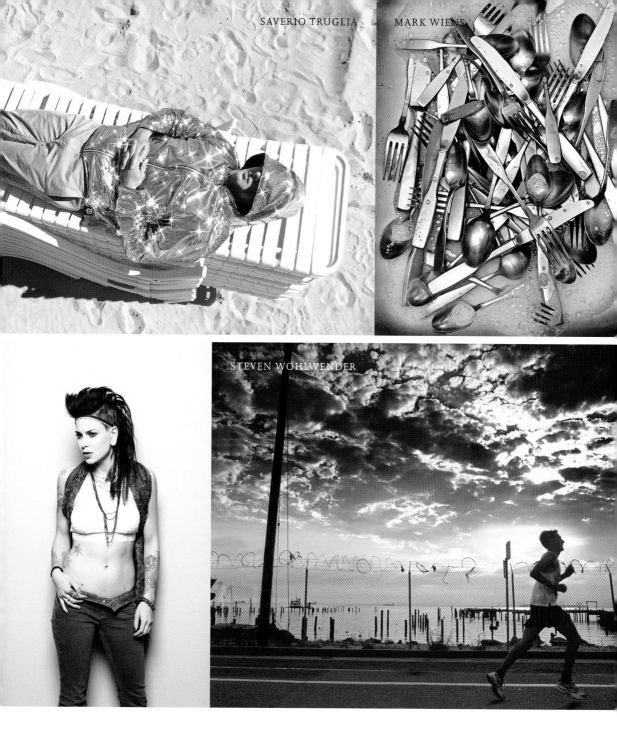

SAVERIO TRUGLIA MARK WIENS

STEVEN WOHLWENDER

S/&/C

MARK WIENS

schumann & company / 312.925.1530 / www.schumannco.com / www.markwiens.com

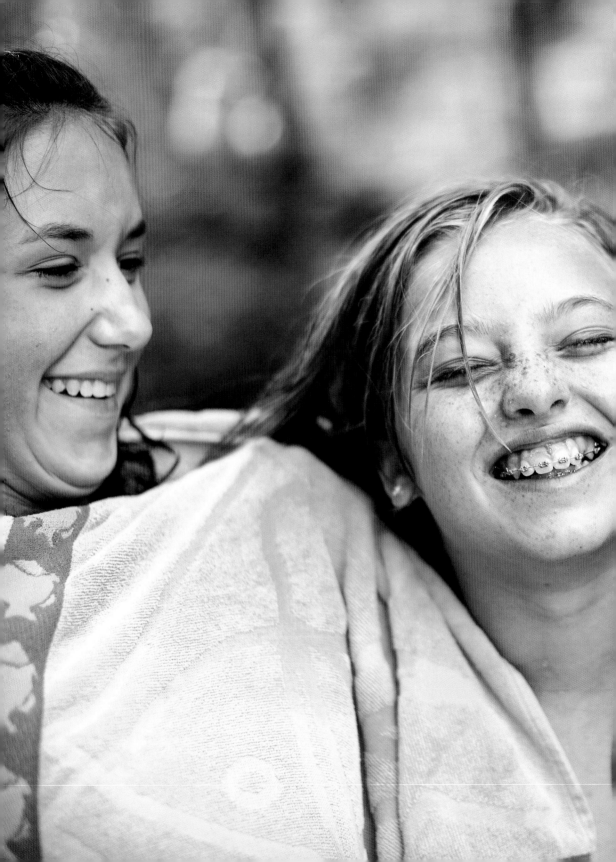

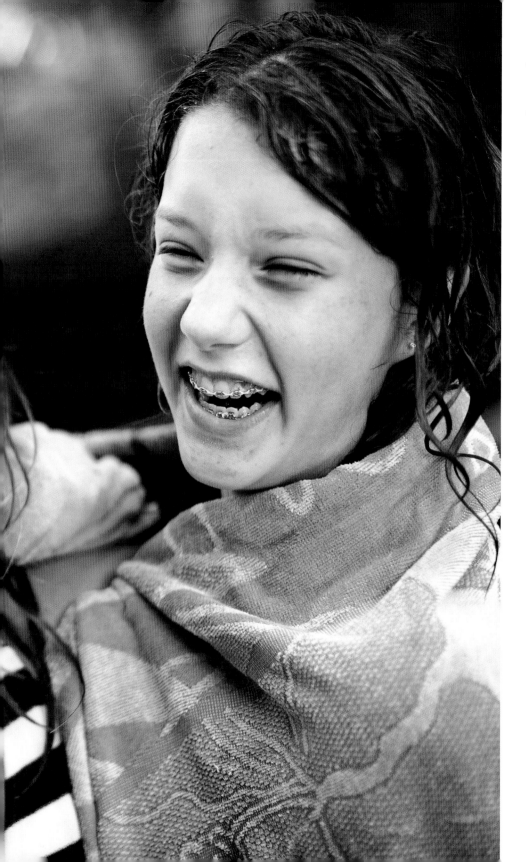

S|&|C

JASON LINDSEY

schumann & company / 312.925.1530 / www.schumannco.com / www.jasonlindsey.com

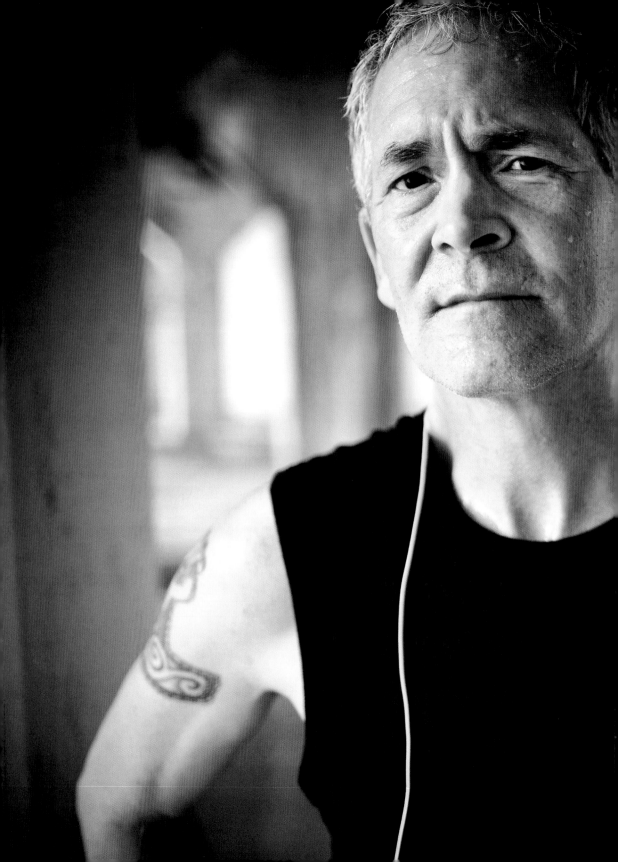

S/&/C

JASON LINDSEY

schumann & company / 312.925.1530 / www.schumannco.com / www.jasonlindsey.com

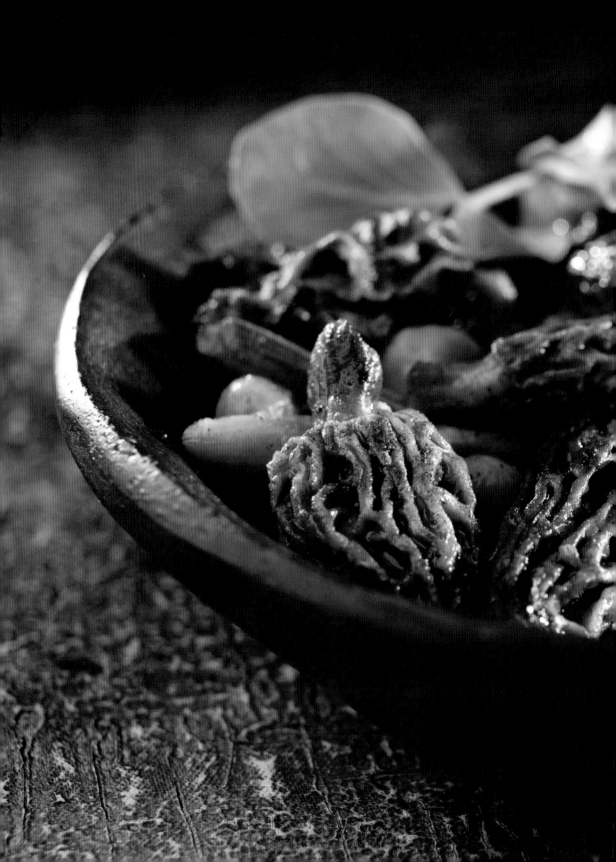

S/&/C

STEPHEN HAMILTON

schumann & company / 312.925.1530 / www.schumannco.com / www.stephenhamilton.com

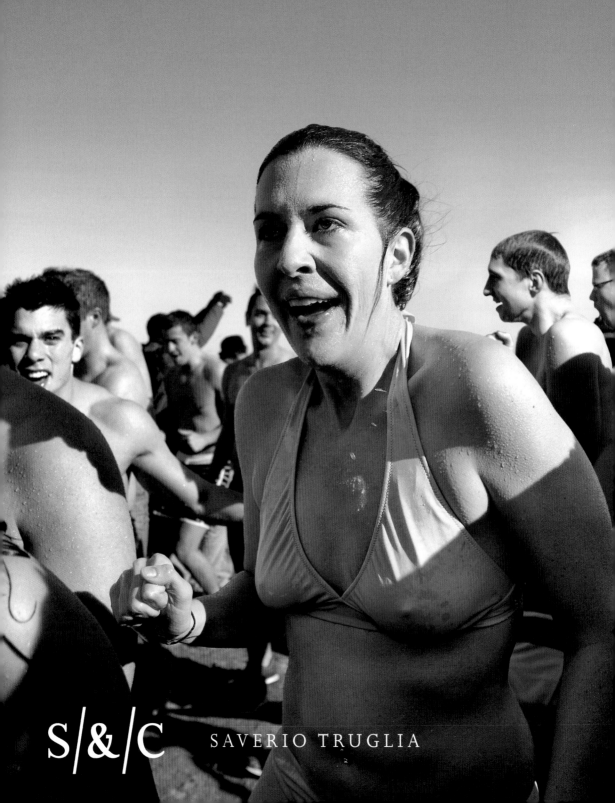

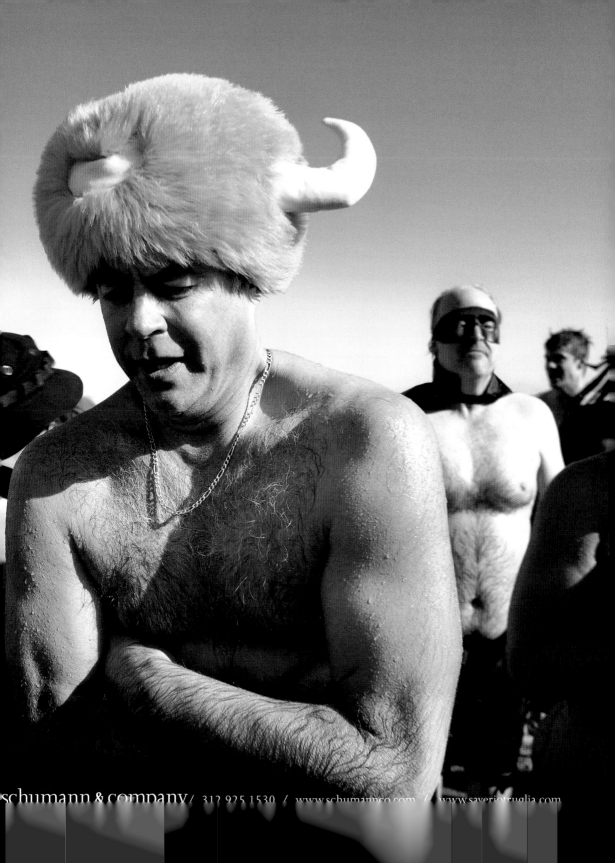

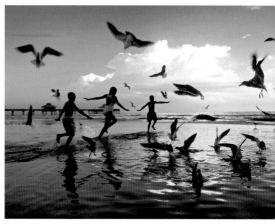
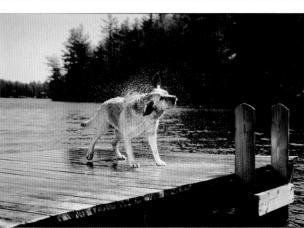
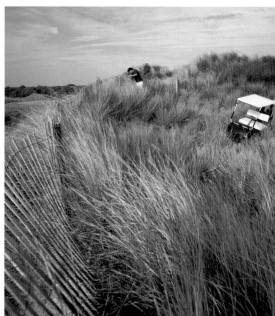

STILL CINEMATOGRAPHY

Chip Henderson Photography chiphenderson.com 919.606.7711 chip@chiphenderson.com

182

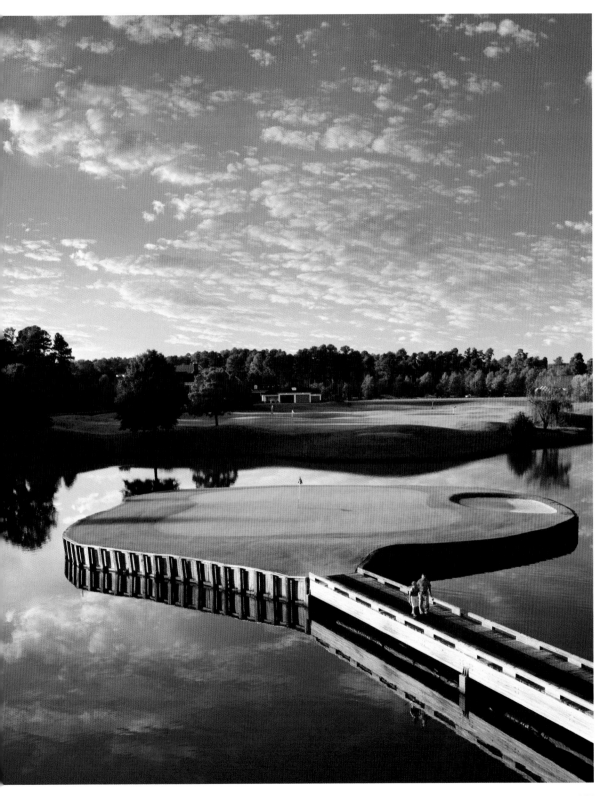

www.terishootsfood.com

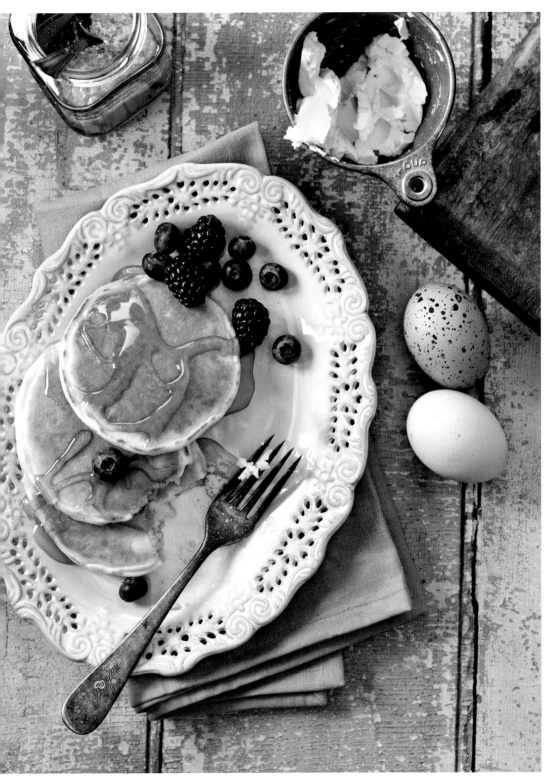

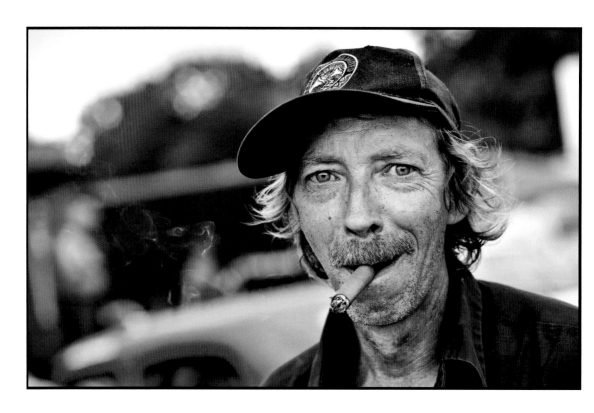

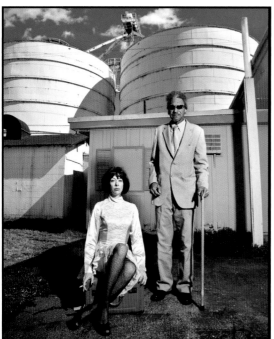

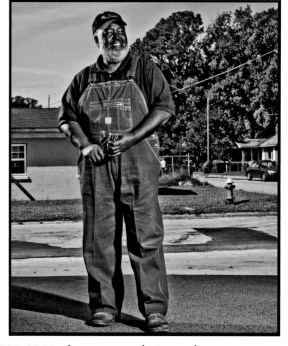

BRYAN REGAN PHOTOGRAPHY · 919-829-0960 · bryanreganphotography.com
represented by Wonderful Machine

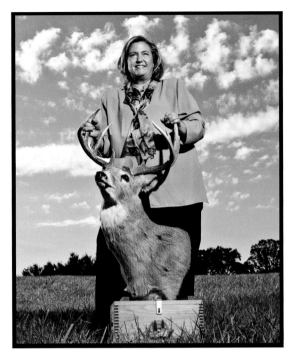
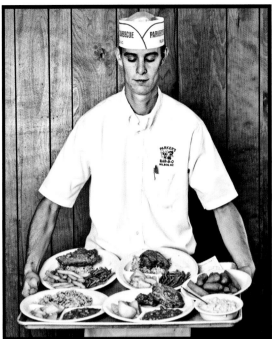
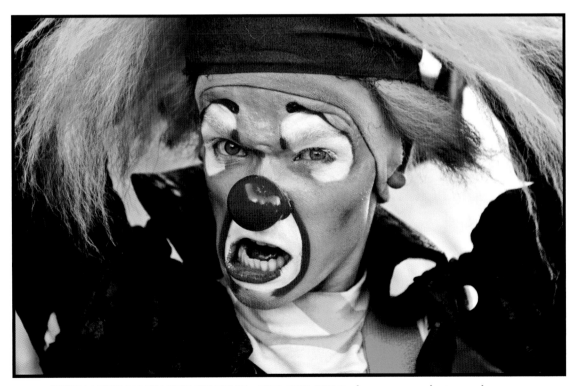

BRYAN REGAN PHOTOGRAPHY · 919-829-0960 · bryanreganphotography.com
represented by Wonderful Machine

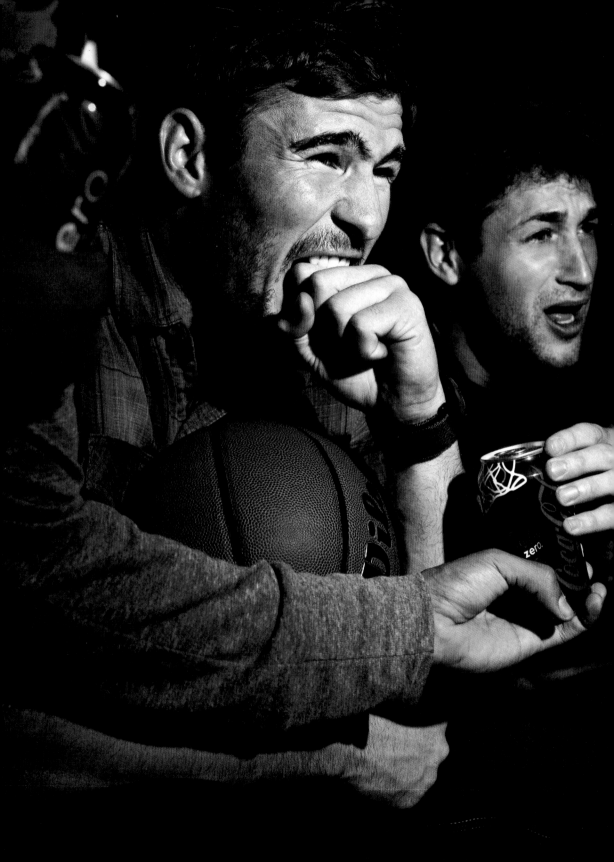

BIL
ZEL
MAN
PHOT
OGRA
PHER

zelmanstudios.com

represented by
Riad Represents
212.797.0009

What's your name? ANDI ♡

What's your Occupation?
Artist / Singer-songwriter

What's your favorite Color?
Today, maroon!

If you could have a super power,
what would it be?
TOO FLY!!! c q c

What is your favorite place on
this earth?
Venice Beach, haha!!

x _____ date: 1·12·12

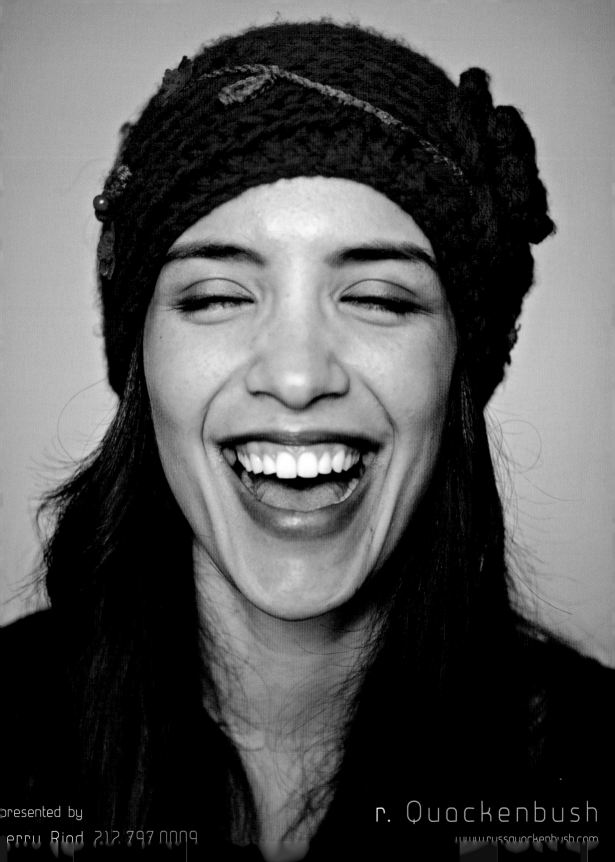

r. Quackenbush

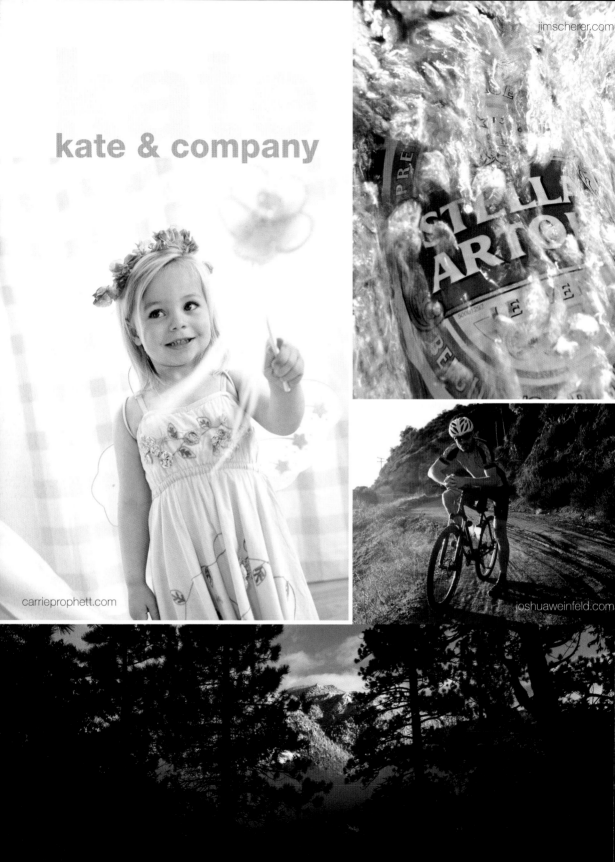

kate & company

jimscherer.com

carrieprophett.com

joshuaweinfeld.com

rodney rascona

topher cox

carrie prophett

joshua weinfeld

eric kulin

jim scherer

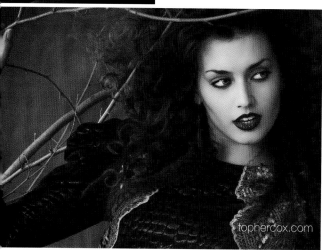

tophercox.com

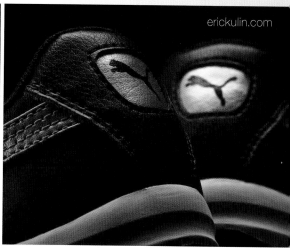

erickulin.com

rascona.com

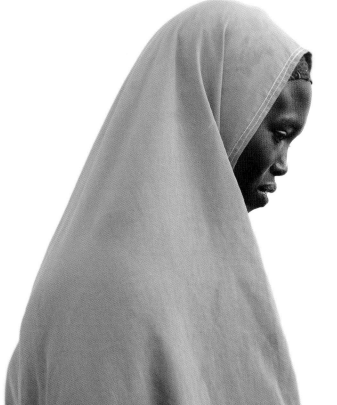

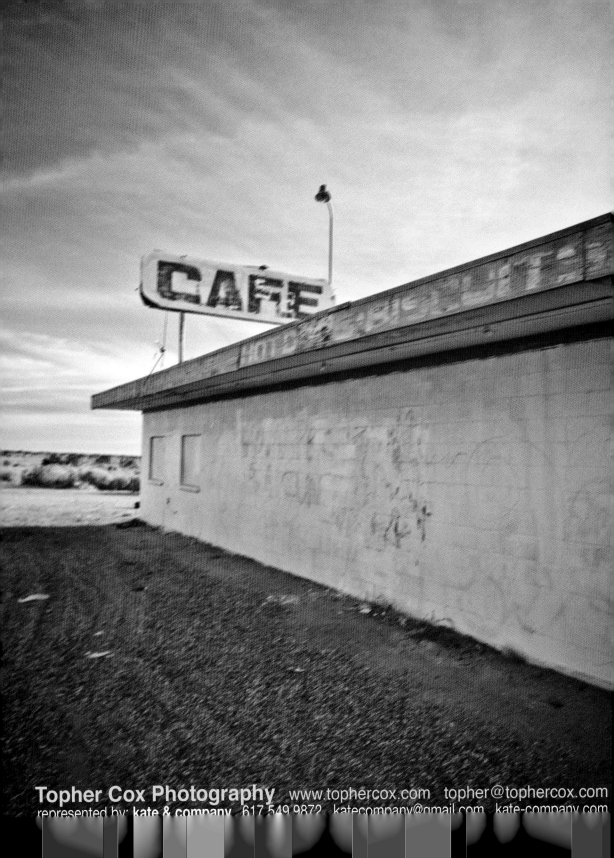

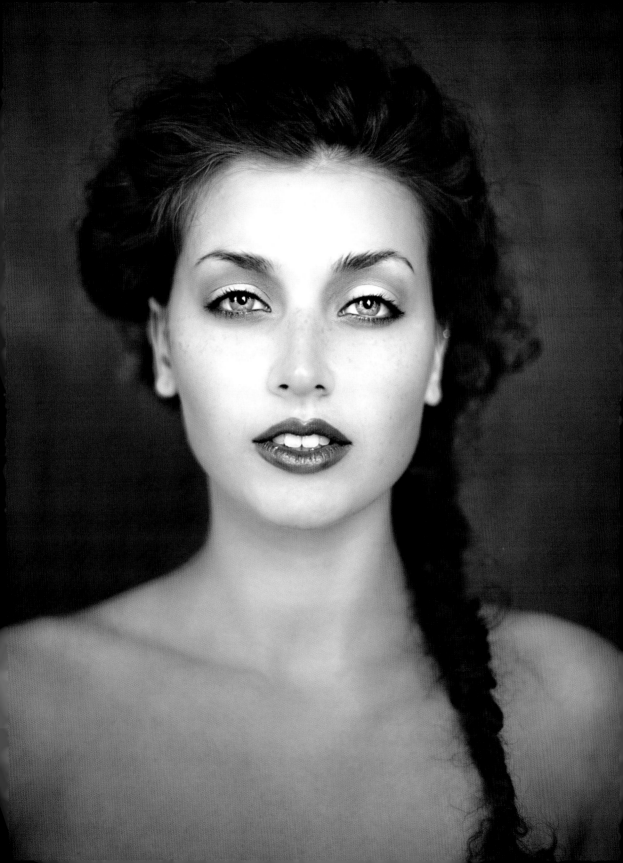

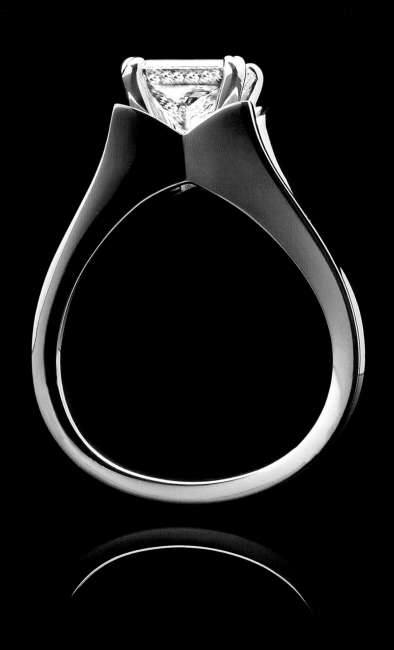

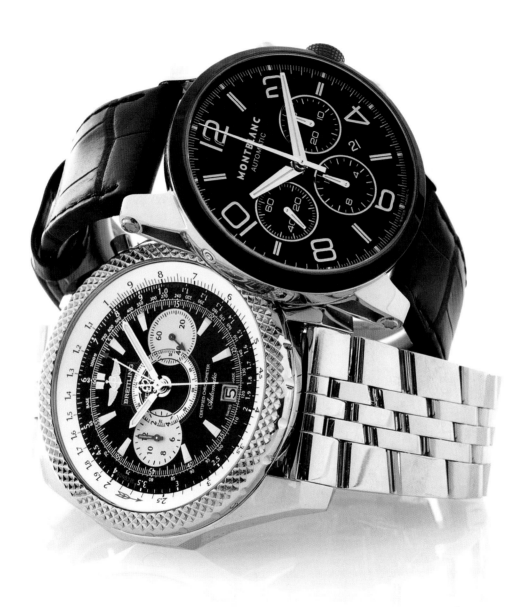

Kulin

represented by **kate & company** 617.549.9872 katecompany@gmail.com kate-company.com
eric kulin photography 617.645.5500 erickulin.com

joshuaweinfeld

photographer

www.joshuaweinfeld.com

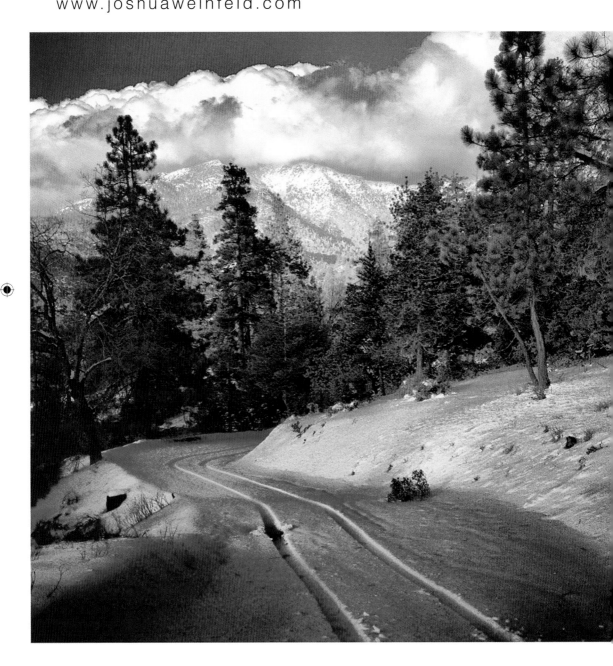

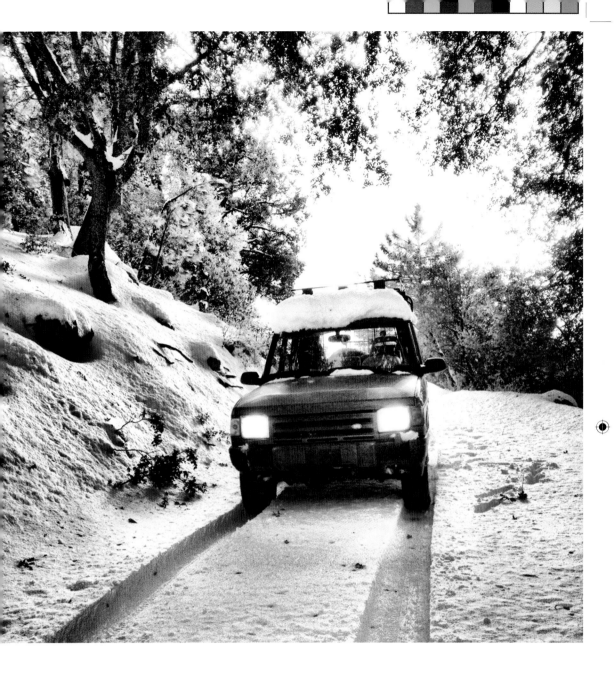

represented by: **kate & company** 617.549.9872 katecompany@gmail.com kate-company.com

3/7/12 9:33 AM

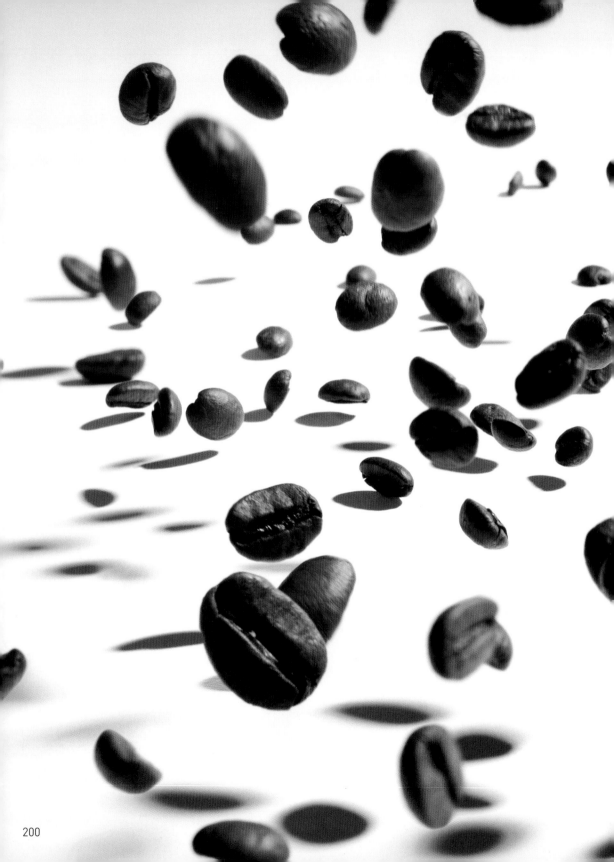

JIM SCHERER
PHOTOGRAPHY
www.jimscherer.com

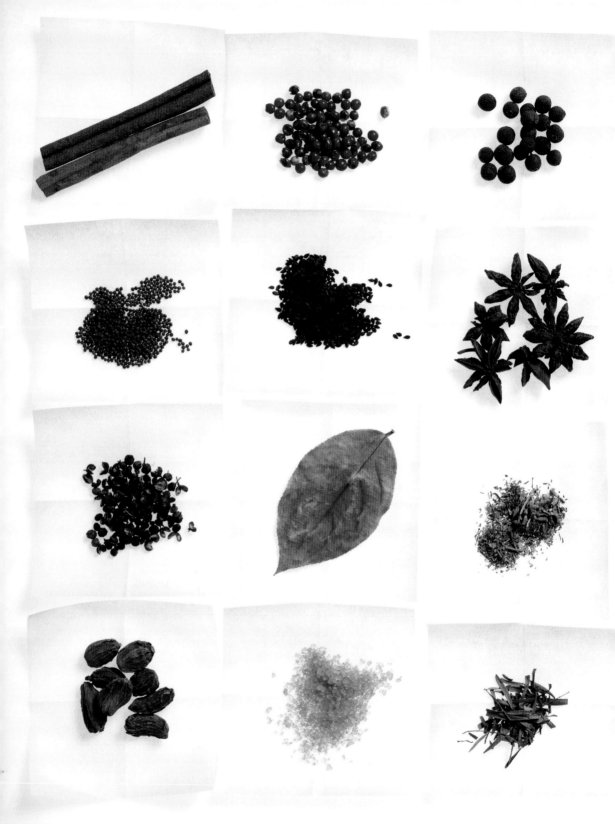

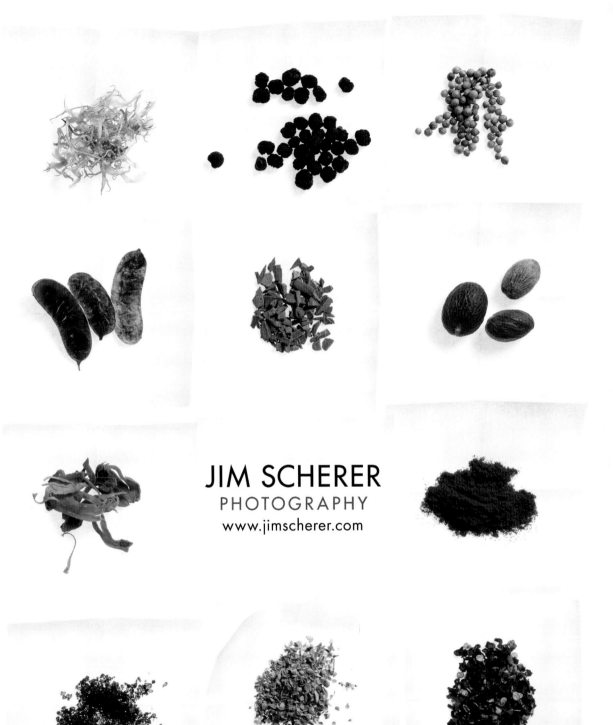

JIM SCHERER

PHOTOGRAPHY

www.jimscherer.com

represented by **kate & company** 617.549.9872 katecompany@gmail.com kate-company.com

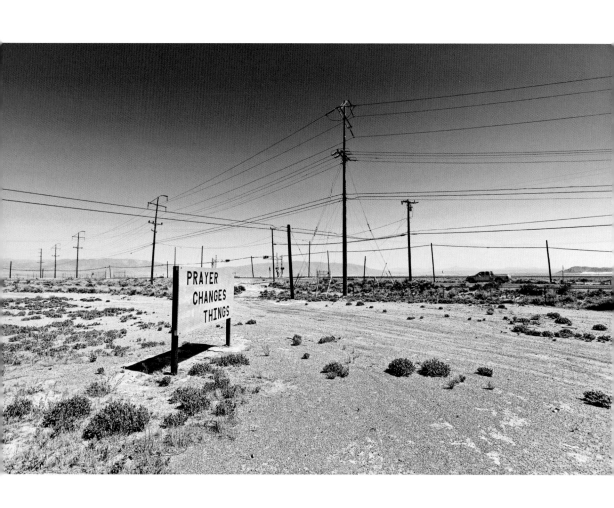

PRAYER
CHANGES
THINGS

DAVID ZAITZ PHOTOGRAPHY

PORTFOLIO: **DAVIDZAITZ.COM** | OFFICE: **310.645.5088**

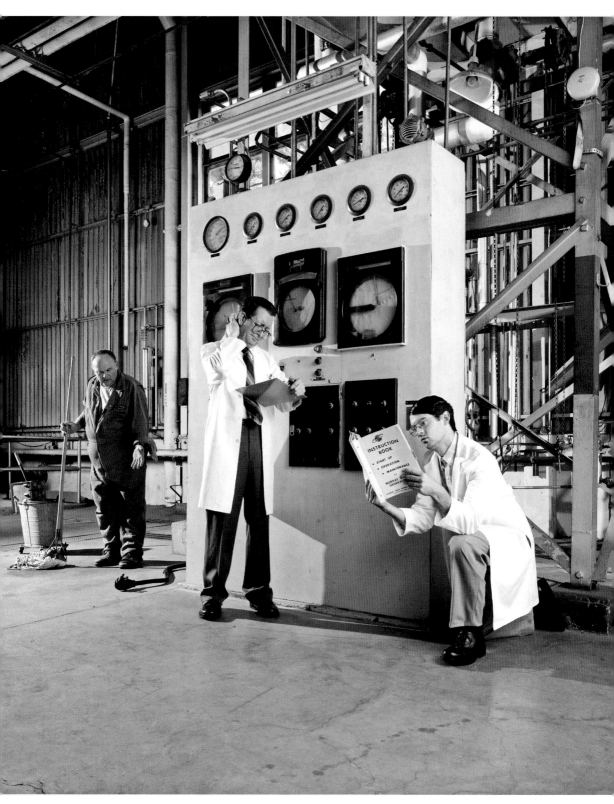

photographer **MARK LAFAVOR** art director RAINER SCHMIDT

LA**FAVOR** PHOTOGRAPHY

{
MARK LAFAVOR web lafavorpictures.com
office 612.904.1750 mobile 612.385.8640
}

1304 2ND STREET NE • MINNEAPOLIS, MN

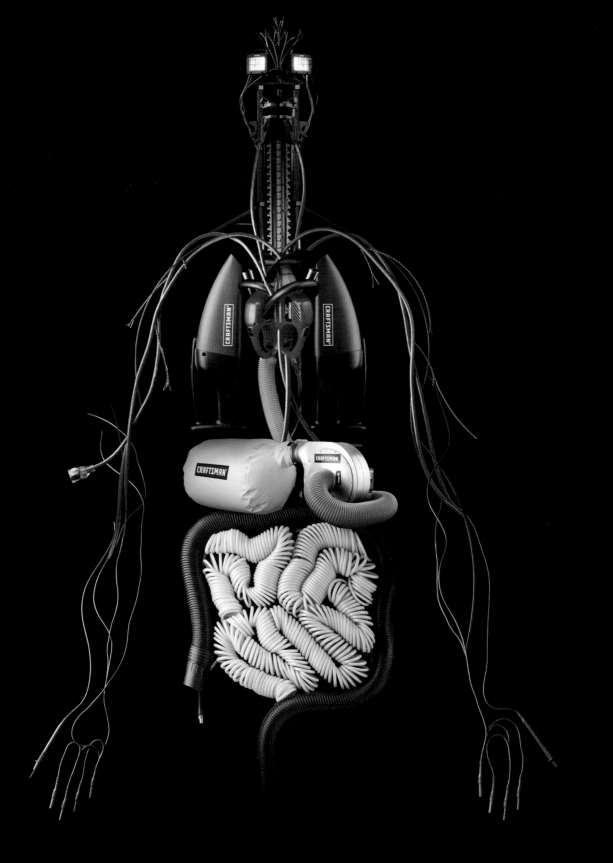

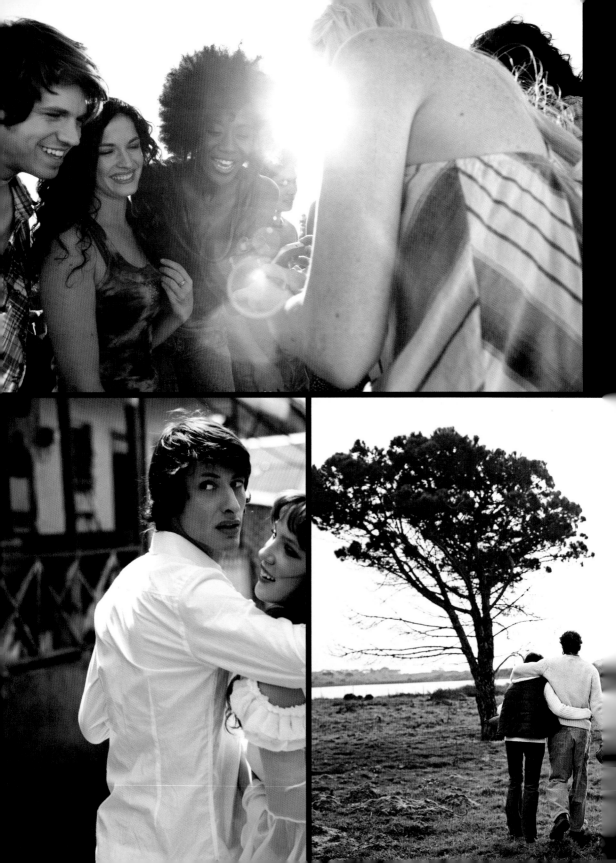

CREATIVE MANAGEMENT @

mc²

REPRESENTING:

MAX ABADIAN
DELLA BASS
GEOFF BARRENGER
MICHAEL FILONOW
GREG HINSDALE
KEITH LATHROP
JOSEPH MONTEZINOS
CHRIS NICHOLLS
JEFF OLSON
PAUL WRIGHT

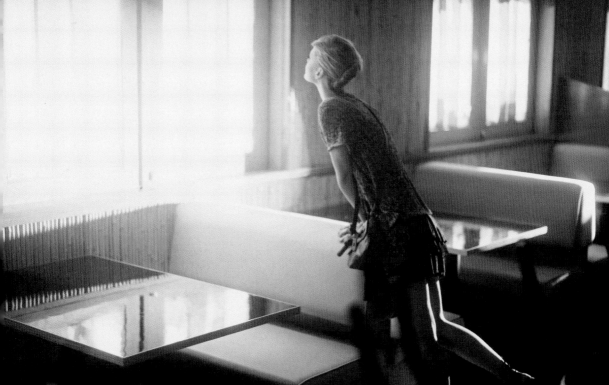

HOTOGRAPHY | NEW YORK | MIAMI | 646.638.3321 | www.creativemanagementmc2.com

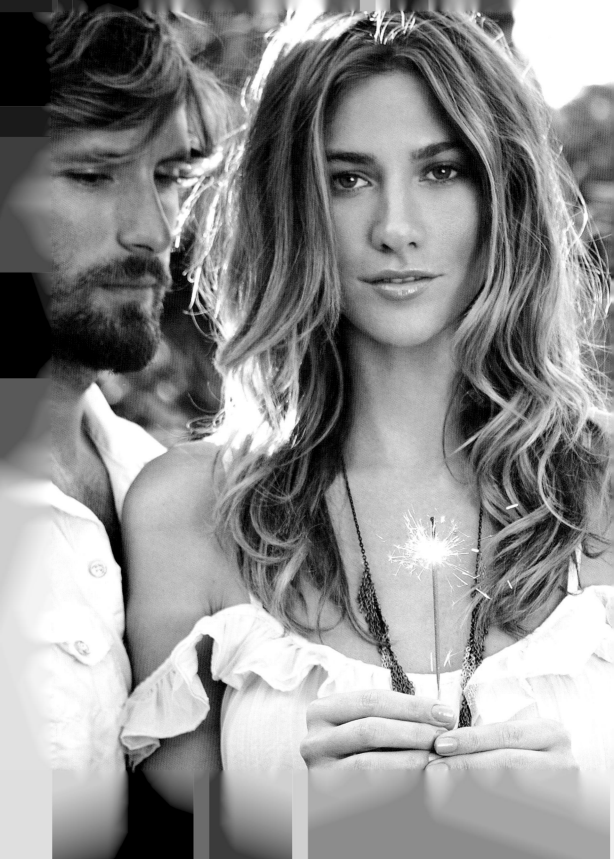

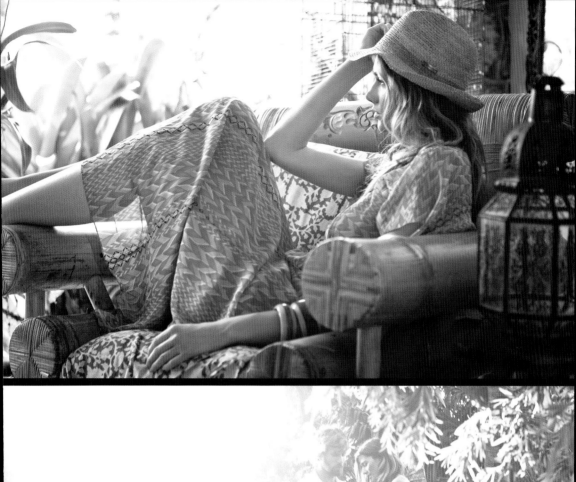
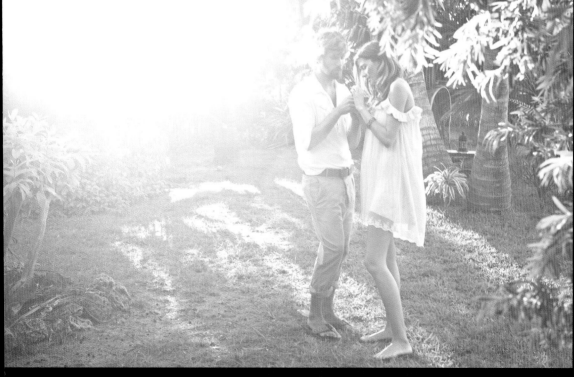

KEITH LATHROP

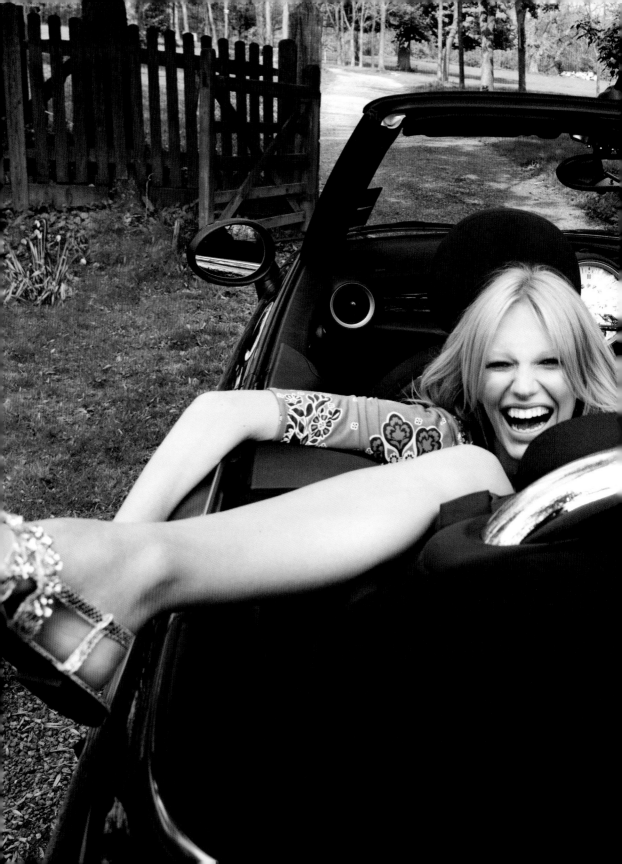

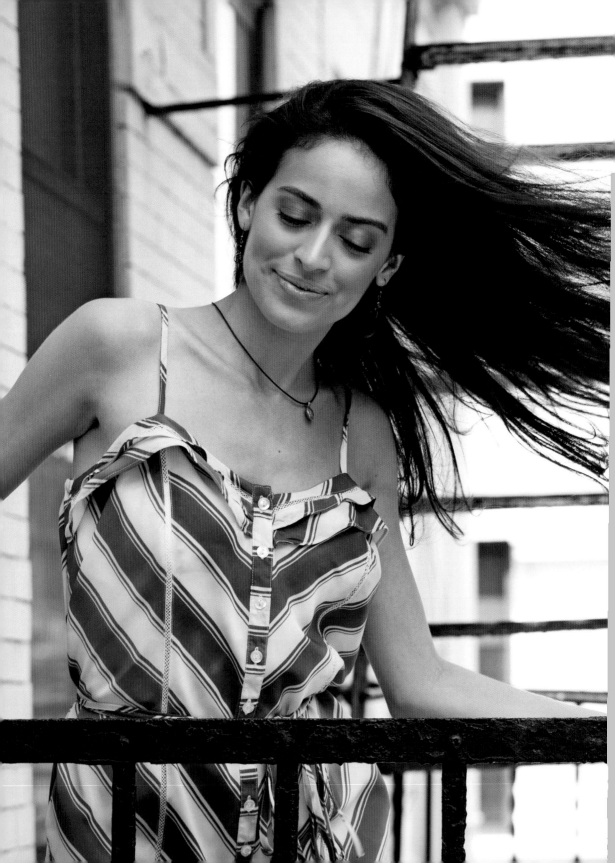

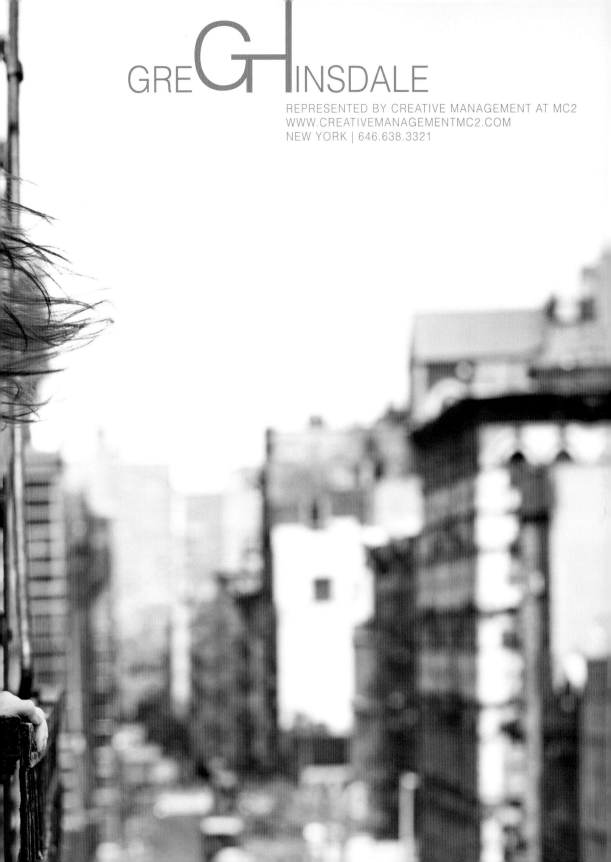

GRE**GH**INSDALE

REPRESENTED BY CREATIVE MANAGEMENT AT MC2
WWW.CREATIVEMANAGEMENTMC2.COM
NEW YORK | 646.638.3321

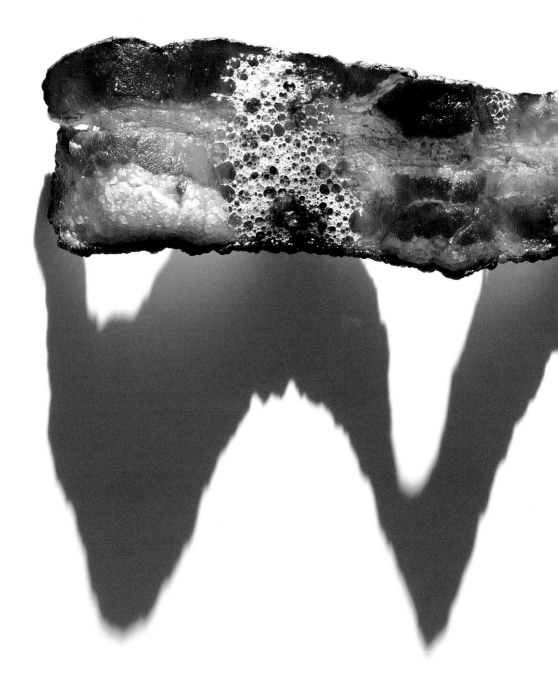

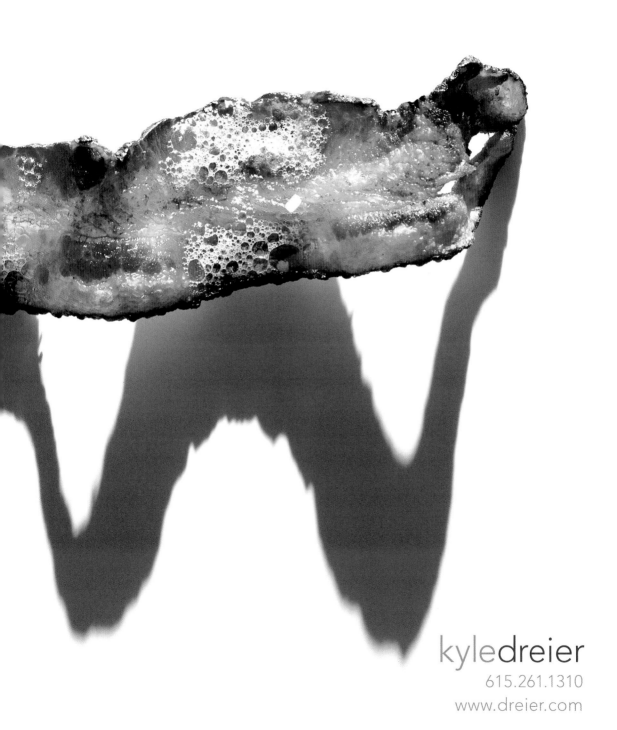

kyledreier
615.261.1310
www.dreier.com

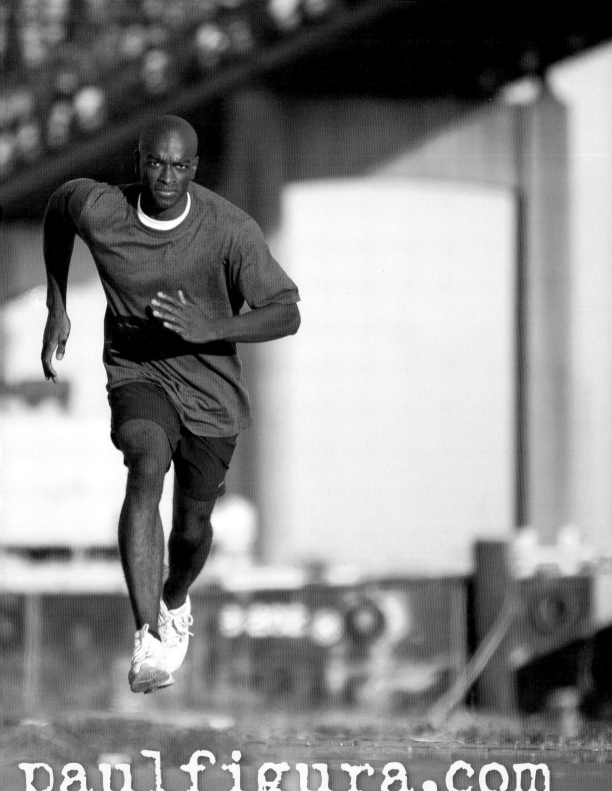

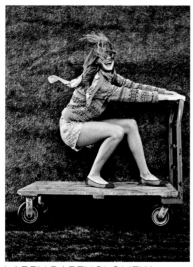

LARRY BARTHOLOMEW

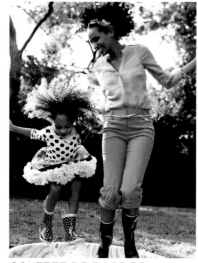

COLETTE DE BARROS

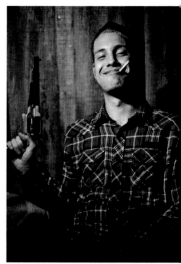

GARY COPELAND

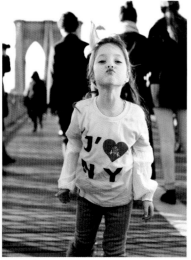

PRISCILLA GRAGG

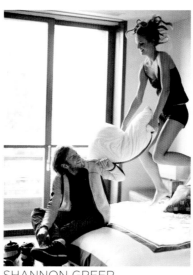

SHANNON GREER

PHILIP HARVEY

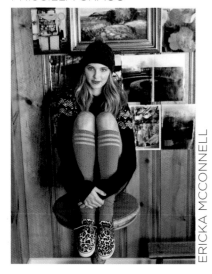

ERICKA MCCONNELL

Alyssa Pizer
MANAGEMENT

ALYSSAPIZER.COM • ALYSSA@ALYSSAPIZER.COM • 310.440.39

ON DIAZ

GRETCHEN EASTON

CHEYENNE ELLIS

.FF JOHNSON

EMMET MALMSTROM

MARTIN RUSCH

Follow us on:
facebook.com/alyssapizermanagement
twitter.com/alyssapizer
alyssapizer.com/blog/

LARRY BARTHOLOMEW

ALYSSA PIZER MANAGEMENT • ALYSSAPIZER.COM
ALYSSA@ALYSSAPIZER.COM • 310.440.3930

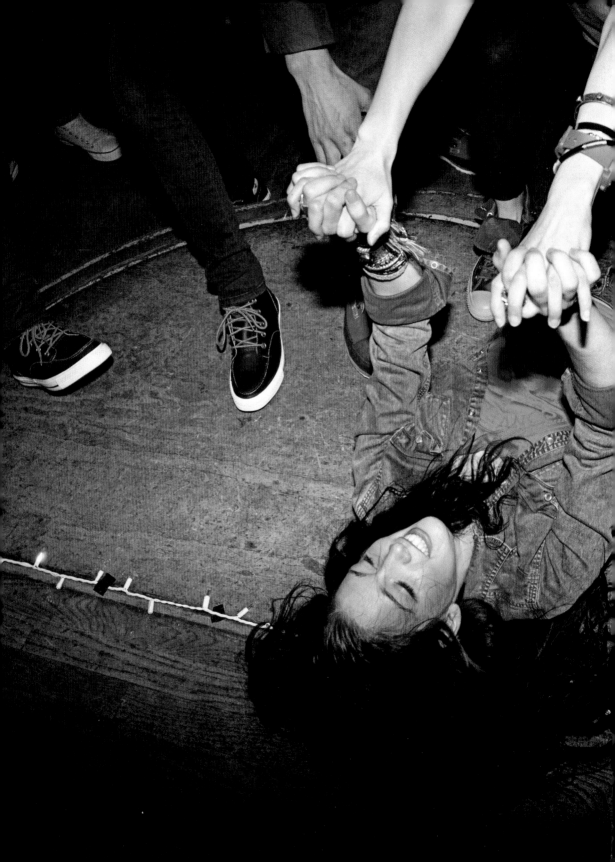

GARY COPELAND

PHOTOGRAPHY

ALYSSA PIZER
MANAGEMENT
310-440-3930
alyssa@alyssapizer.com
www.alyssapizer.com

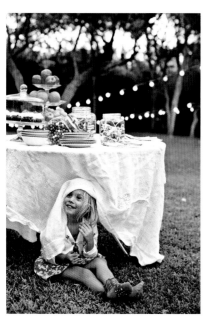
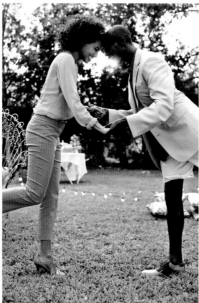
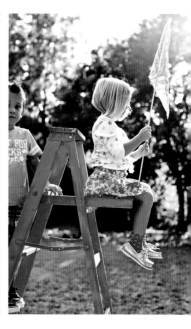
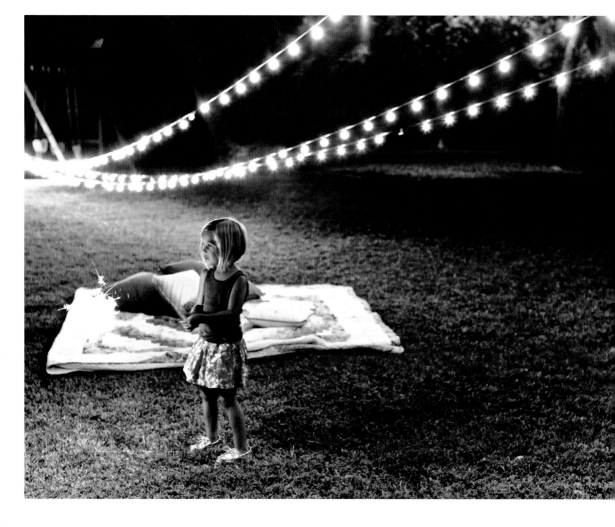

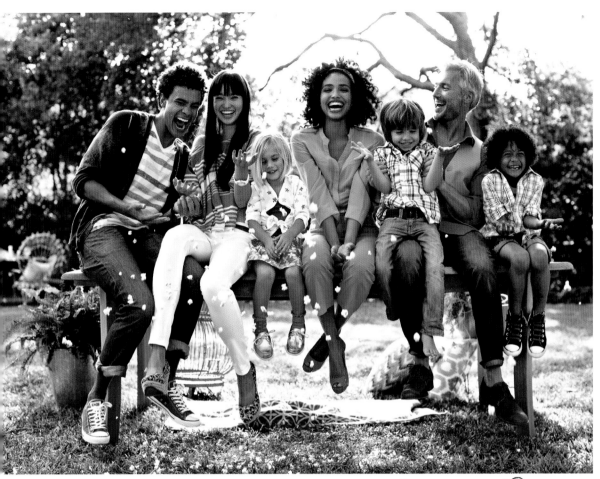

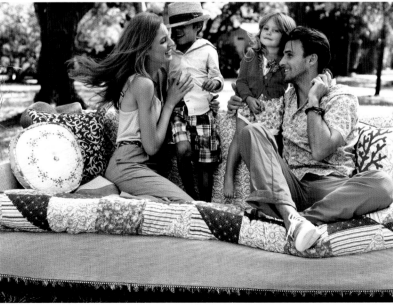

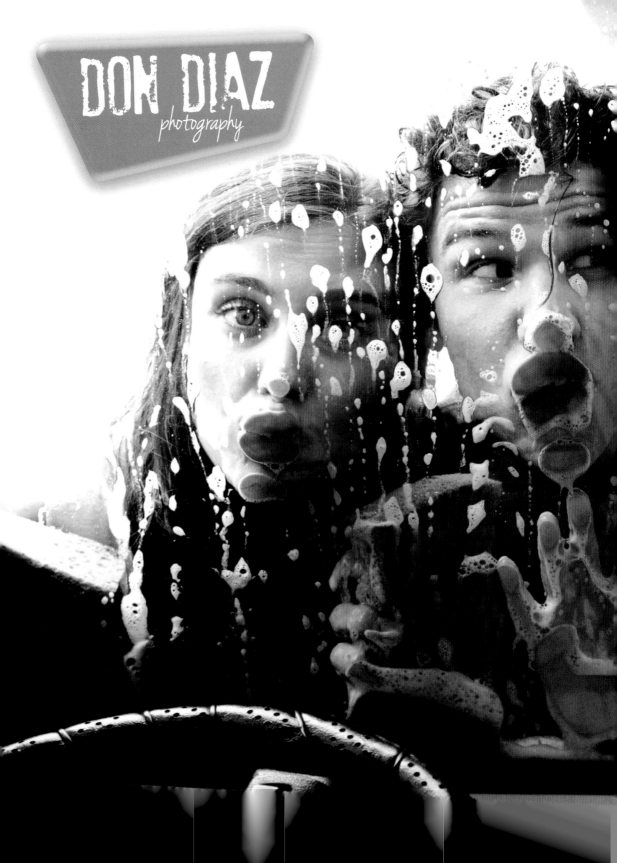

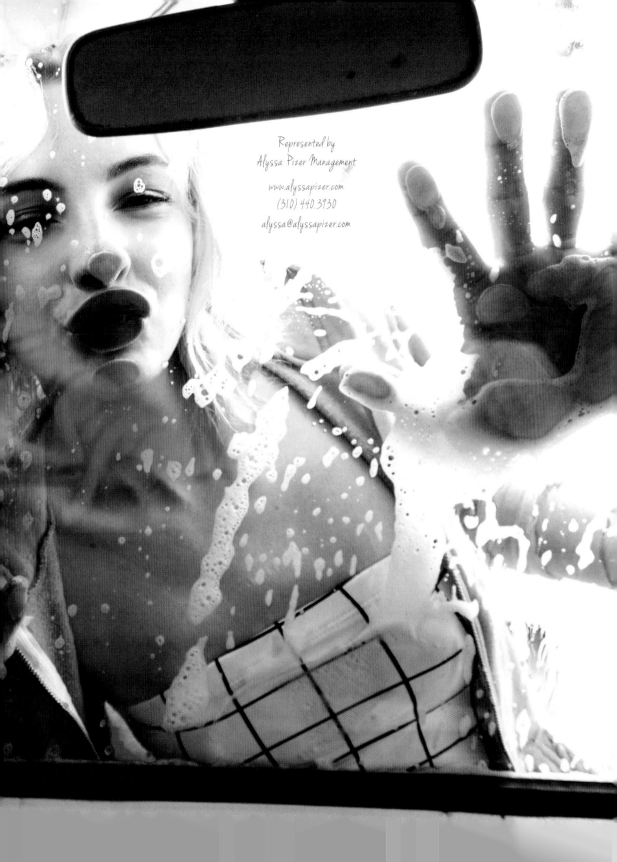

Represented by
Alyssa Pizer Management

www.alyssapizer.com
(310) 440.3930
alyssa@alyssapizer.com

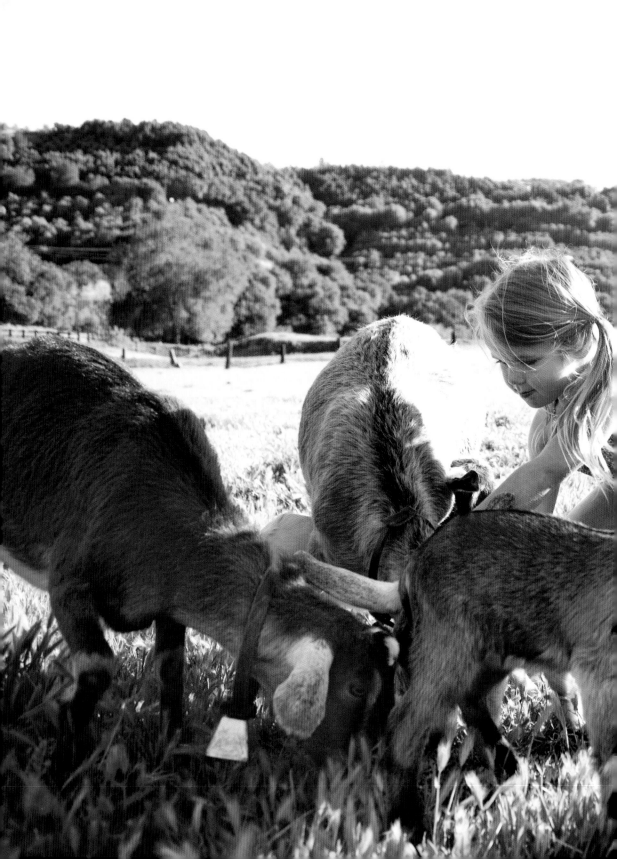

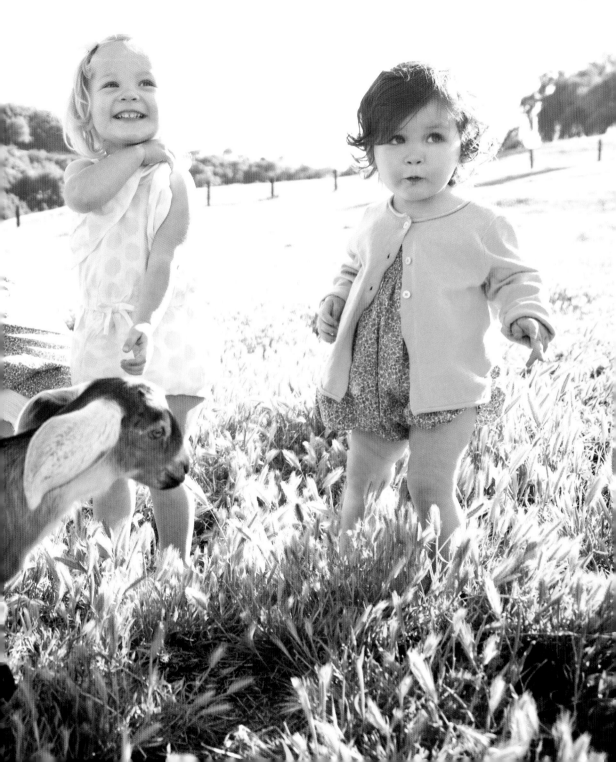

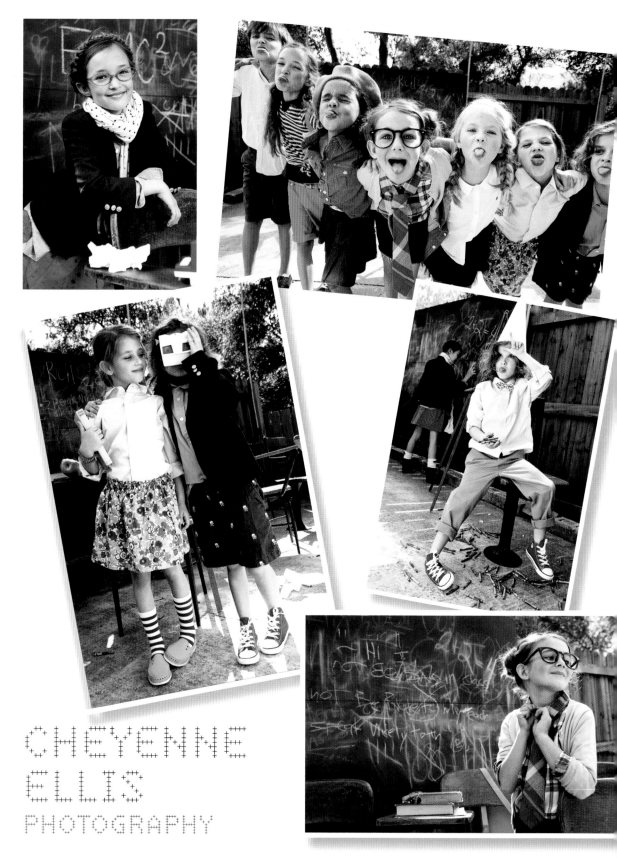

CHEYENNE
ELLIS
PHOTOGRAPHY

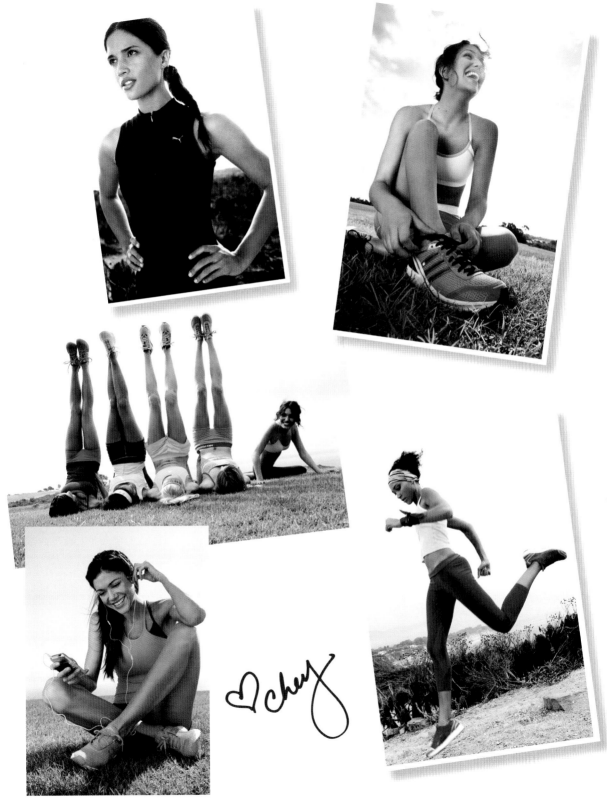

Alyssa Pizer Management | 310-440-3930 | alyssa@alyssapizer.com | www.alyssapizer.com

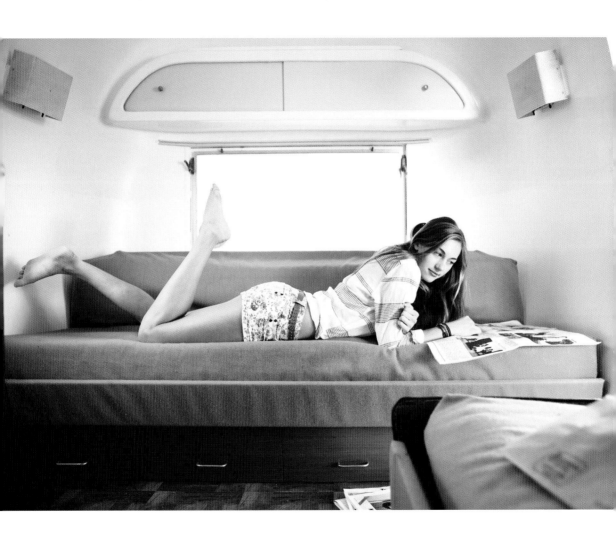

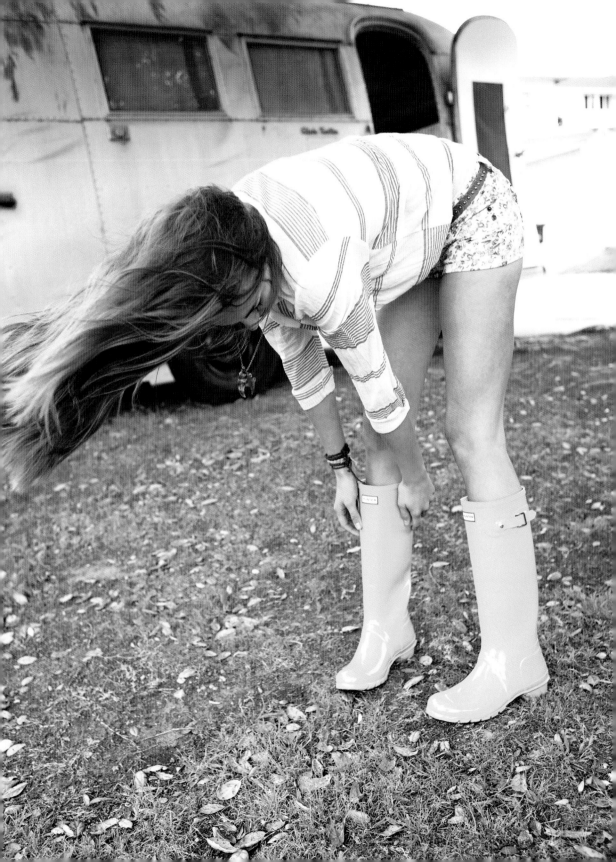

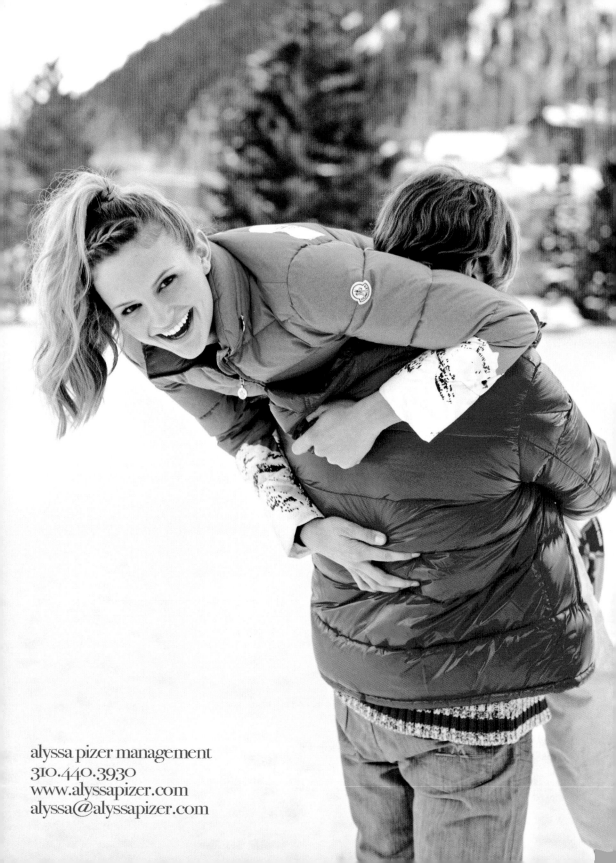

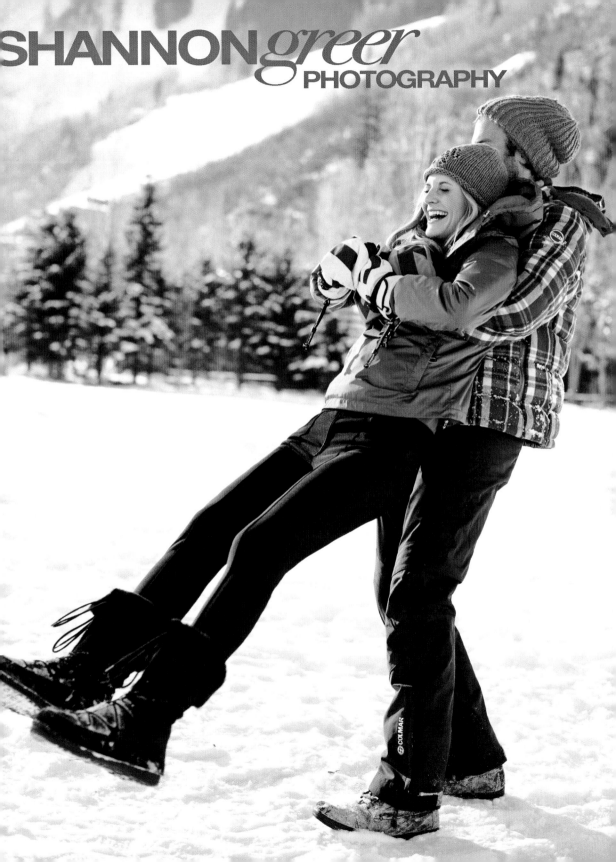

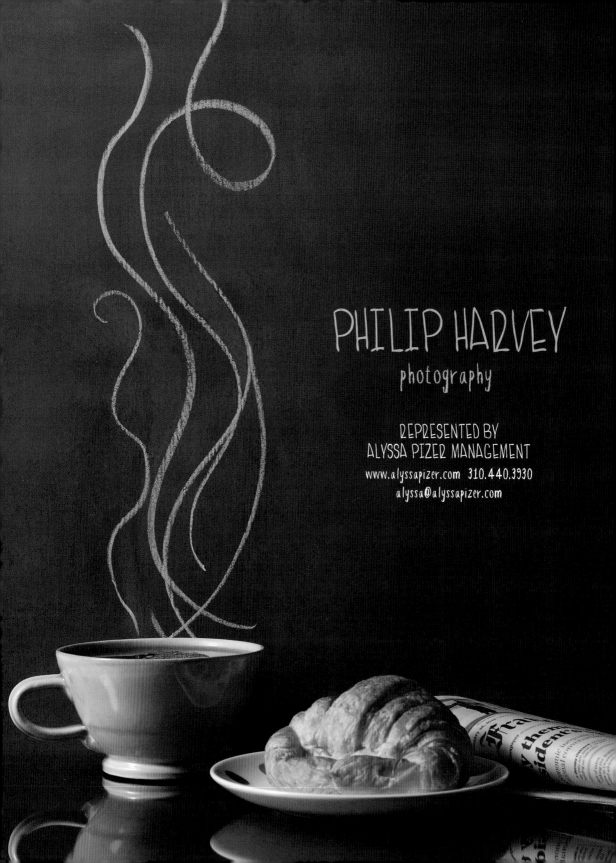

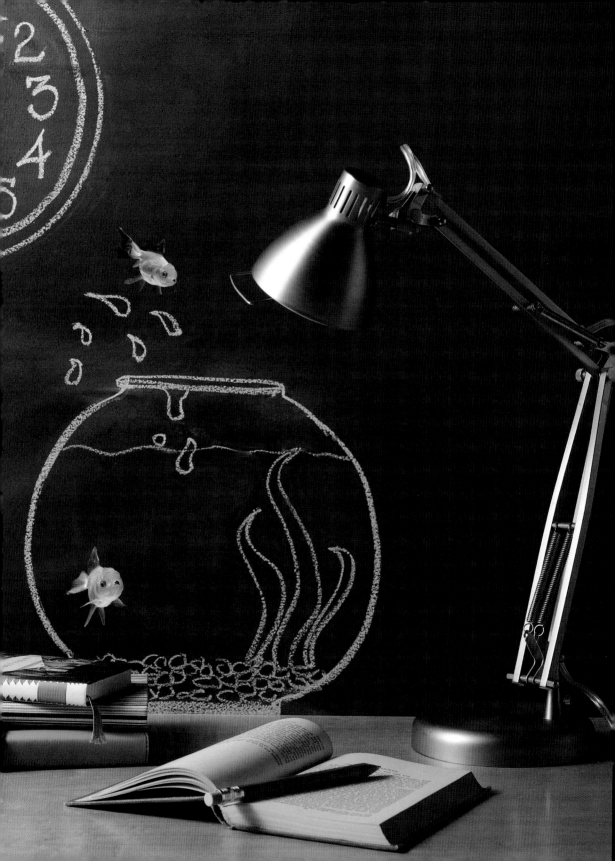

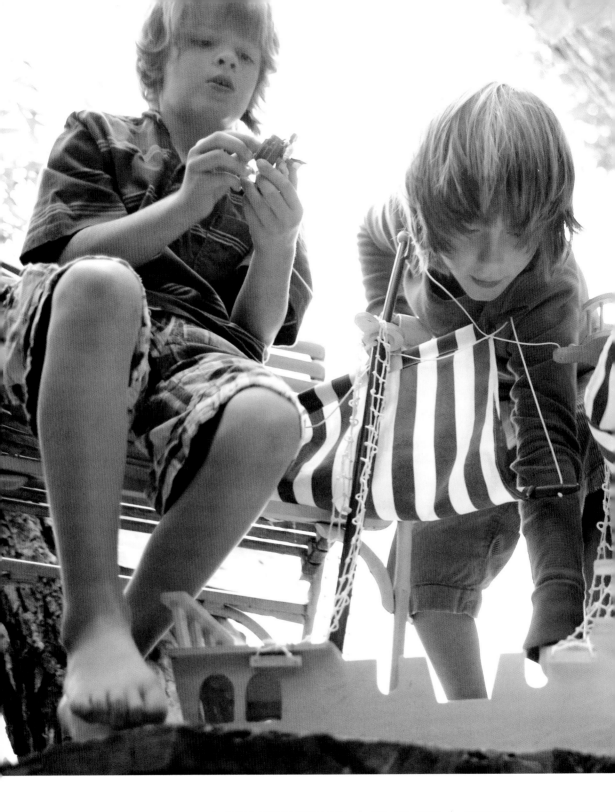

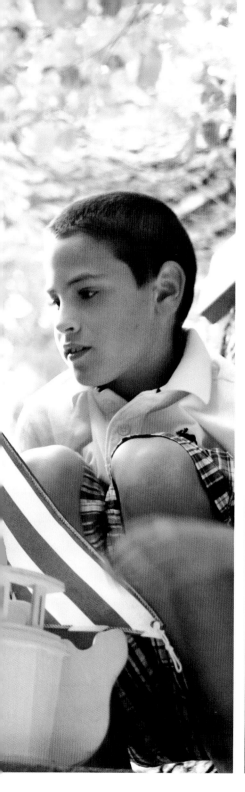
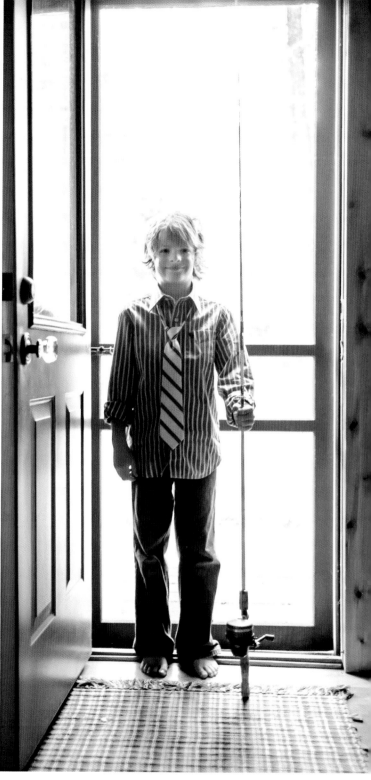

EMMET MALMSTRÖM

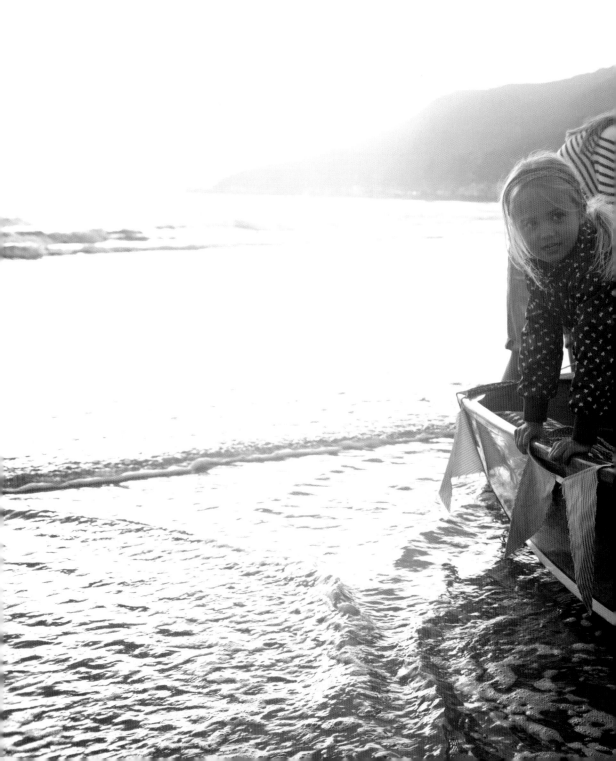

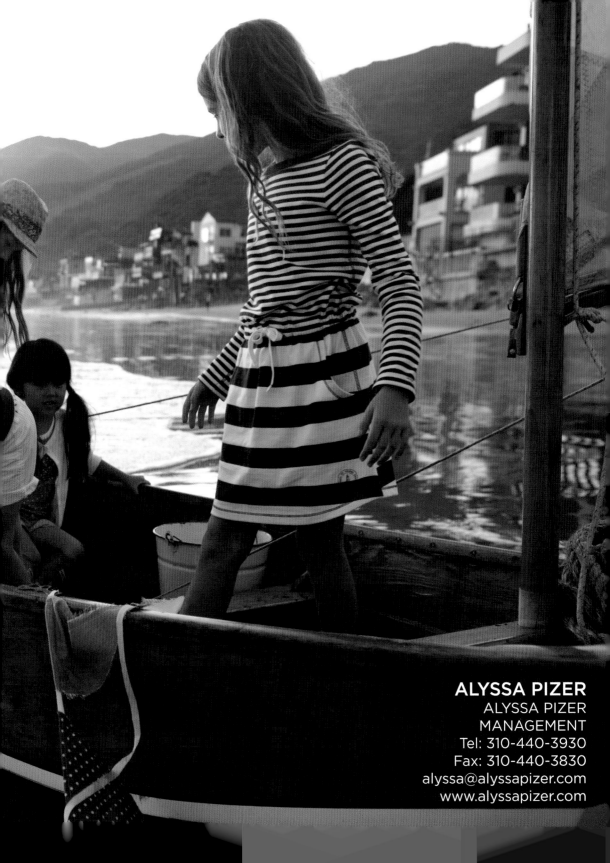

ALYSSA PIZER
ALYSSA PIZER
MANAGEMENT
Tel: 310-440-3930
Fax: 310-440-3830
alyssa@alyssapizer.com
www.alyssapizer.com

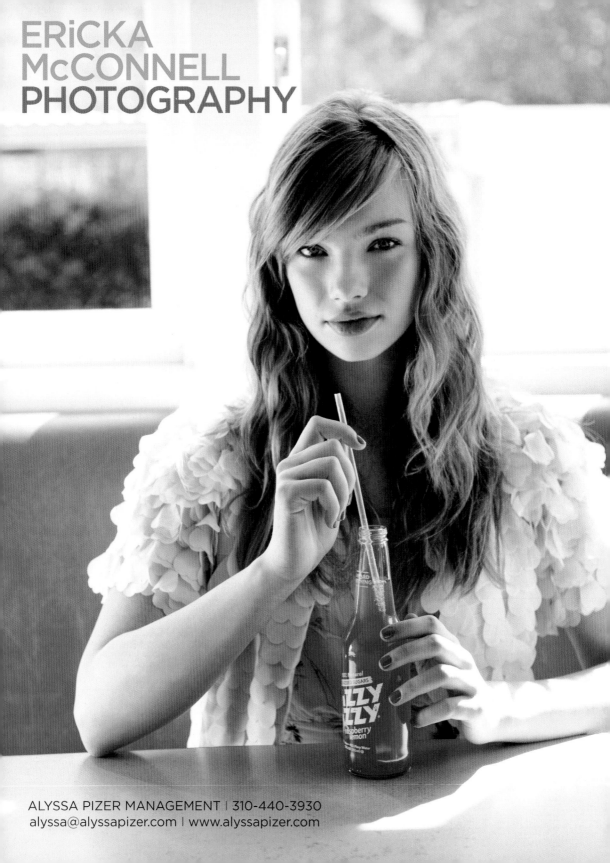

ERiCKA
McCONNELL
PHOTOGRAPHY

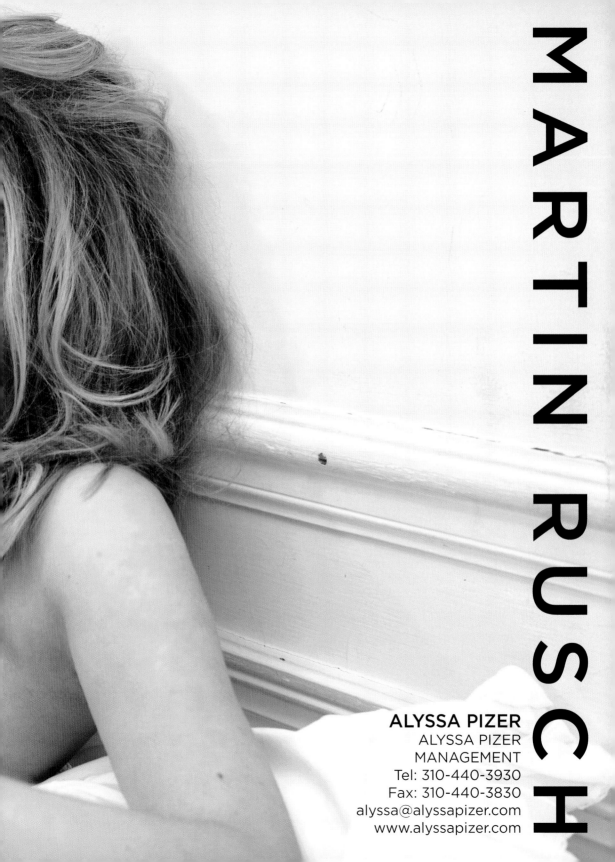

MARTIN RUSCH

ALYSSA PIZER
ALYSSA PIZER
MANAGEMENT
Tel: 310-440-3930
Fax: 310-440-3830
alyssa@alyssapizer.com
www.alyssapizer.com

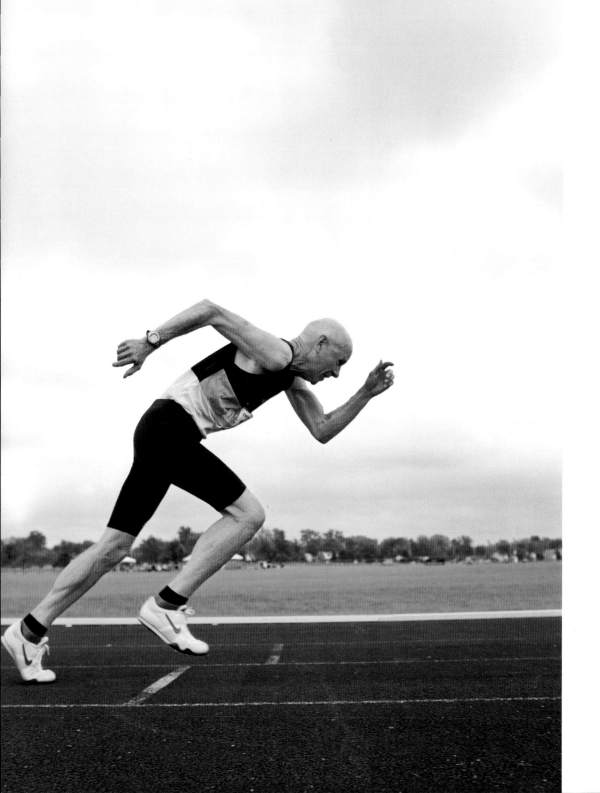

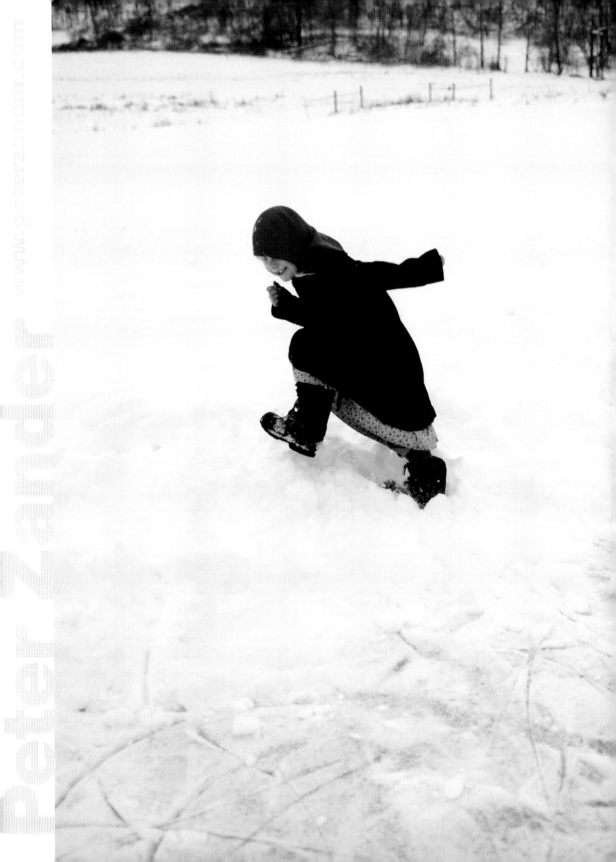

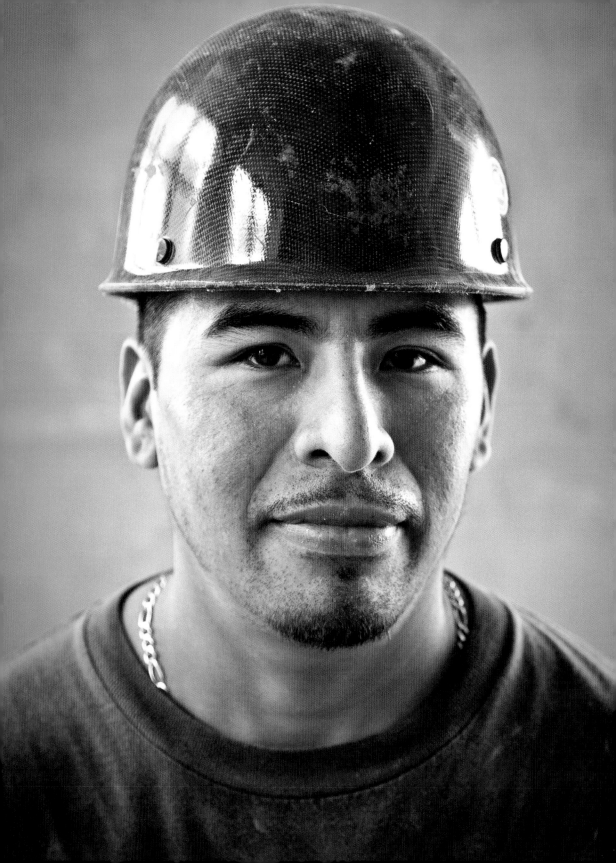

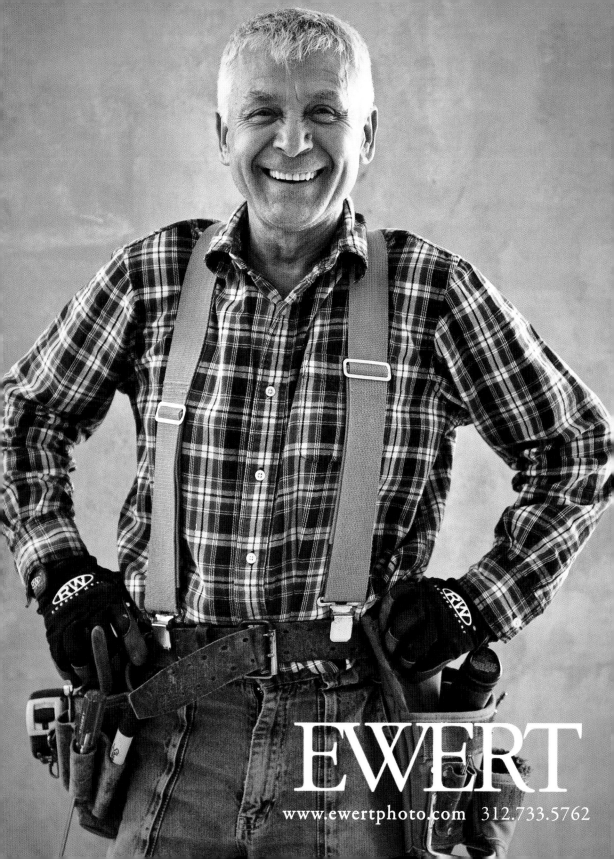

EWERT

www.ewertphoto.com 312.733.5762

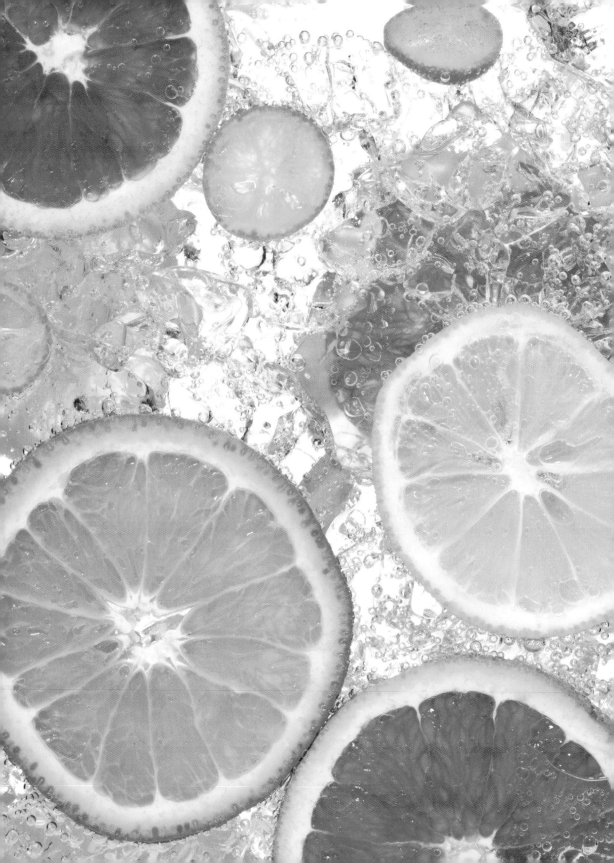

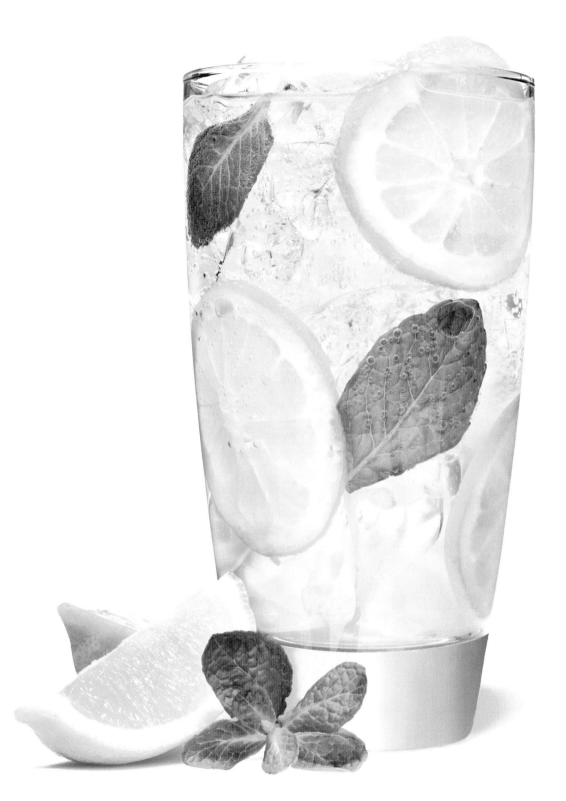

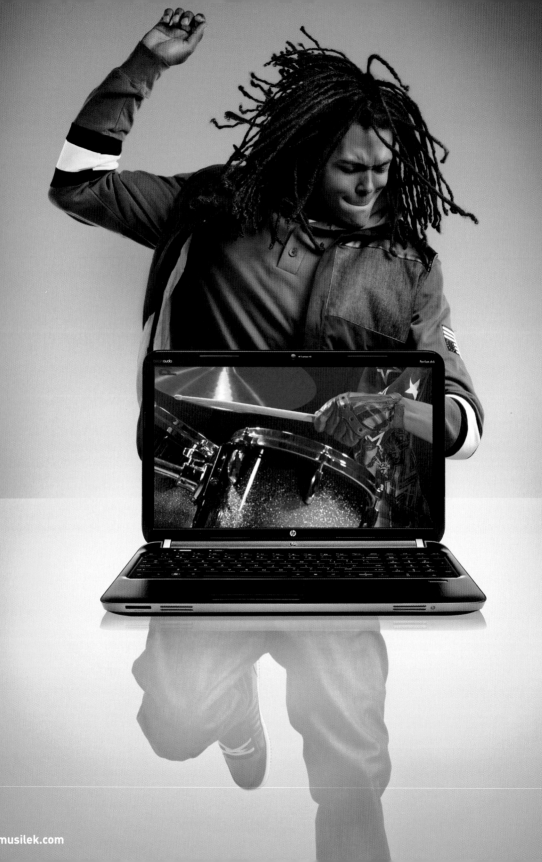

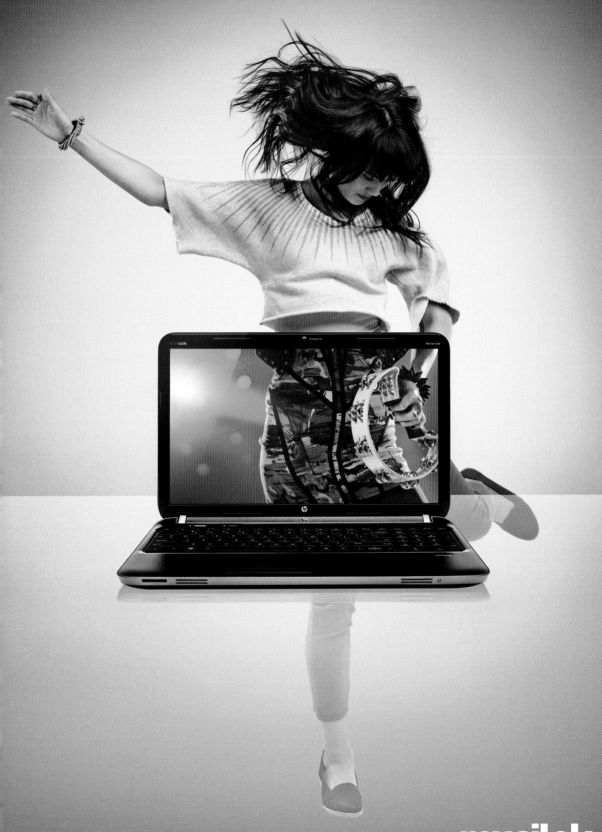

415.621.5336 1224 Mariposa St. San Francisco CA 94107
+33 (0) 6 30.13.35.0457 Rue de la Roquette Paris 75011

musilek

ROBERT BACALL

R E P R E S E N T A T I V E S

photography/motion/cgi

Andrew Hall	Natural Light Exploration/ Geometric Rhythms
Dennis Murphy	Sports/Adventure/ People/Recreation
Leland Bobbé	Portraits/Landscapes/ Urbanscapes/Documentary
Lorenz & Avelar	Visual Creations using Traditional Photography, CGI, Motion and Animation
Niels Van Iperen	Environmental Portraits
Robb Scharetg	People/Portraits/Lifestyle/ Landscapes/Environments/ Visual Narratives/Still/Motion
Ross Whitaker	Babies/Kids/Family Life/ Motion
Sam Robles	Fitness/Recreational Sports Portraits
Satoshi	Exactitude (Still Life) Liquid/Splash Specialist
Steve Beaudet	Travel & Tourism/Recreation/ Motion/Resort + Spa
Stephen Scott Gross	Food/Travel/People
Terry Heffernan	Food/Still Life/ Video Motion

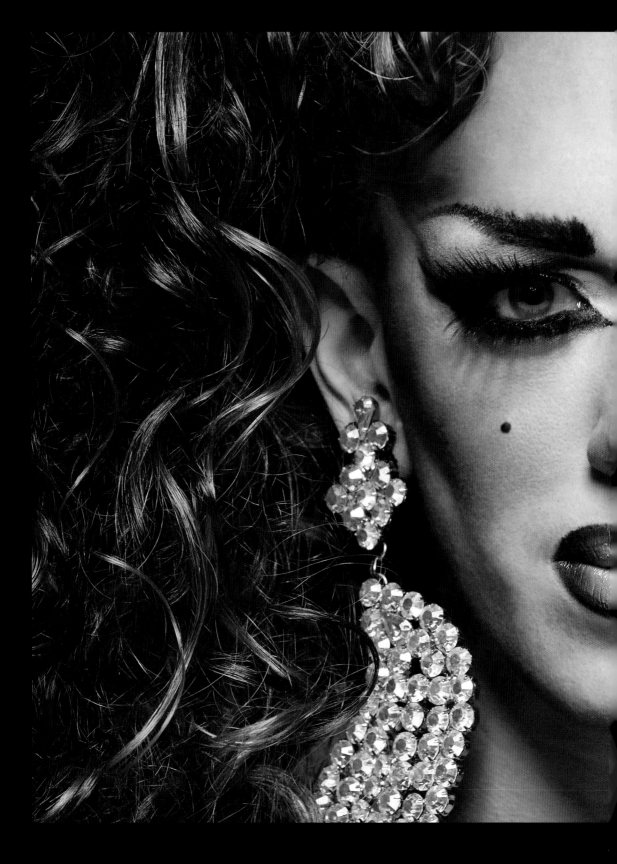

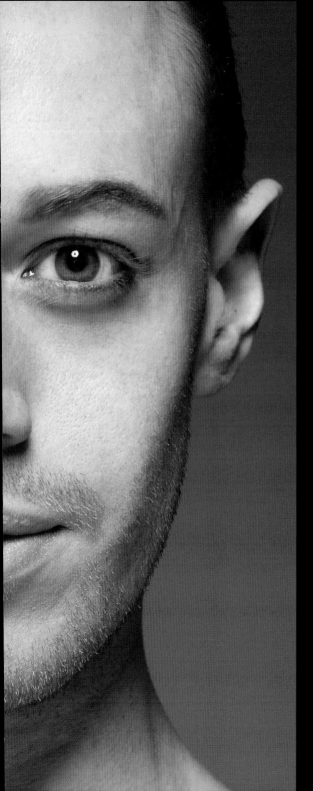

lelandbobbè

lelandbobbe.com

Bō
Shoots

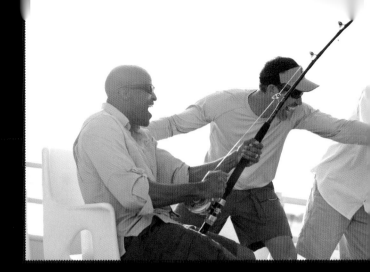

— represented by —

917.763.6554
rob@bacall.com

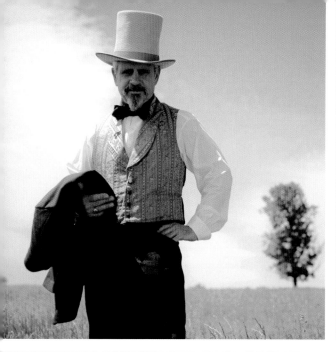

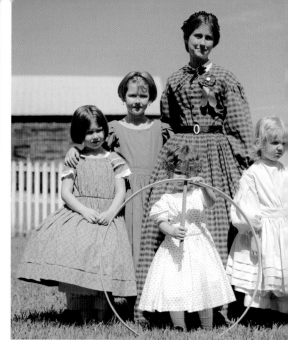

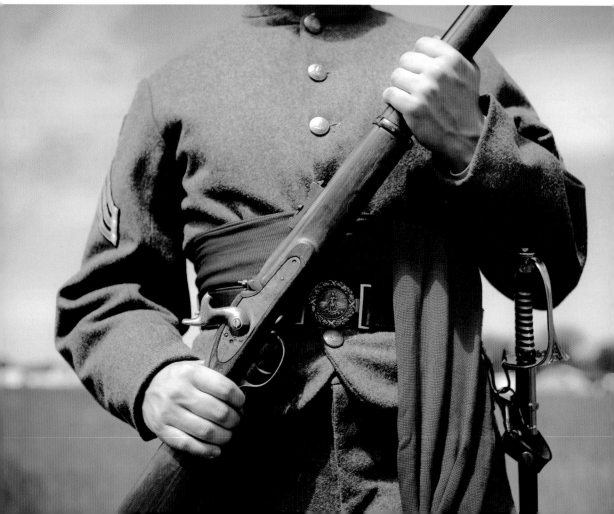

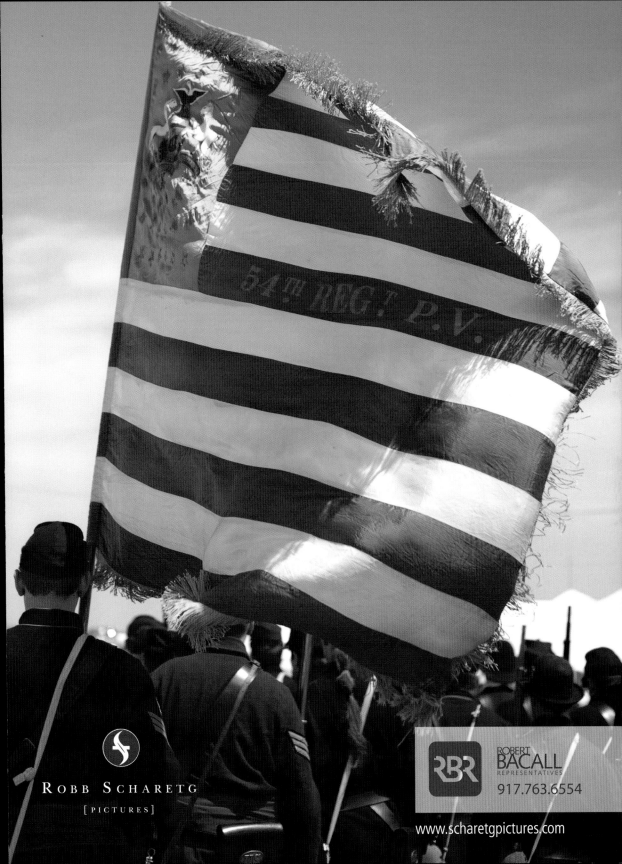

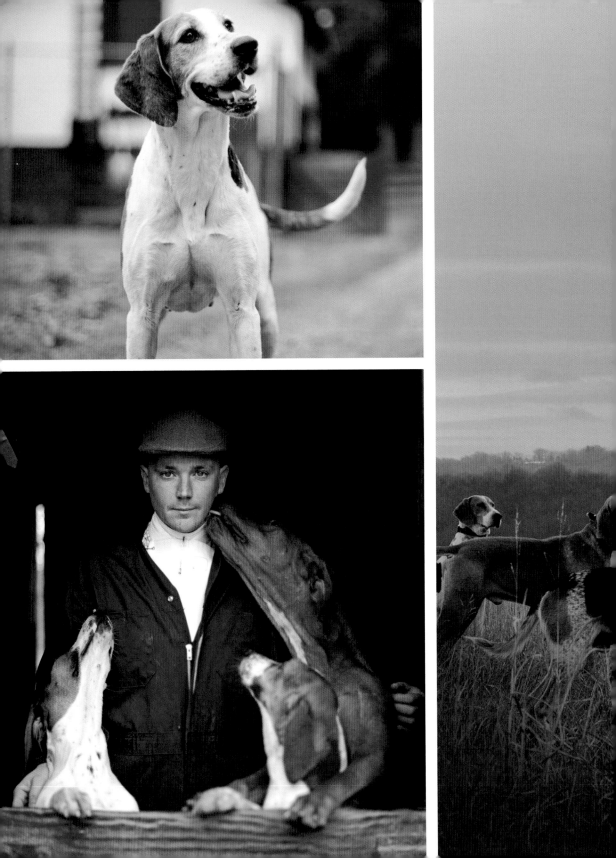

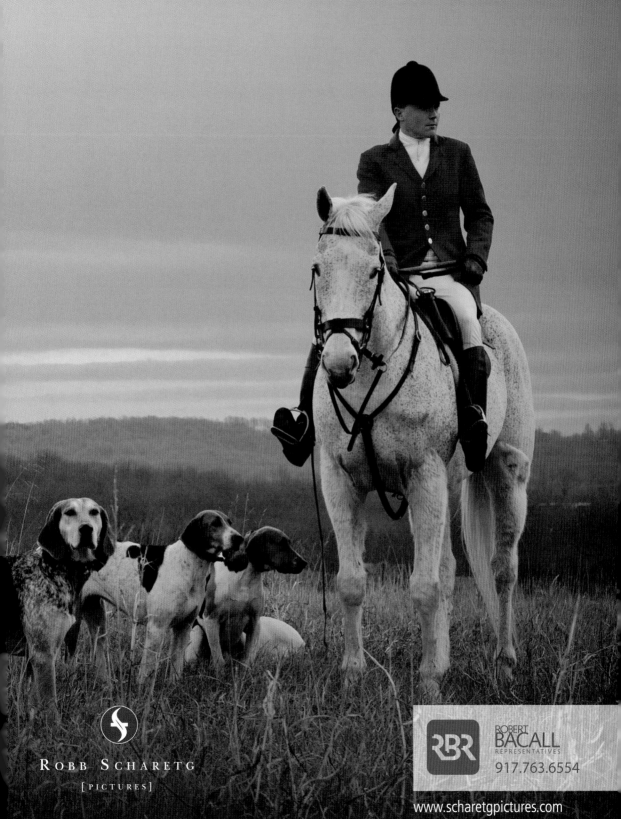

DENNIS MURPHY 214.651.7516 :: dmurphyphoto.com

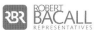

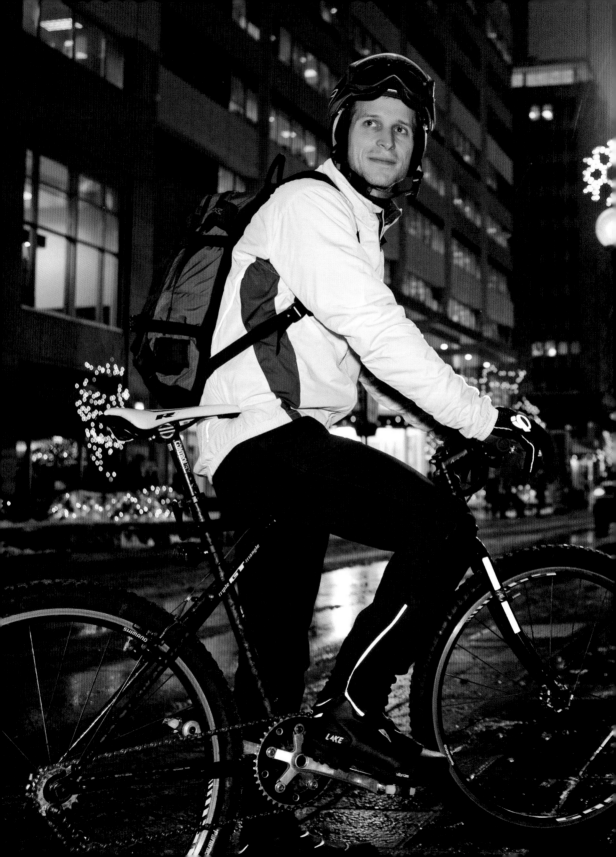

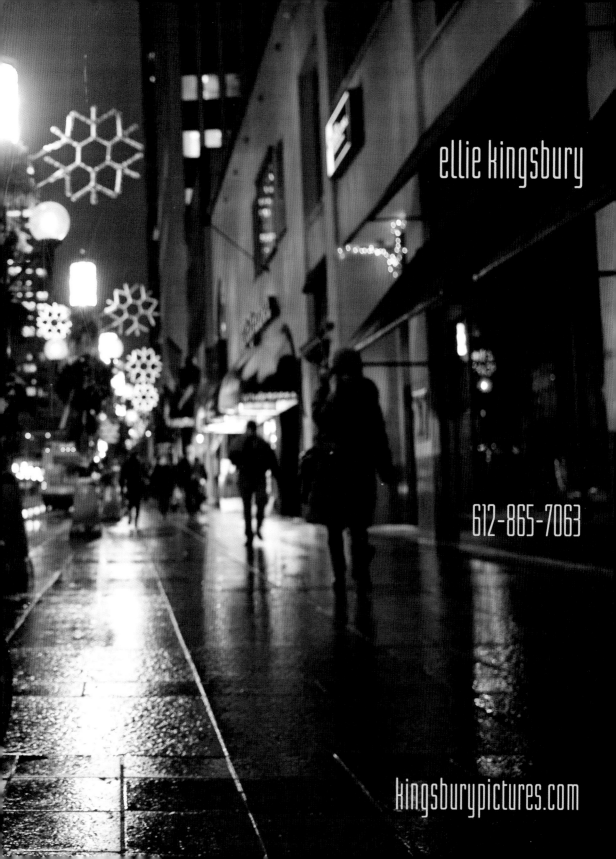

ellie kingsbury

612-865-7063

kingsburypictures.com

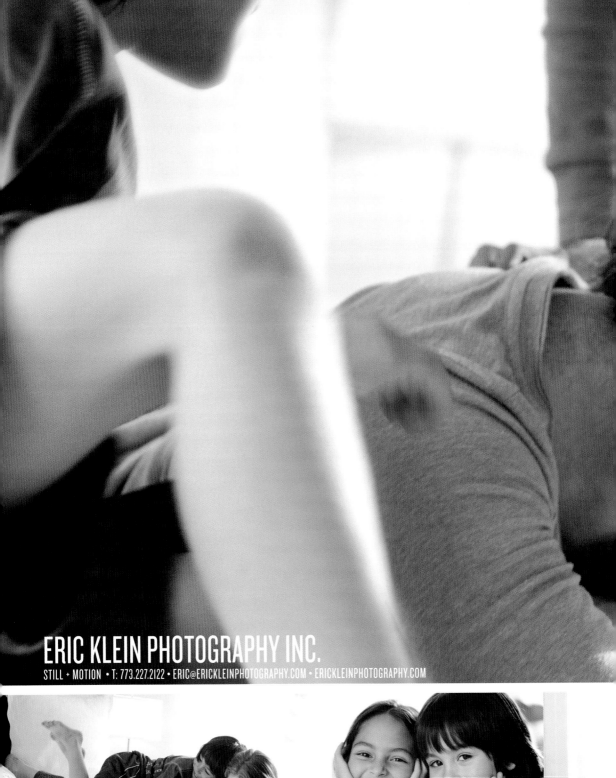

ERIC KLEIN PHOTOGRAPHY INC.
STILL + MOTION • T: 773.227.2122 • ERIC@ERICKLEINPHOTOGRAPHY.COM • ERICKLEINPHOTOGRAPHY.COM

BRETT NADAL

via **jim hanson artist agent** ltd.
www.jimhanson.com

www.brettnadal.com

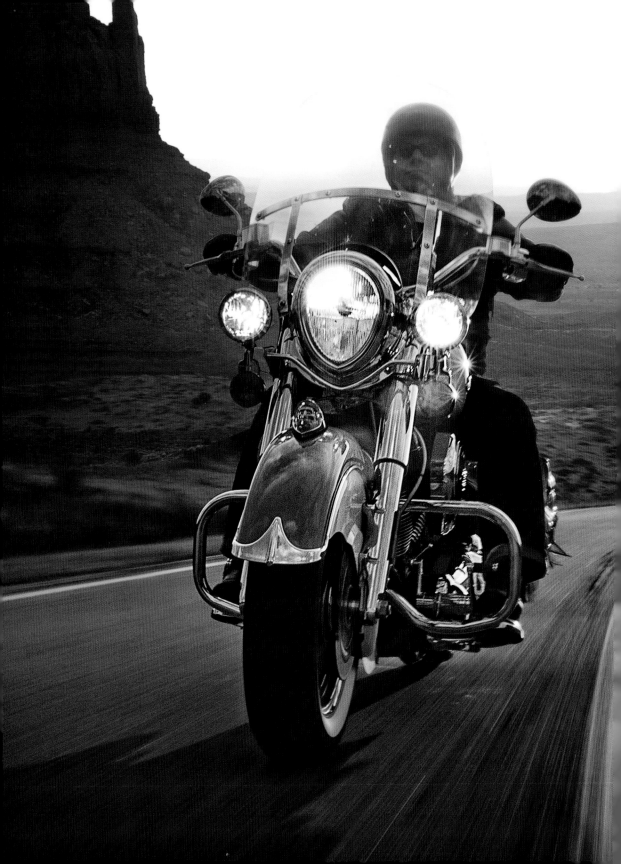

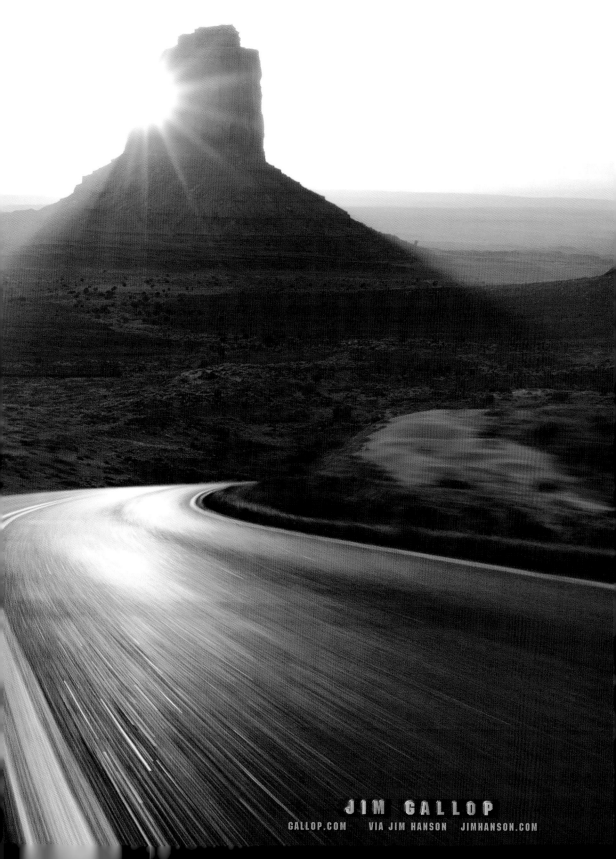

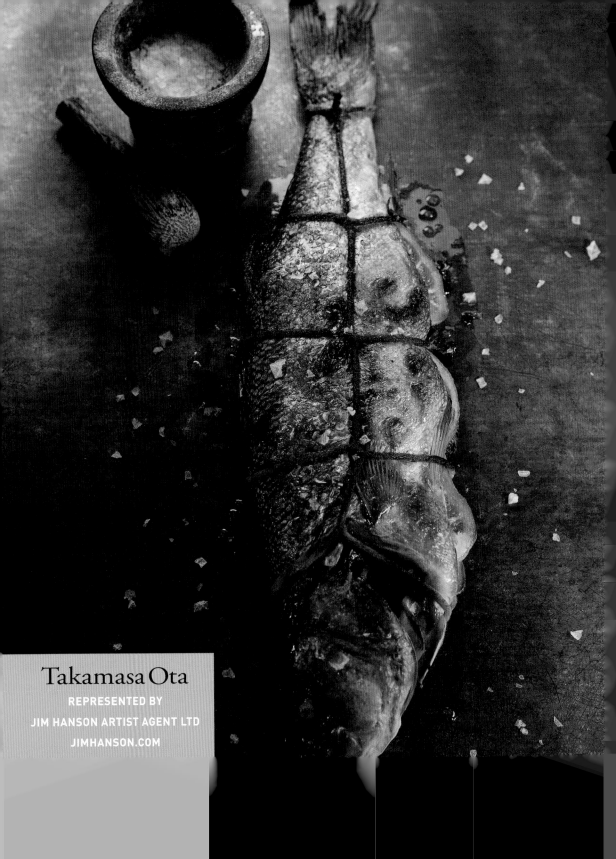

Takamasa Ota

REPRESENTED BY

JIM HANSON ARTIST AGENT LTD

JIMHANSON.COM

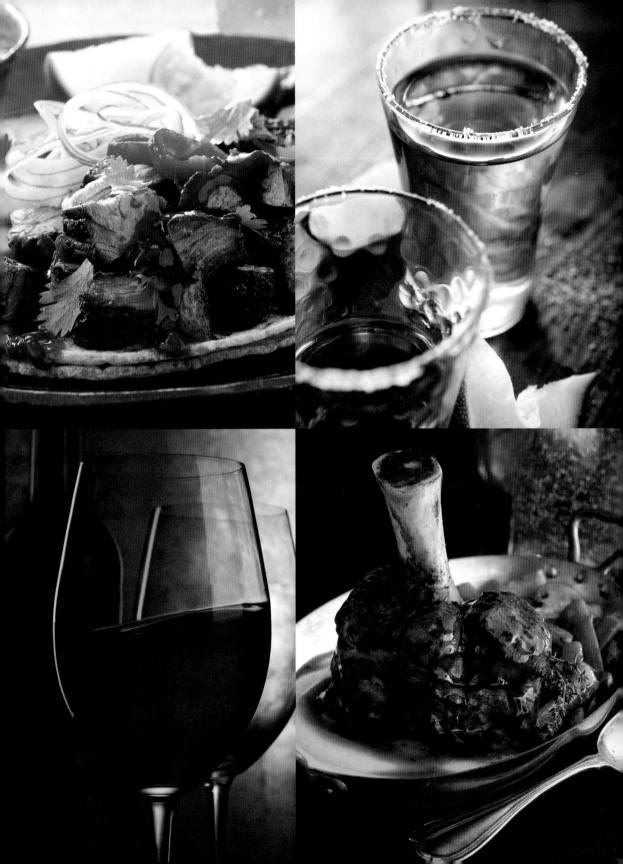

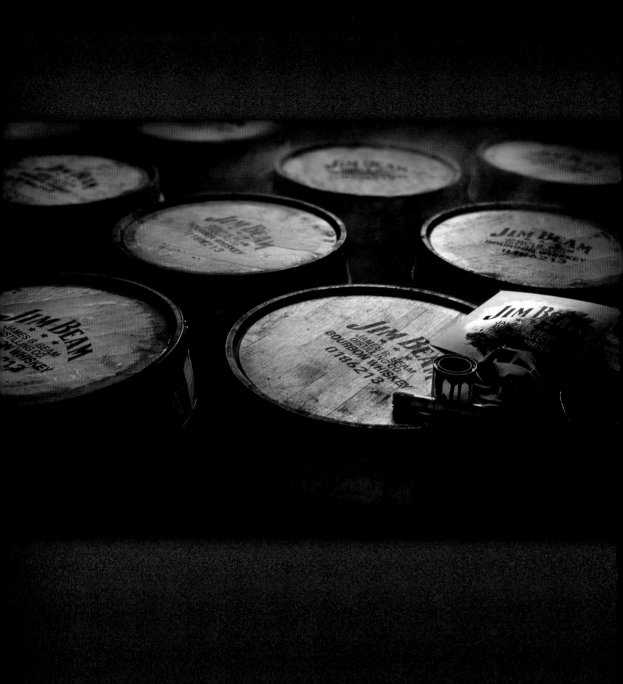

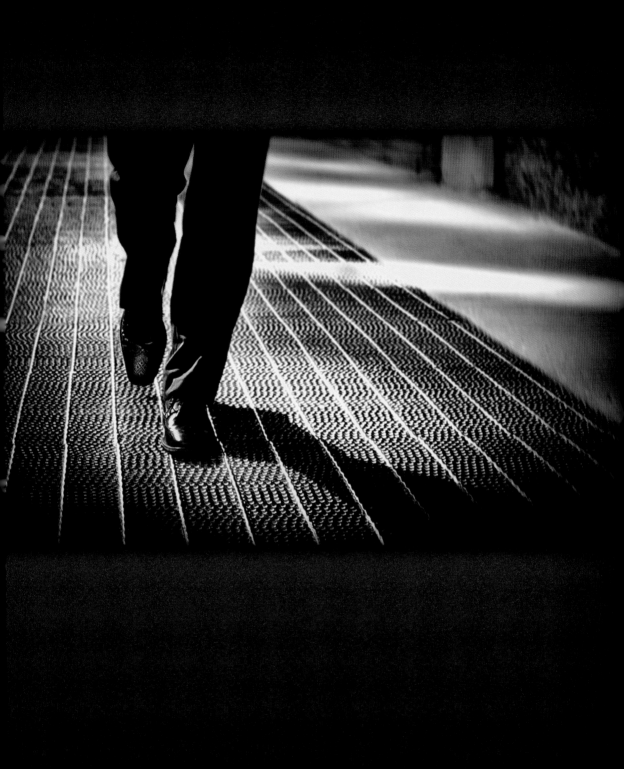

GREGWHITAKER
represented by Holly Hahn 312.371.0500 gregwhitaker.com

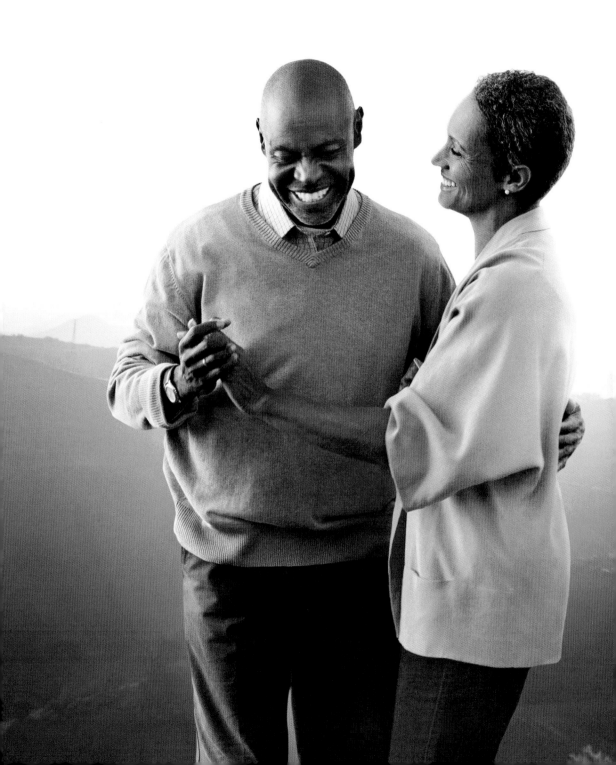

Michael Haskins

Paolo Marchesi

Andrea Rugg

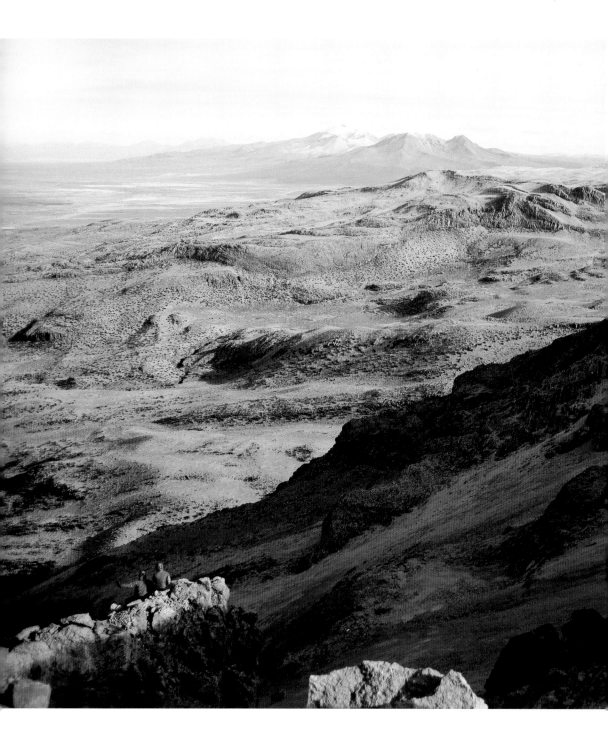

PAOLO MARCHESI

Photography

MONTANA 406 _ _____ 58060

SAN FRANCISCO 415 _ _____ 73820

WWW.MARCHESIPHOTO.CO

AWARDS

View my online reel for some motion pictures

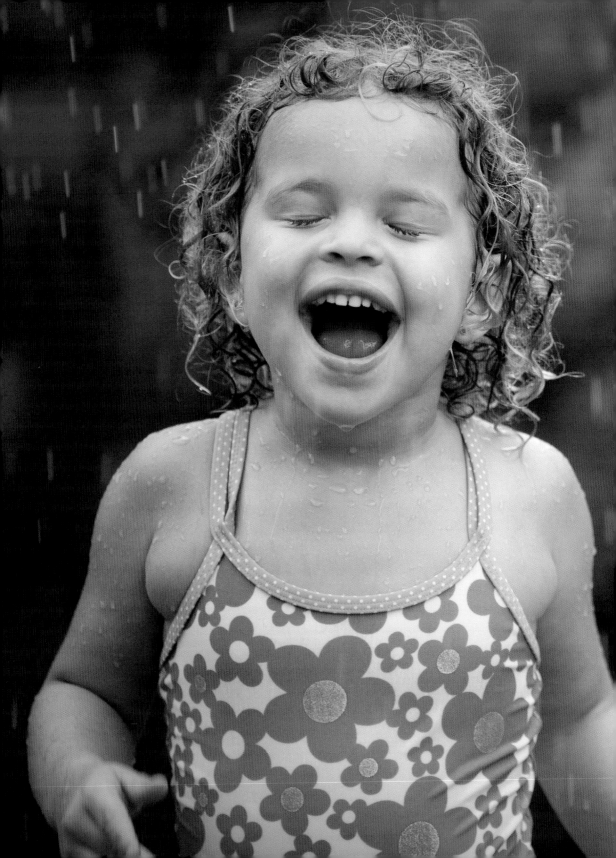

TERRY VINE 713 528 6788 terryvine.com

National: VISU 800 979 8478 Texas: BIG PICTURES REPS 214 530 0979

National: VISU 800 979 8478 Texas: BIG PICTURES REPS 214 530 0979

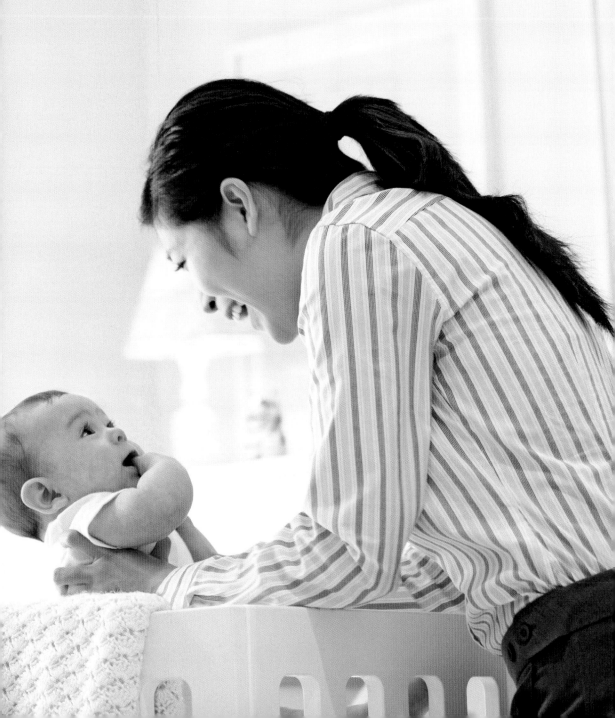

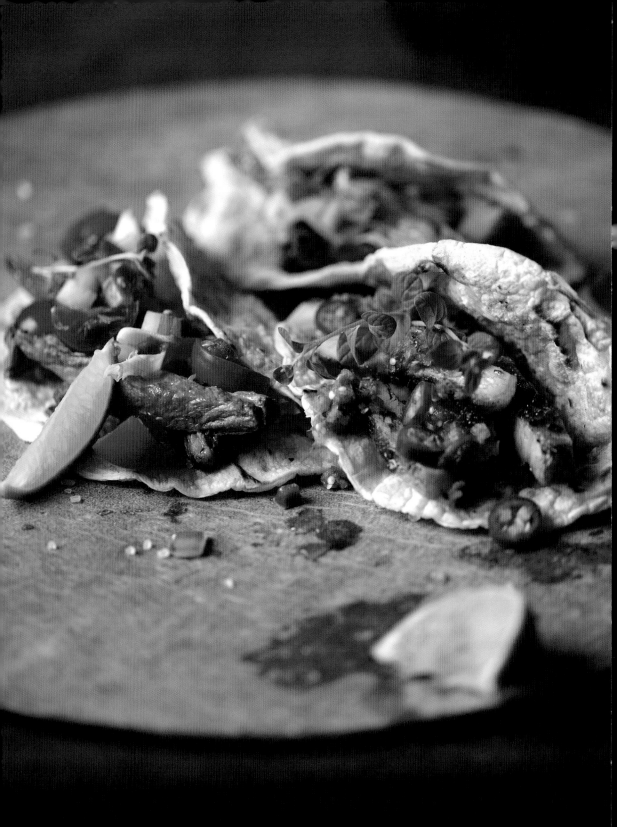

MICHAEL**MAES**

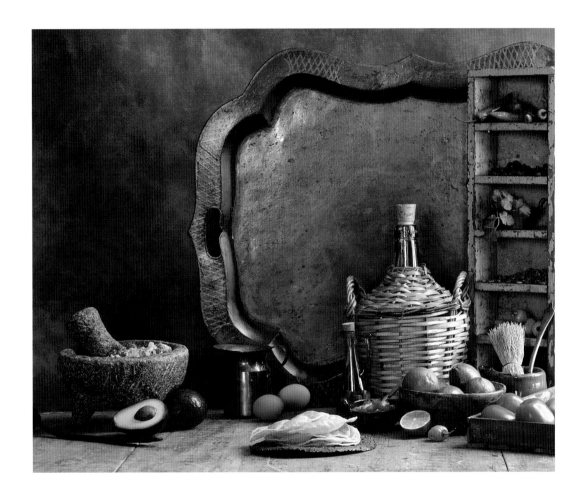

MAES STUDIO
T 312 997 2775 | C 312 952 2770 | MAESSTUDIO.COM
REPRESENTATION: VISU ARTISTS
212 518 3222 | NEW YORK | DALLAS | MIAMI

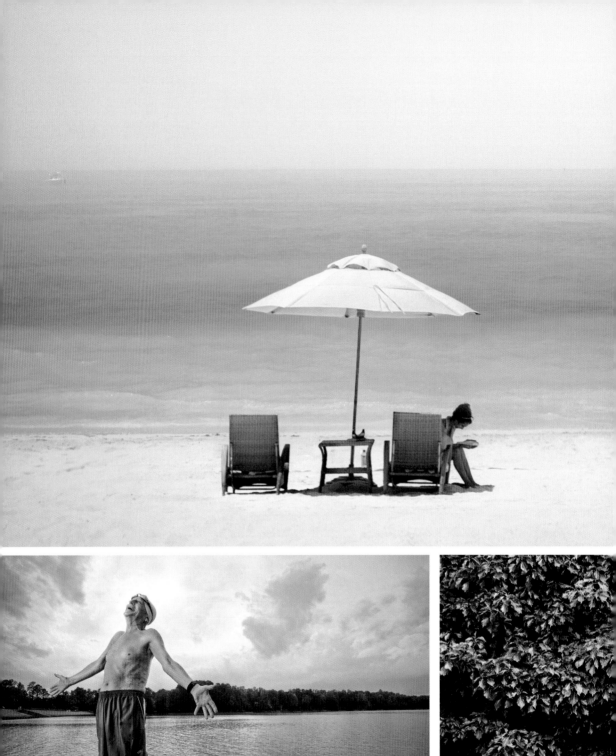
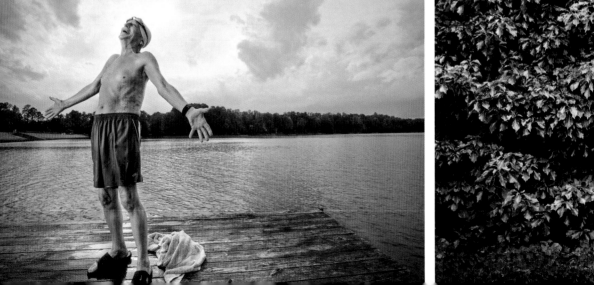

JIMMY WILLIAMS

Life Luxe Faces Places

www.JimmyWilliamsPhotography.com

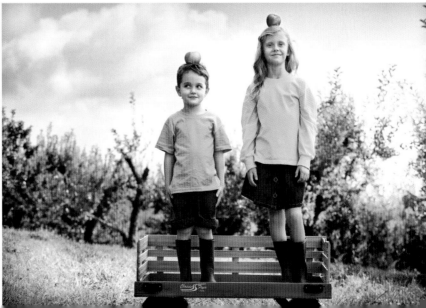

callie lipkin

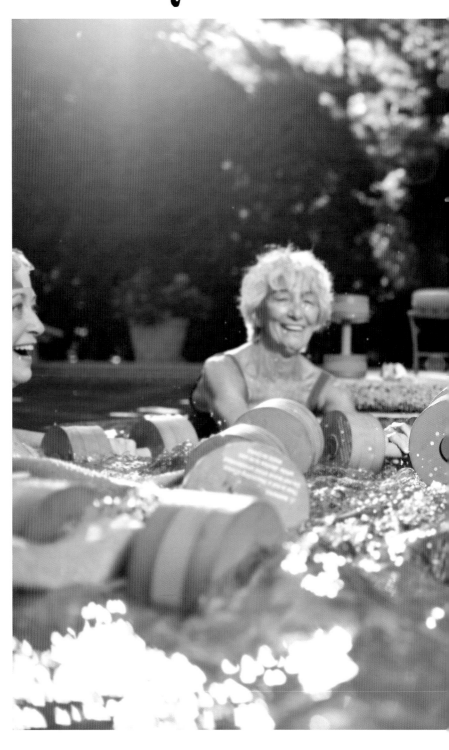

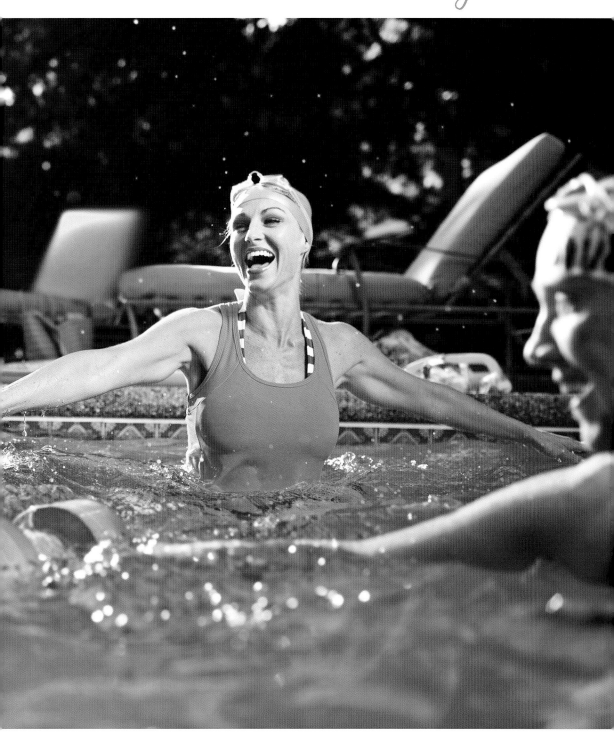

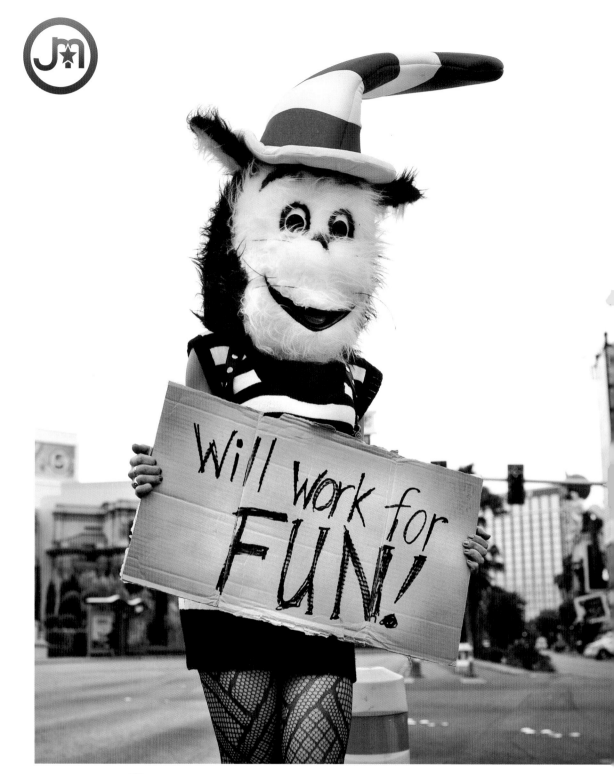

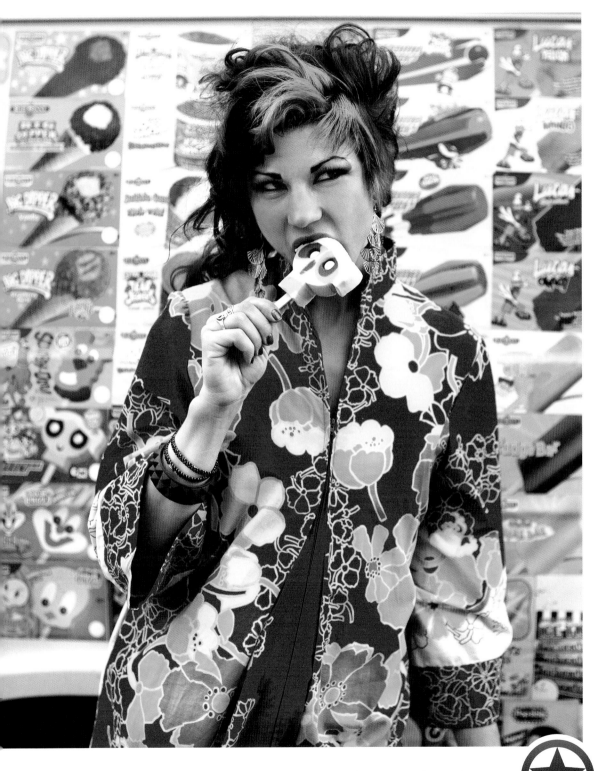

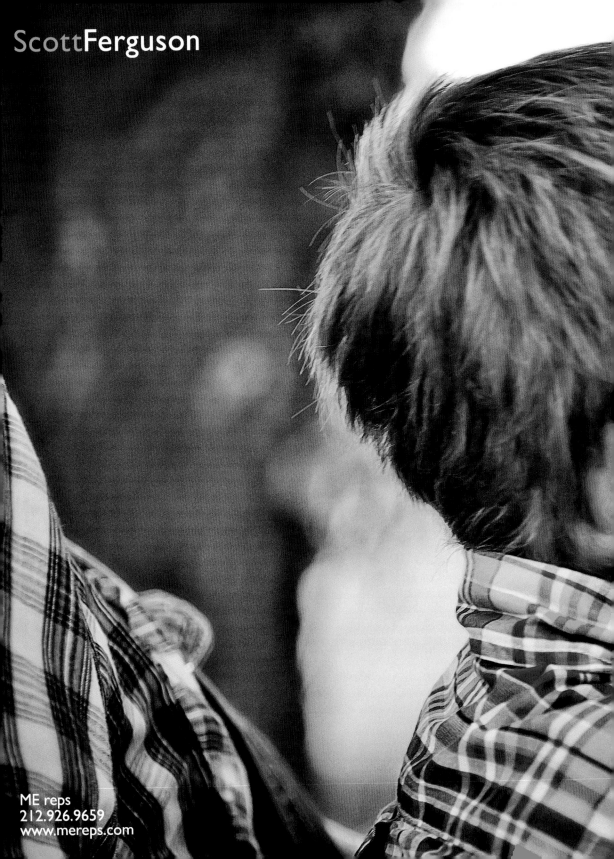

ScottFerguson

ME reps
212.926.9659
www.mereps.com

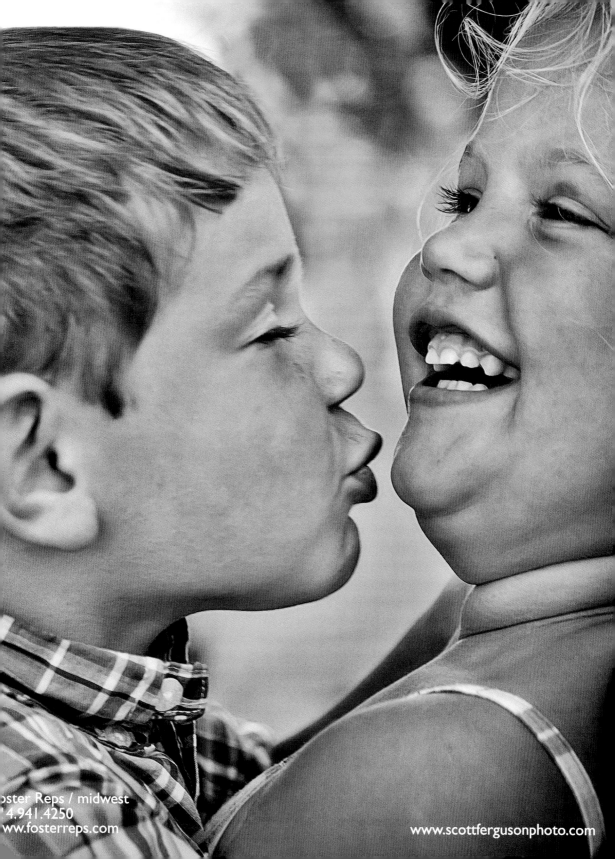

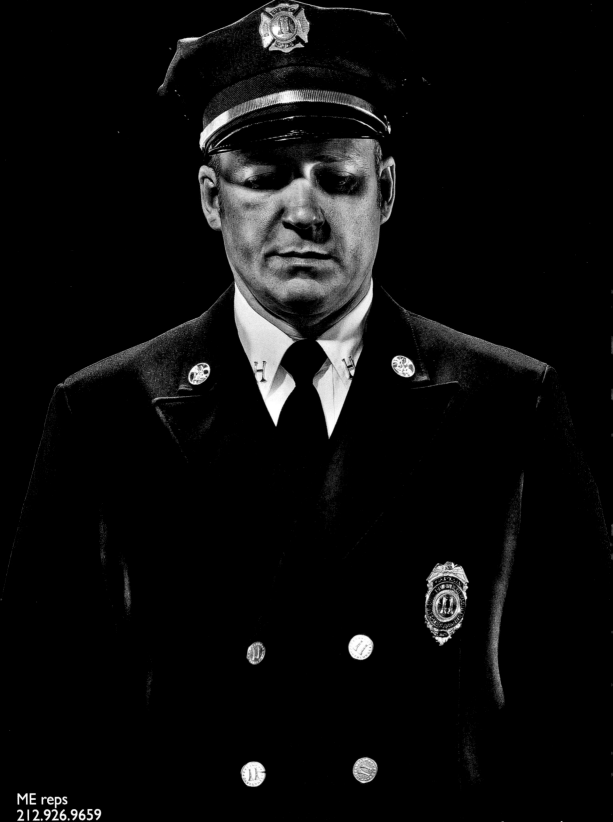

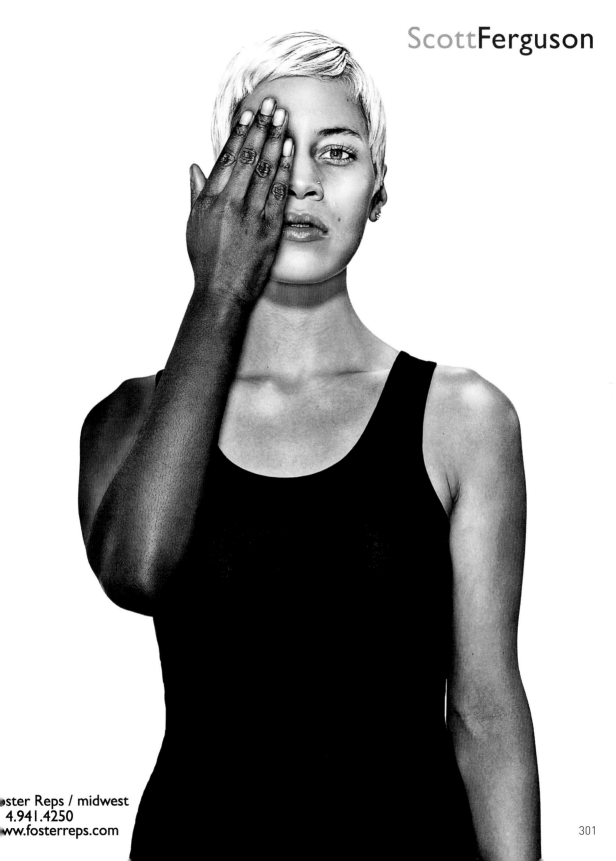

ScottFerguson

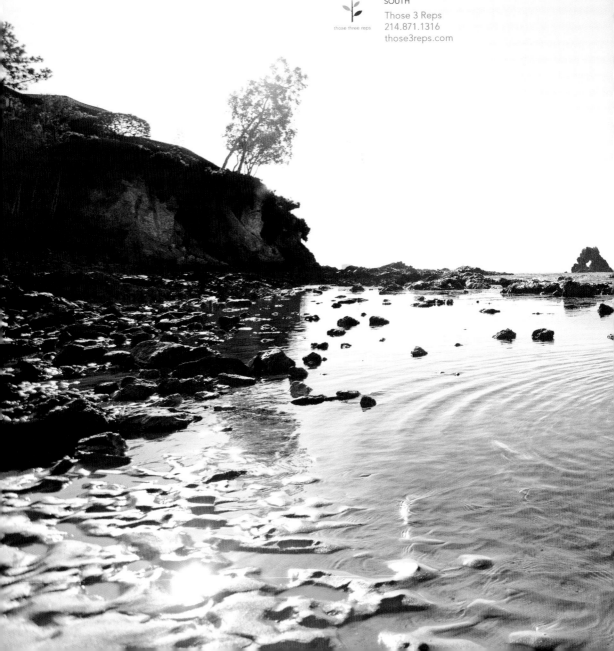

GEORGE KAMPER

www.georgekamper.com

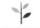

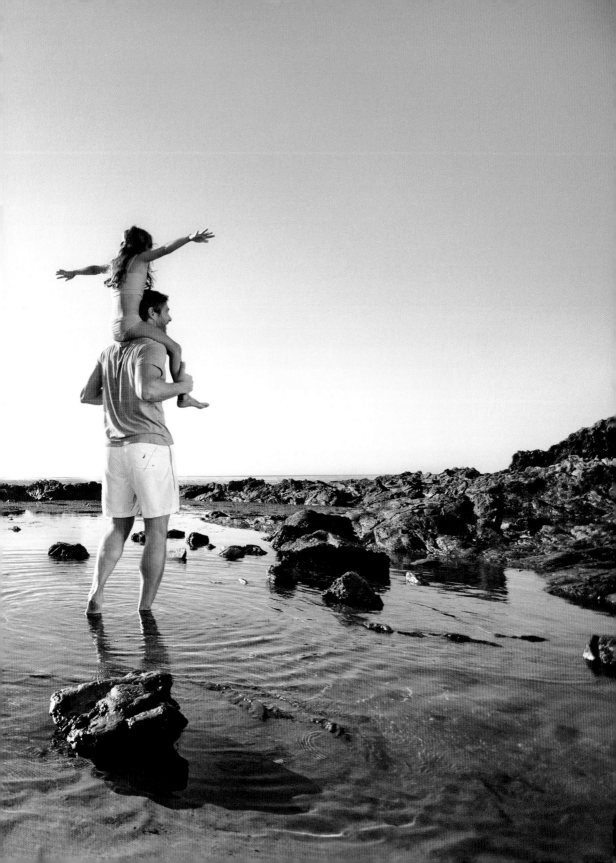

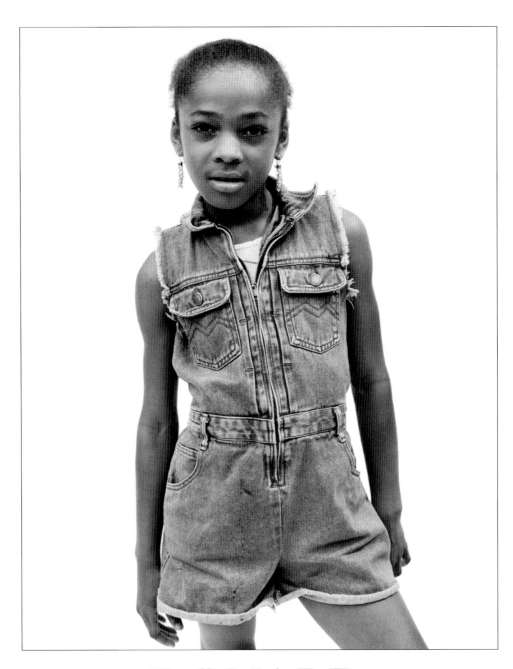

DONALD
GRAHAM

www.donaldgraham.com
Represented by Daniele Forsythe Photographers
New York 212 693 7470 Los Angeles 310 450 1650

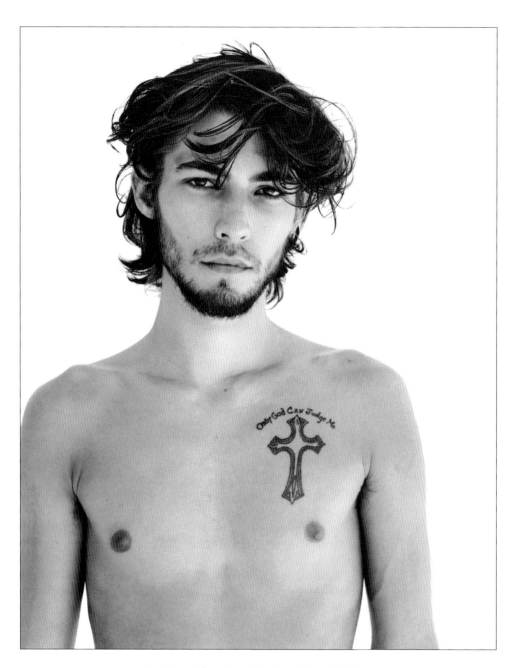

DONALD
GRAHAM

www.donaldgraham.com
Represented by Daniele Forsythe Photographers
New York 212 693 7470 Los Angeles 310 450 1650

DENNIS WELSH

PHOTOGRAPHY and MOTION (207) 846-4130

SEE NEW WORK AT DENNISWELSH.COM

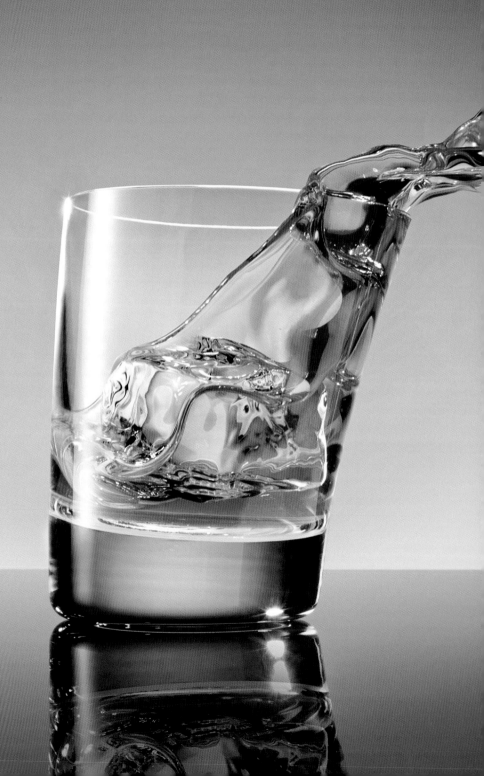

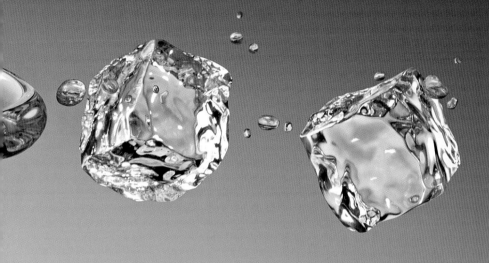

TED TAMBURO PHOTOGRAPHY

312 226-4884 www.tamburo-photography.com
represented by carolyn somlo 312 209-8042

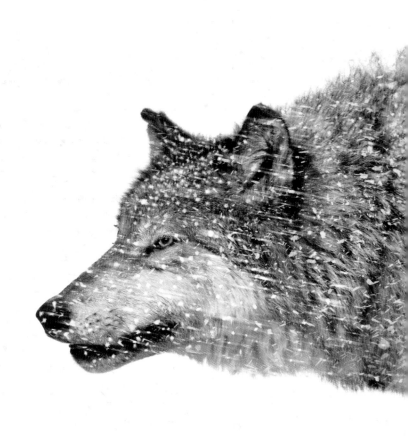

grubman.

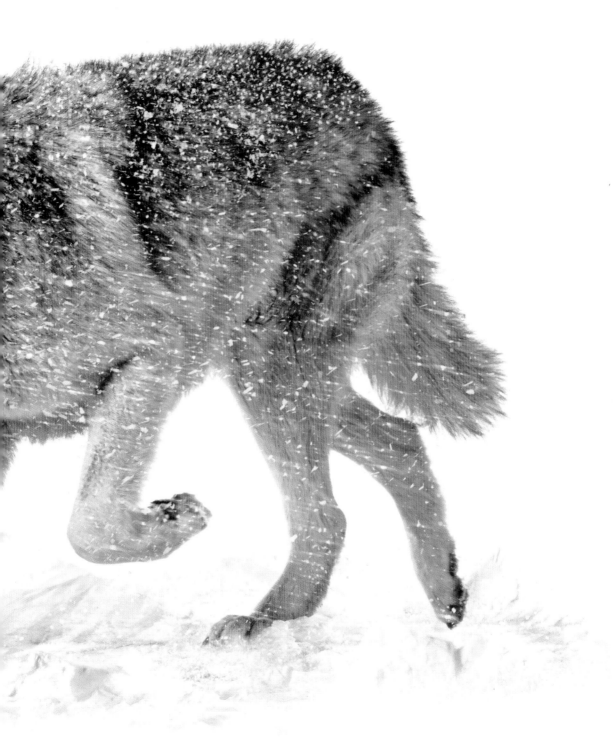

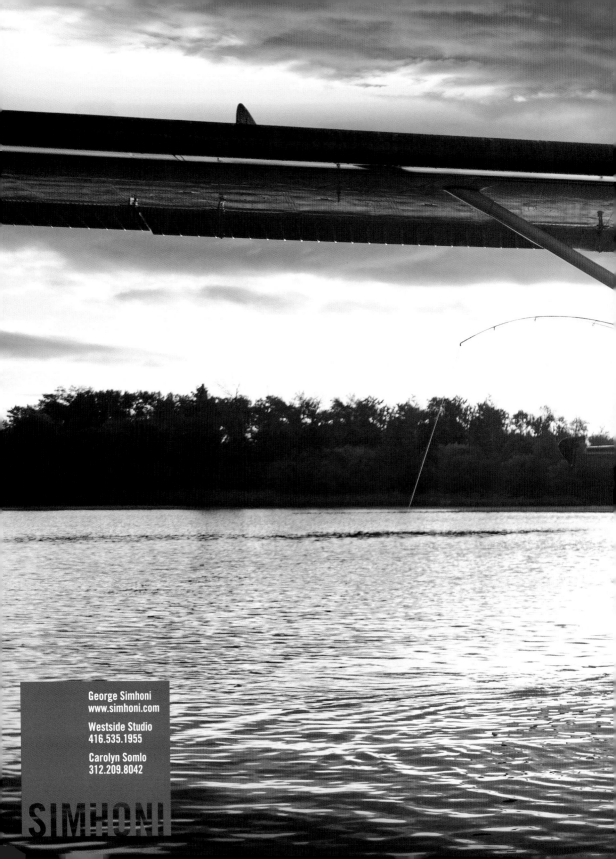

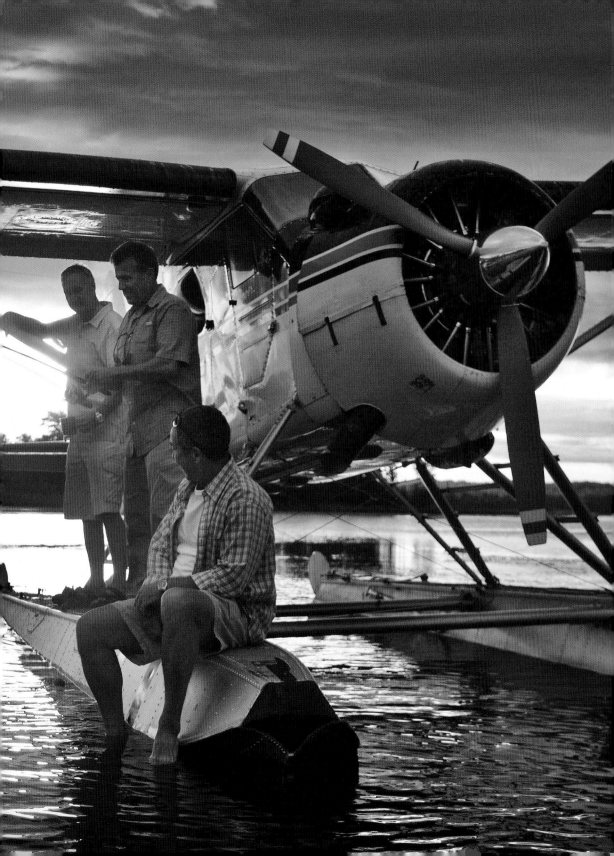

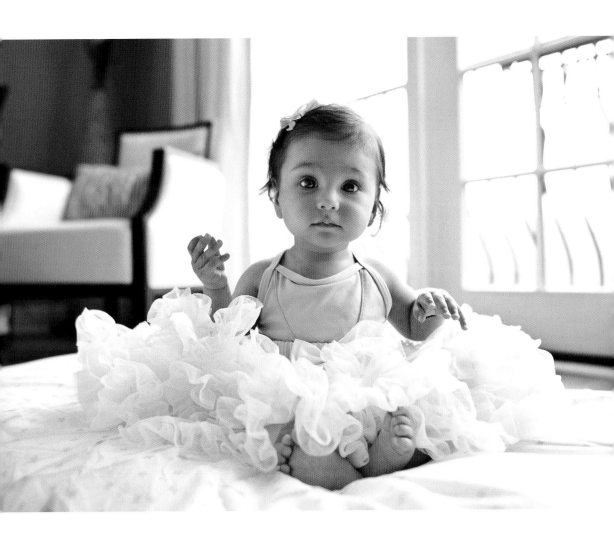

www.andreamandel.com

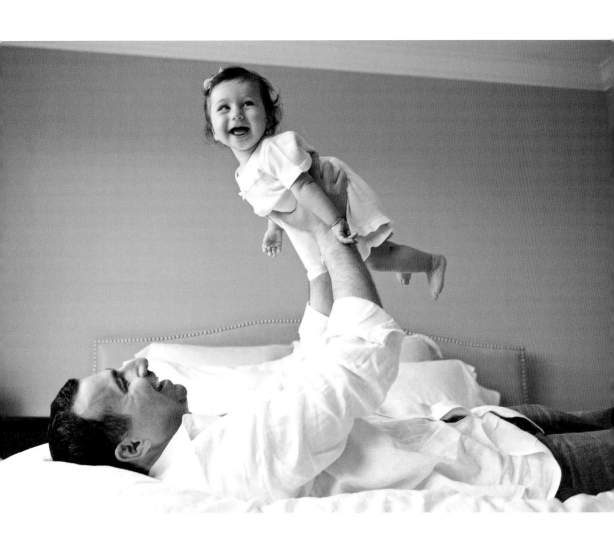

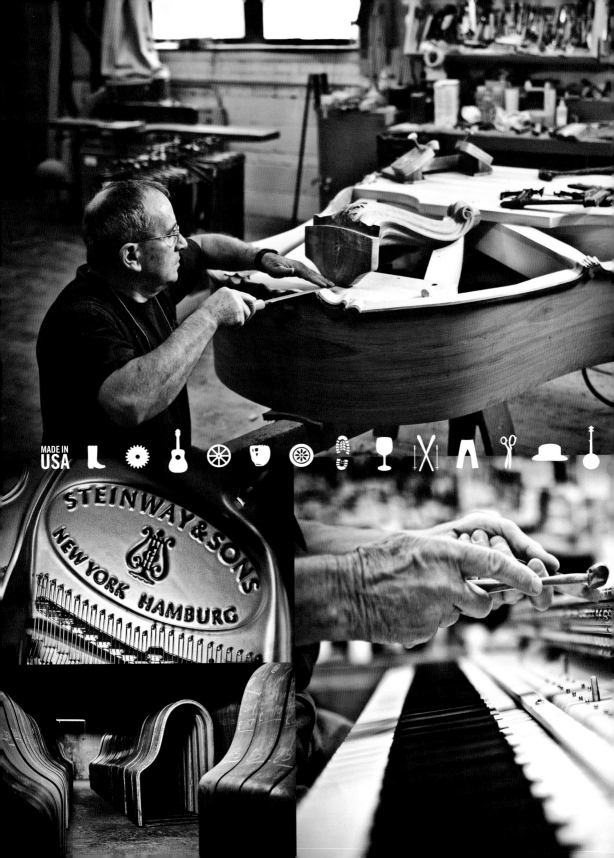

MADE IN USA

-TADD MYERS-

SEE MORE AT

TADDMYERS.COM

---------×

AMERICANCRAFTSMANPROJECT.COM

---------×

214.752.2372

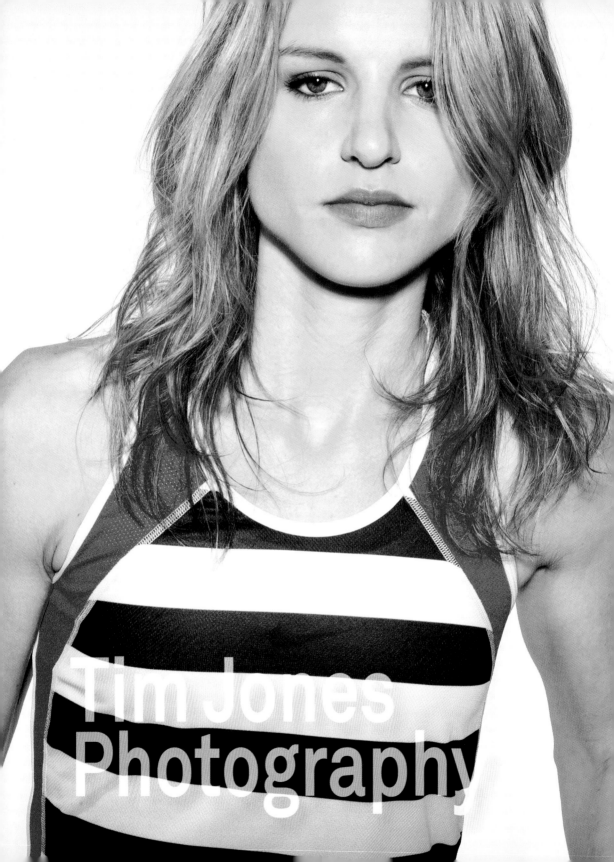

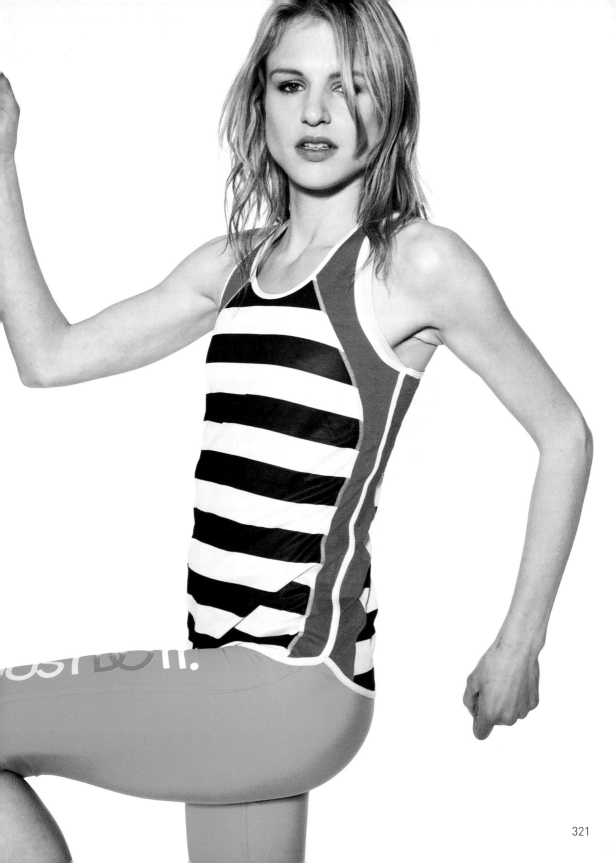

CANDACE GELMAN
& ASSOCIATES

SF 415-897-0808
CH 312-266-0808
NY 212-666-0808

CANDACEGELMAN.COM
FACEBOOK.COM/CANDACEGELMAN

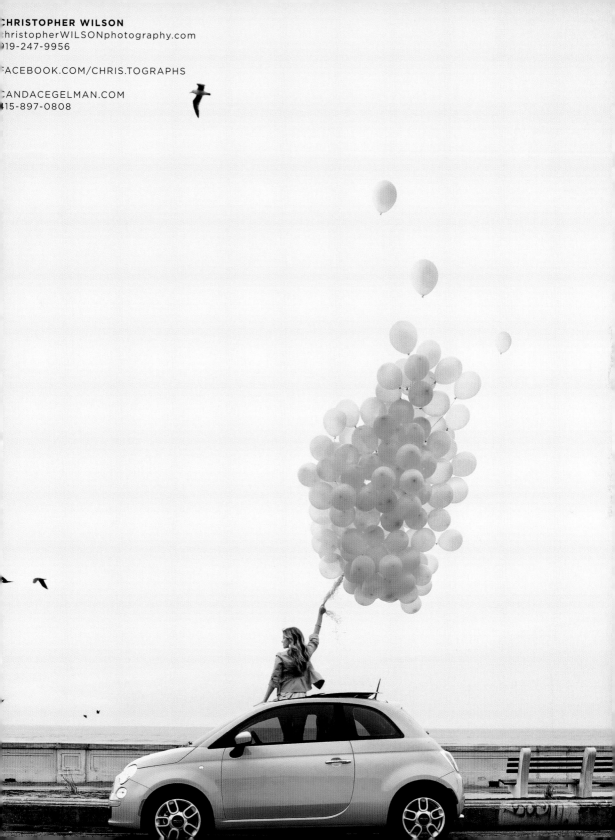

CHRISTOPHER WILSON
christopherWILSONphotography.com
919-247-9956

FACEBOOK.COM/CHRIS.TOGRAPHS

CANDACEGELMAN.COM
415-897-0808

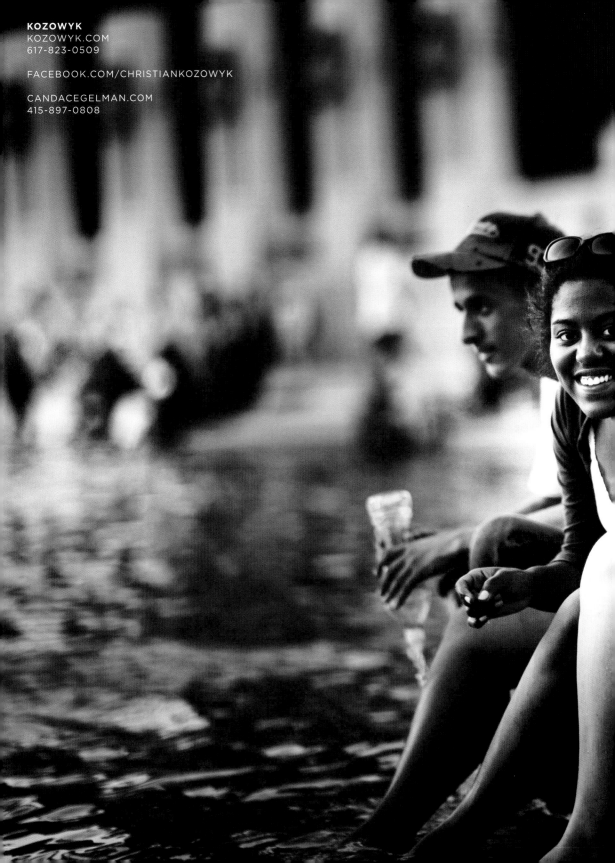

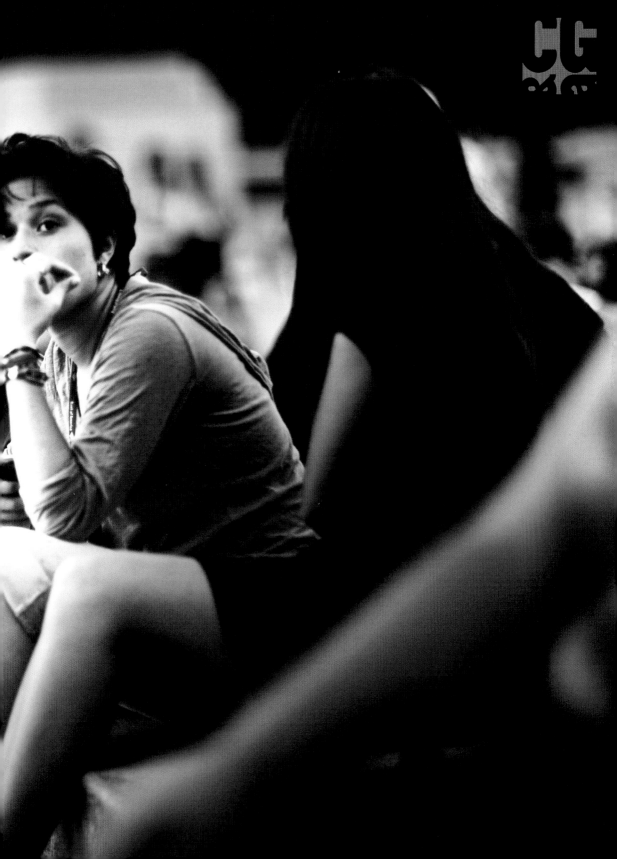

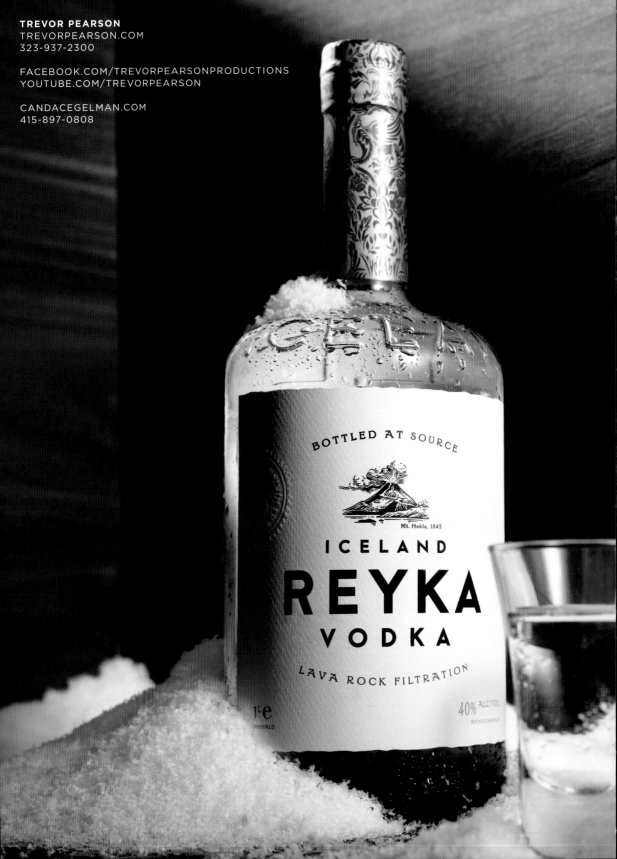

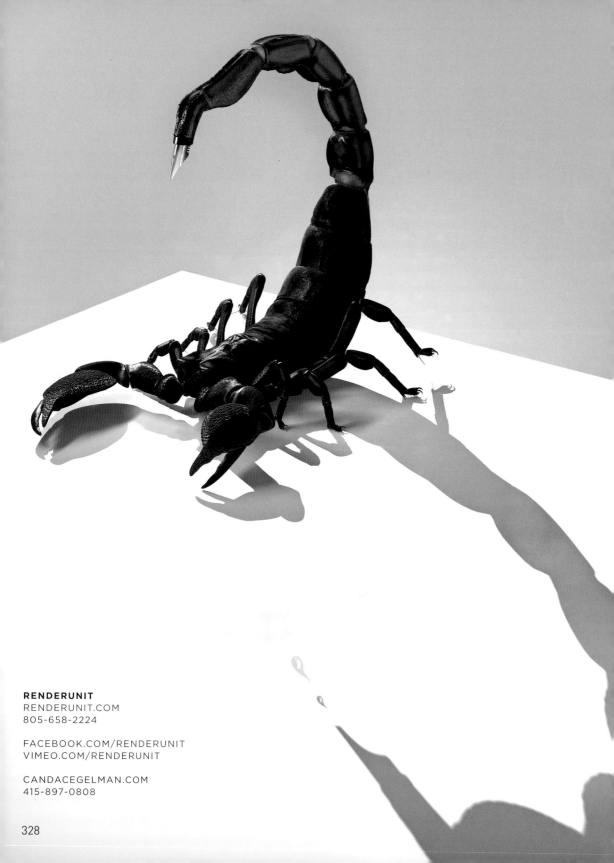

RENDERUNIT
RENDERUNIT.COM
805-658-2224

FACEBOOK.COM/RENDERUNIT
VIMEO.COM/RENDERUNIT

CANDACEGELMAN.COM
415-897-0808

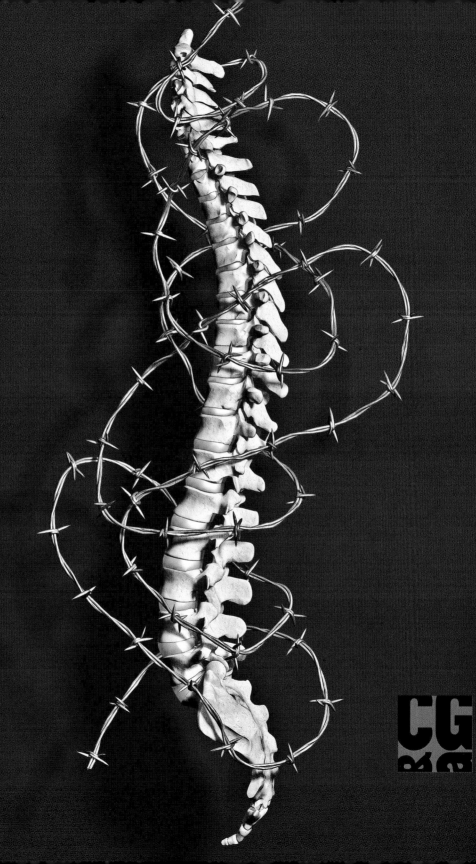

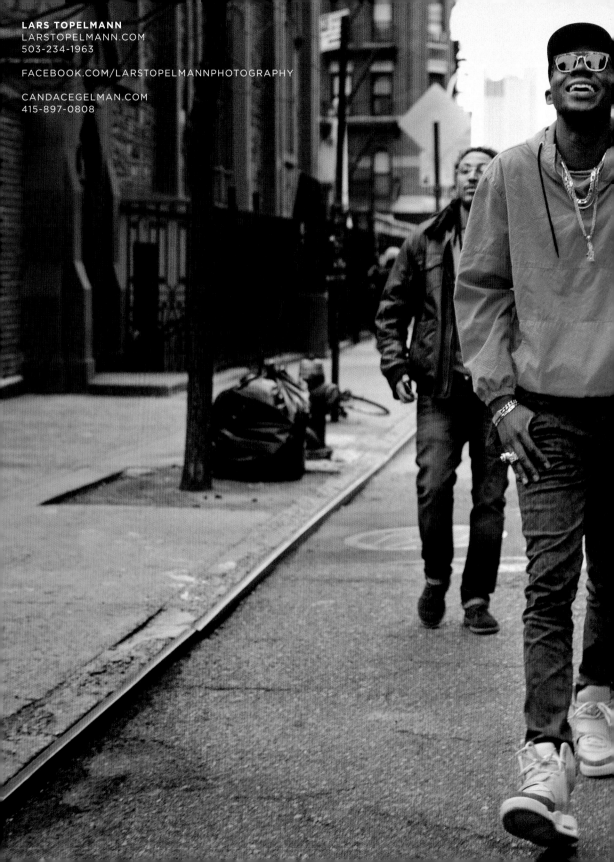

LARS TOPELMANN
LARSTOPELMANN.COM
503-234-1963

FACEBOOK.COM/LARSTOPELMANNPHOTOGRAPHY

CANDACEGELMAN.COM
415-897-0808

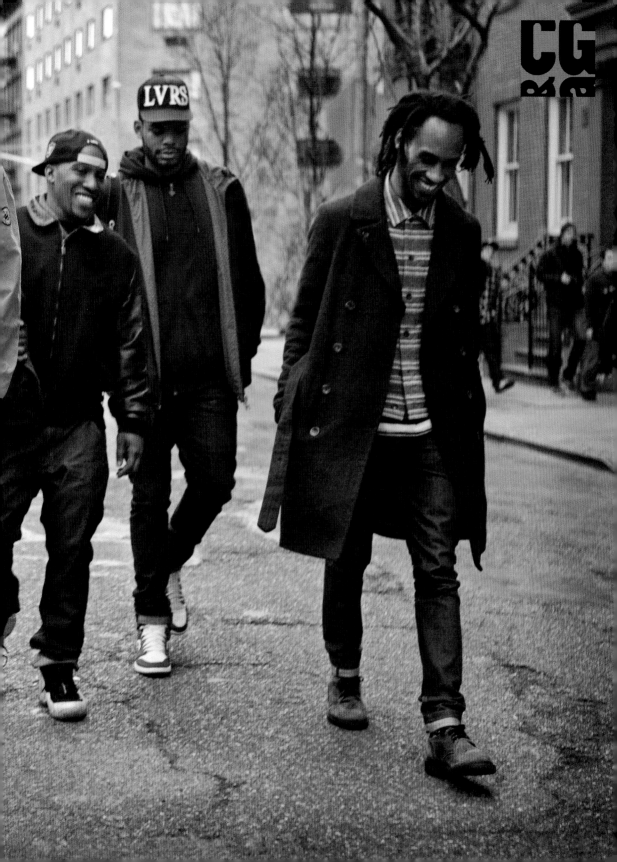

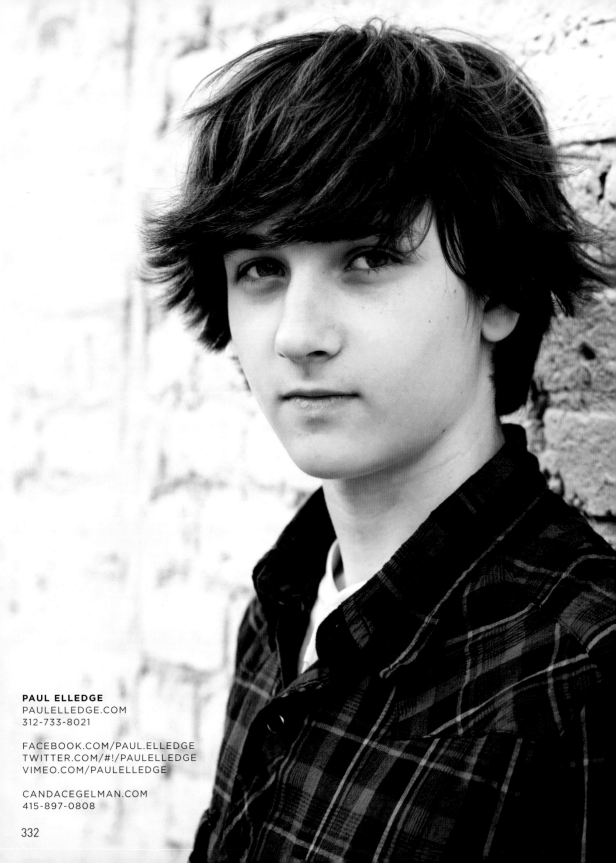

PAUL ELLEDGE
PAULELLEDGE.COM
312-733-8021

FACEBOOK.COM/PAUL.ELLEDGE
TWITTER.COM/#!/PAULELLEDGE
VIMEO.COM/PAULELLEDGE

CANDACEGELMAN.COM
415-897-0808

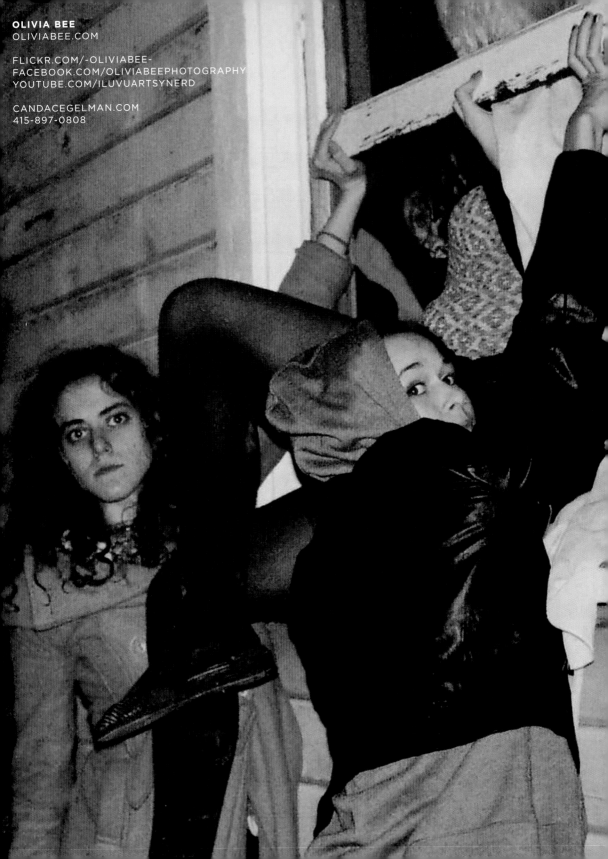

CANDACEGELMAN.COM

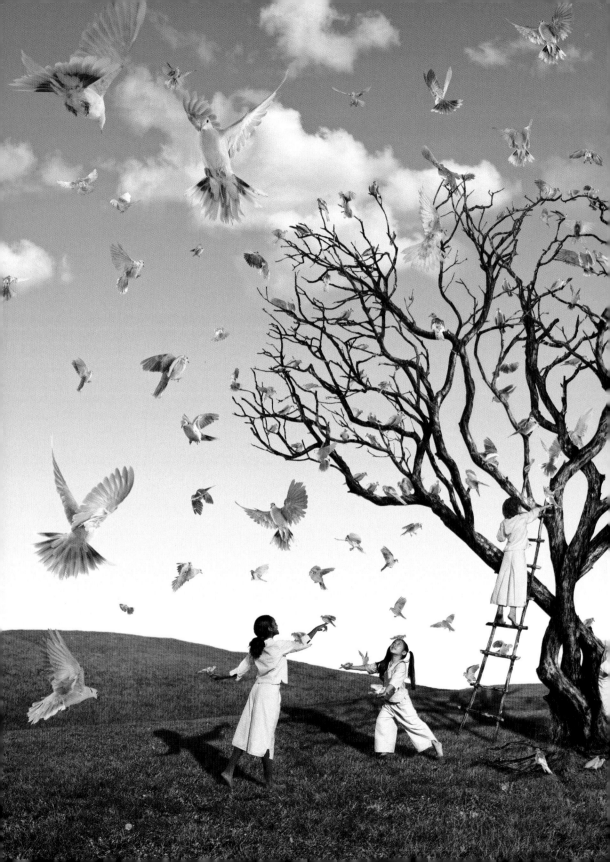

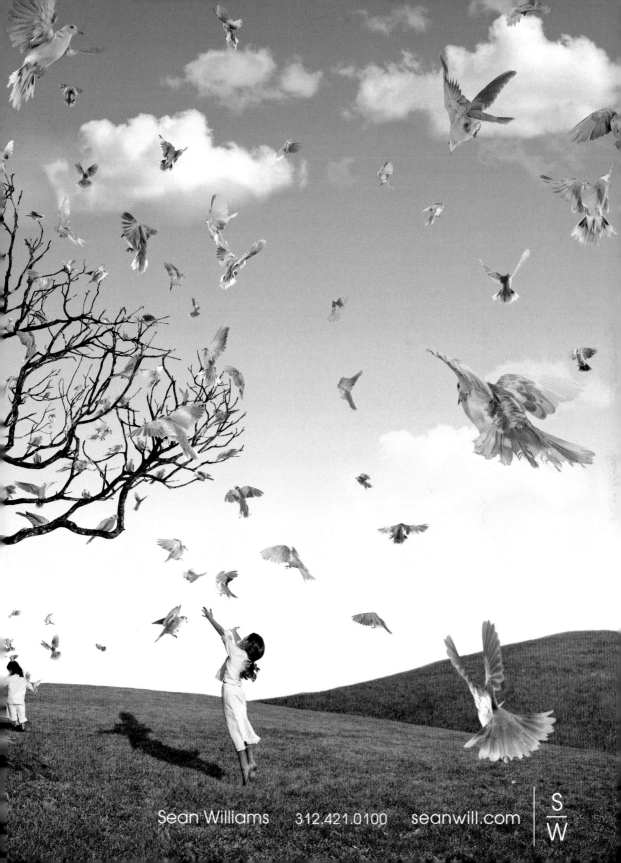

Sean Williams 312.421.0100 seanwill.com S/W

MICHAELVO

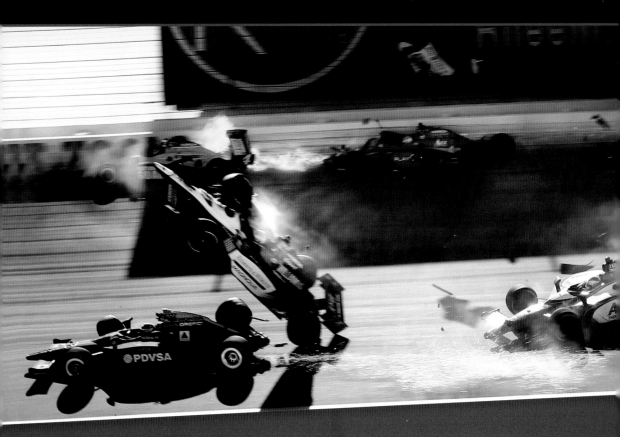

To view the entire 52 frame sequence, visit michaelvoorhees.com,
go to Client Access and enter the password v3_workbook

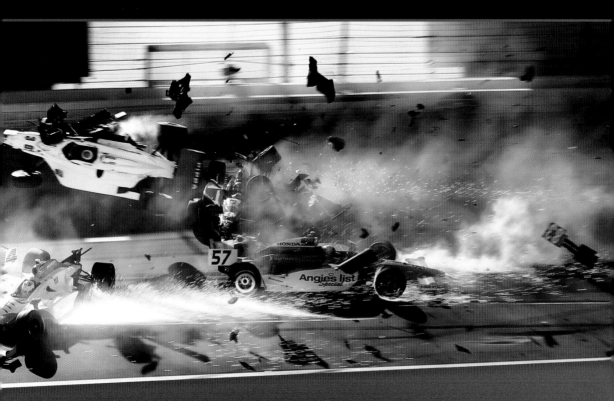

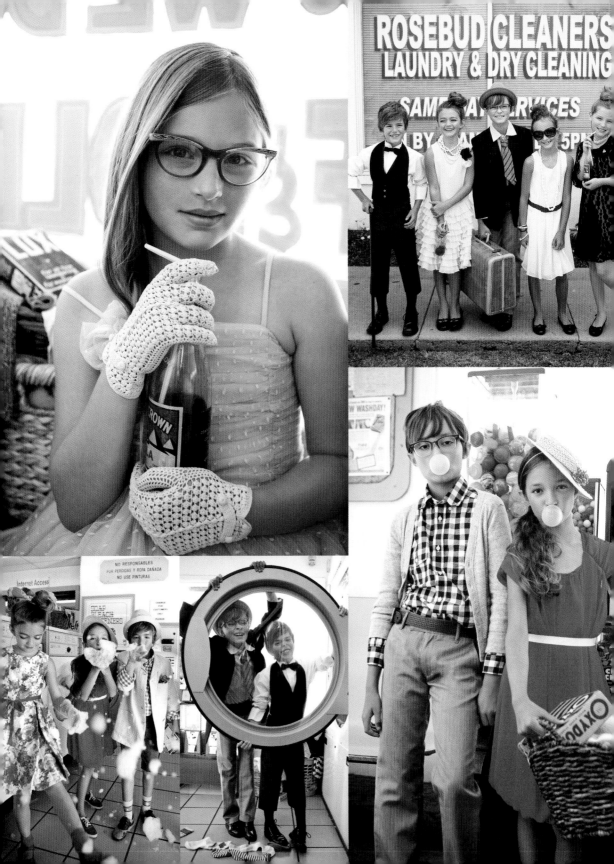

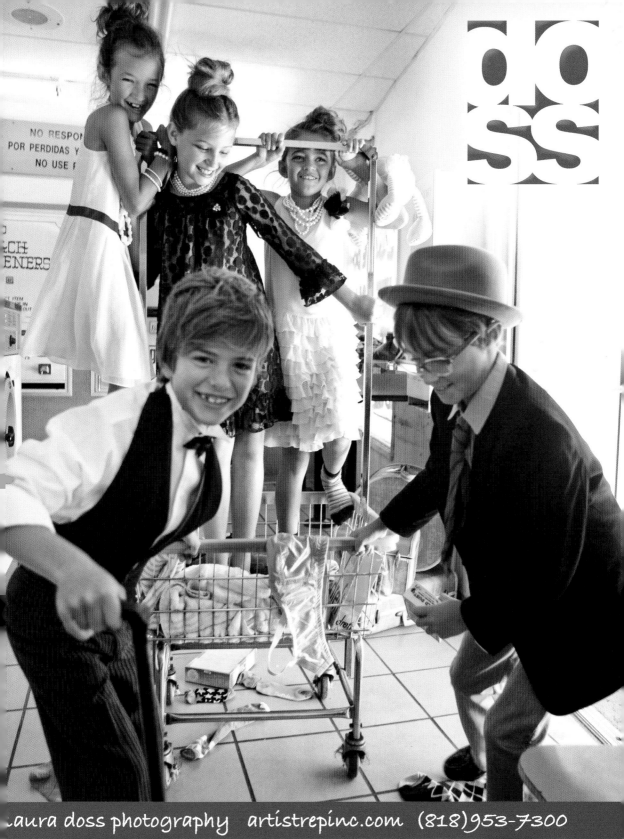

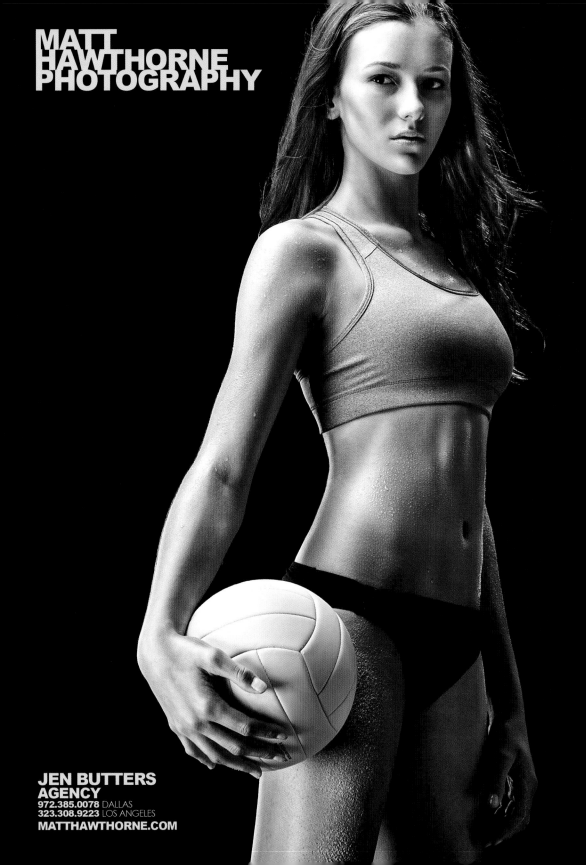

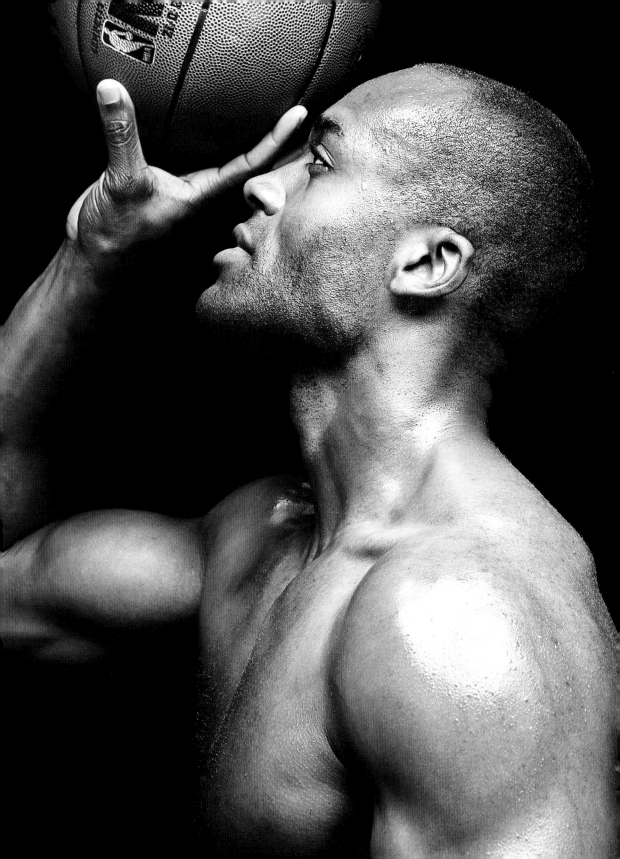

TONY GARCIA

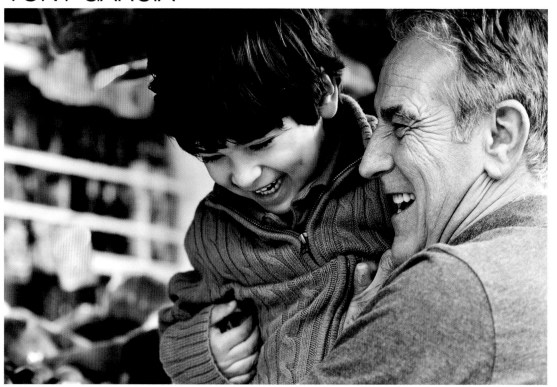

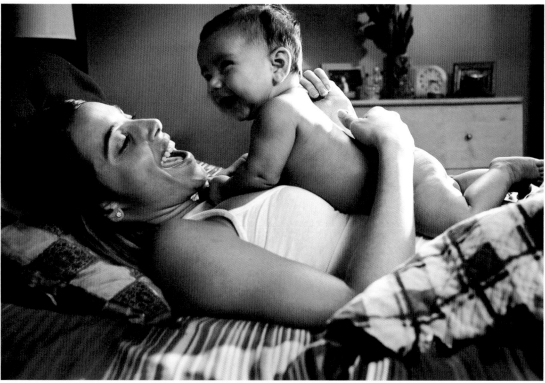

JenButters agency 972.385.0078 DALLAS
323.308.9223 LOS ANGELES

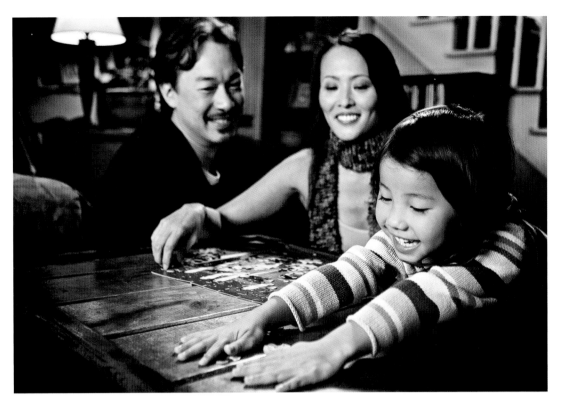

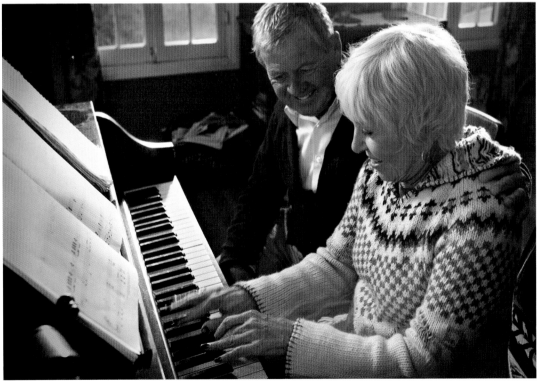

tonygarcia.com
323.463.8260

lifestyle. location. lucha libre.

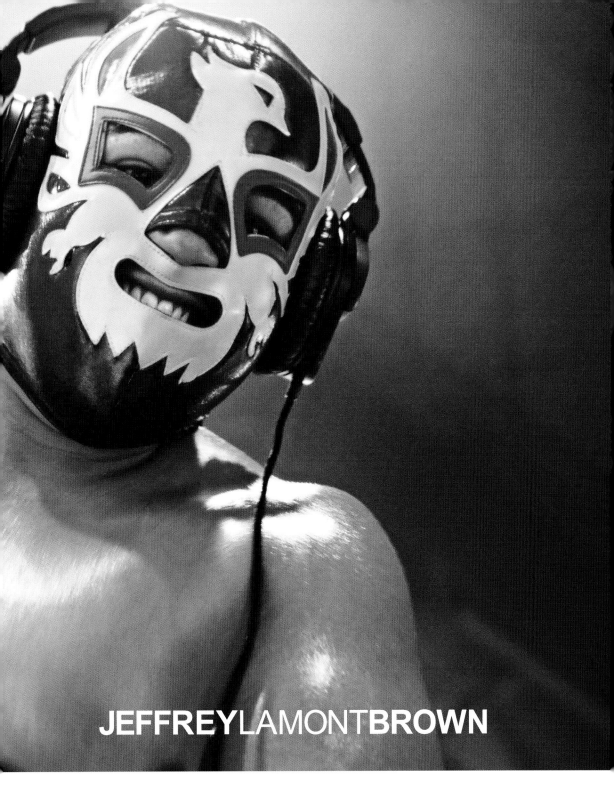

JEFFREYLAMONT**BROWN**

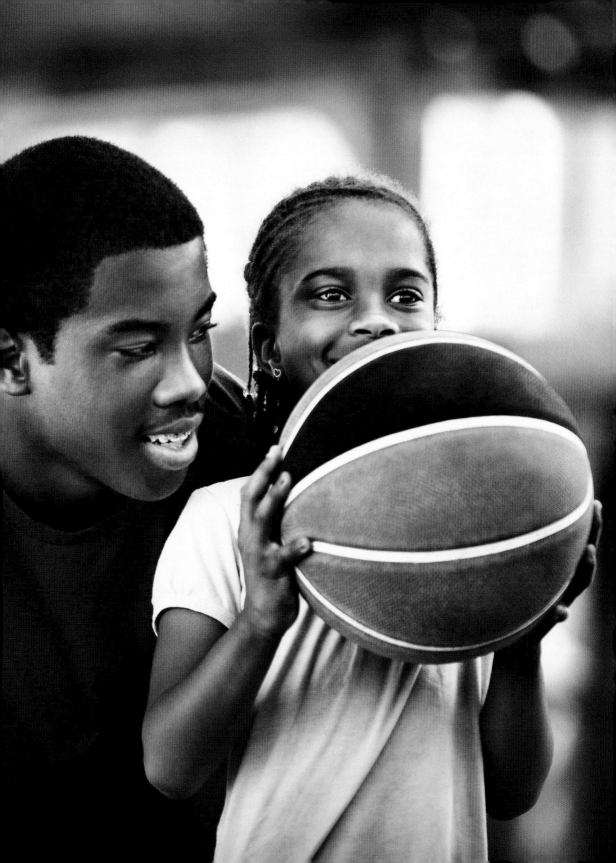

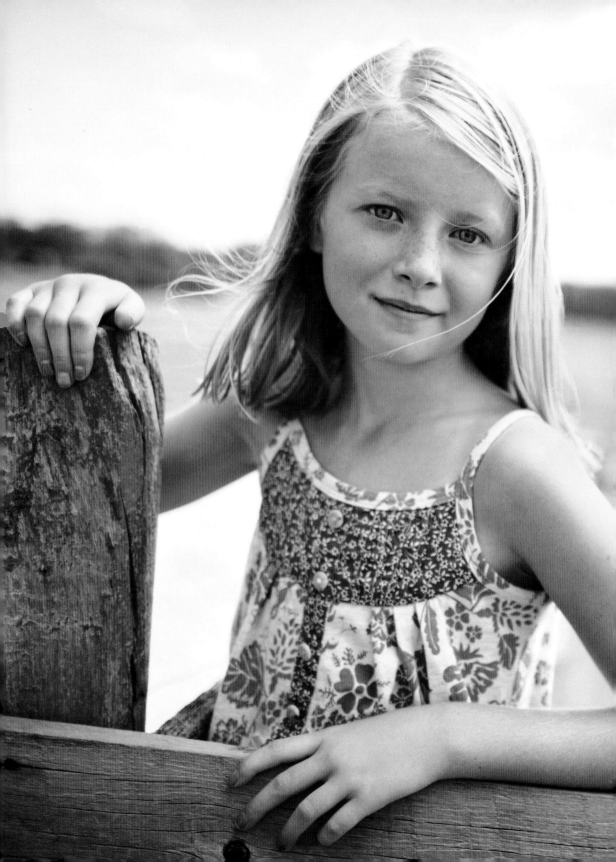

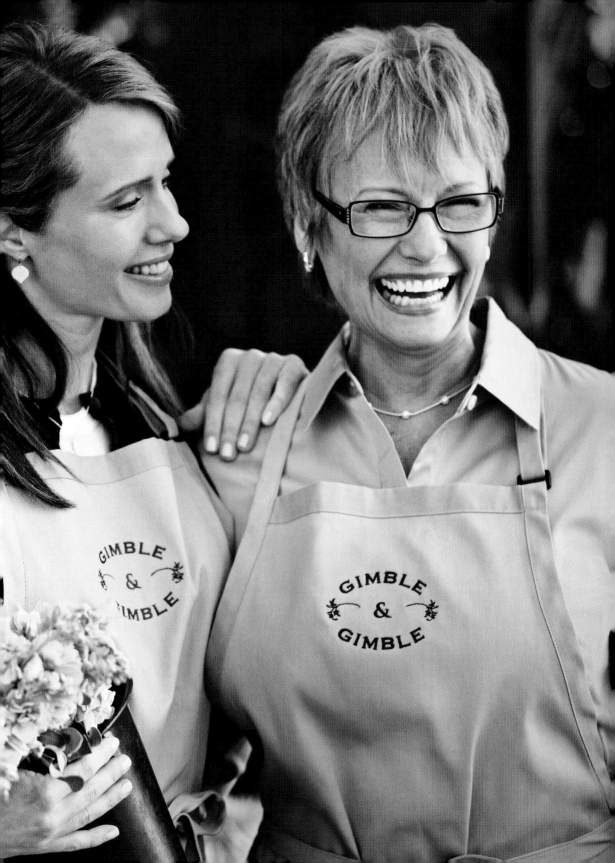

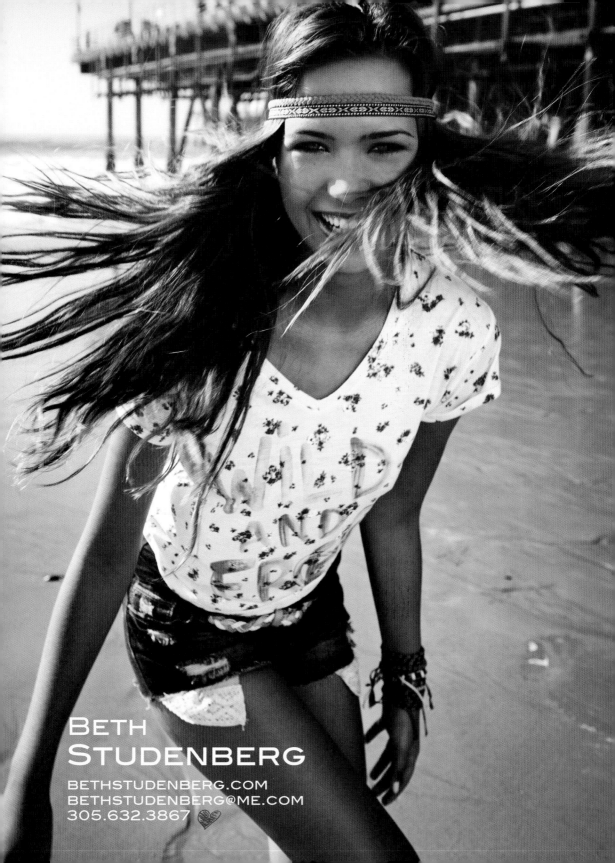

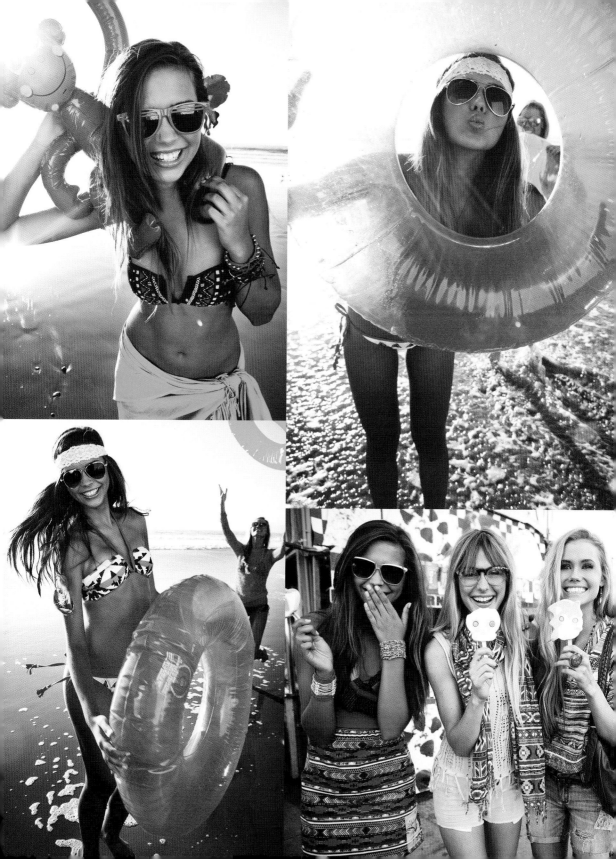

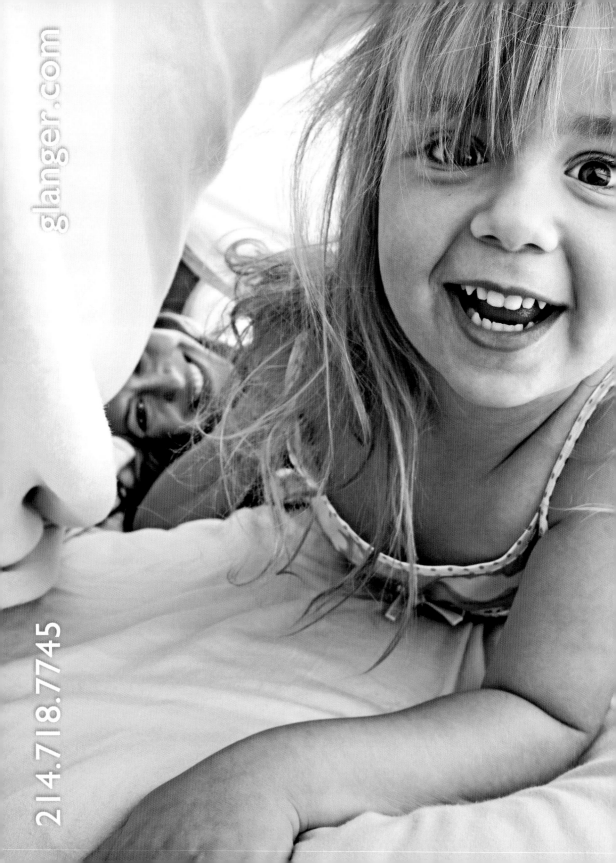

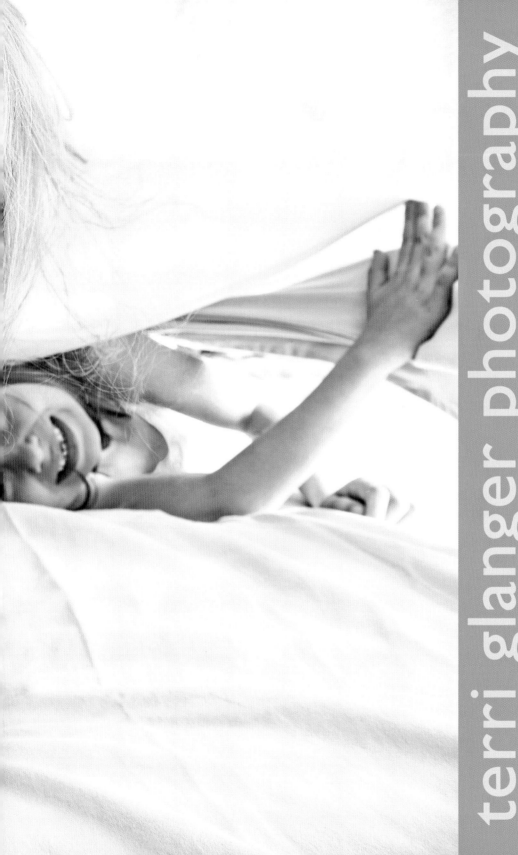

zero2sixty
creative.com

508 533 4600
hello@zero2sixtycreative.com

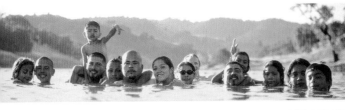

TOM
HOOD

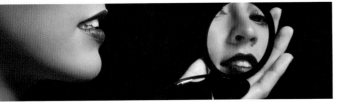

ANDREAS
KUEHN

JARED
LEEDS

BOB
PACKERT

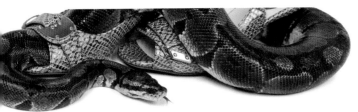

SHARON
WHITE

zero2sixty
creative.com

TOM
HOOD
HOODISGOOD.COM

508 533 4600
hello@zero2sixtycreative.com

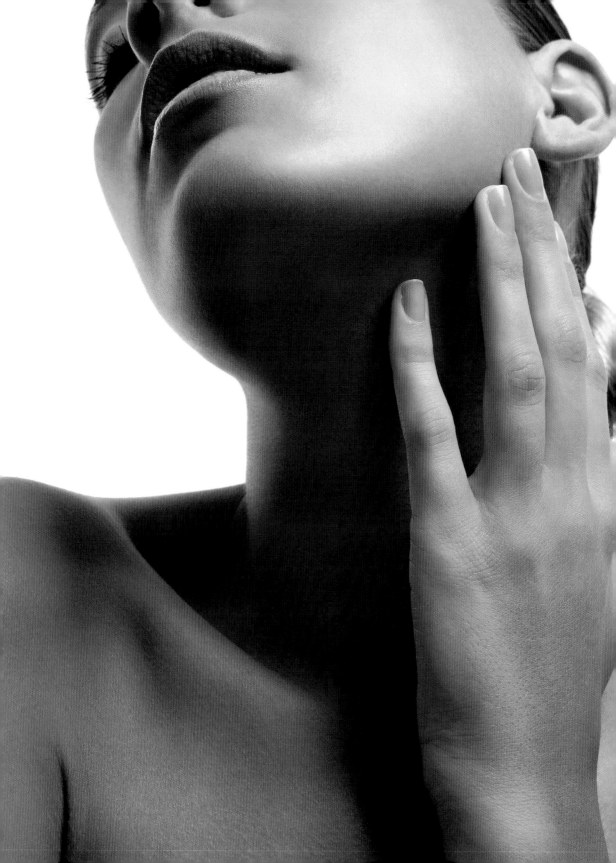

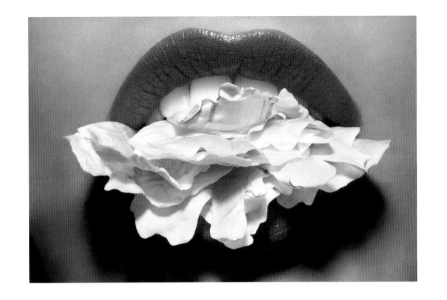

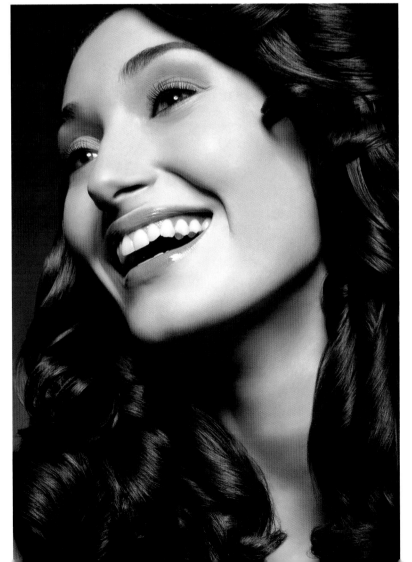

ANDREAS
KUEHN
ANDREASKUEHN.COM

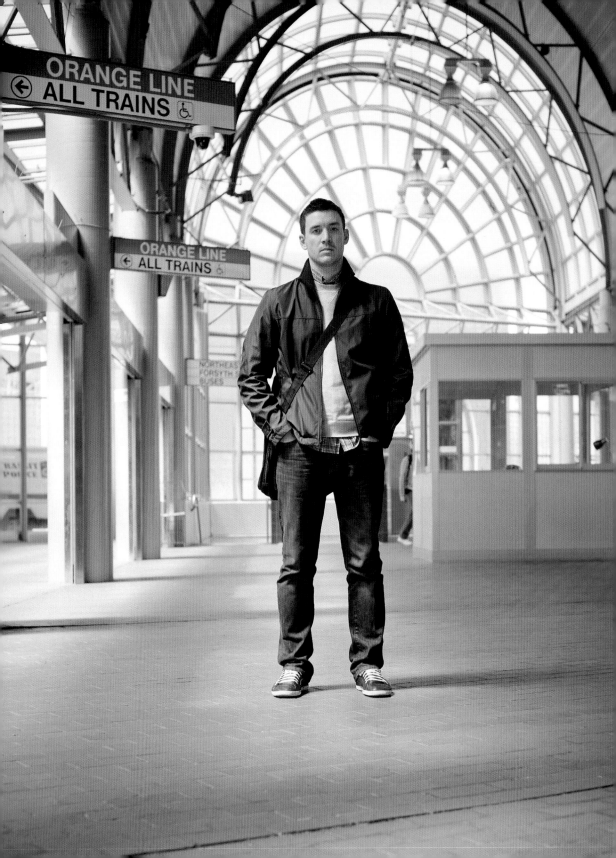

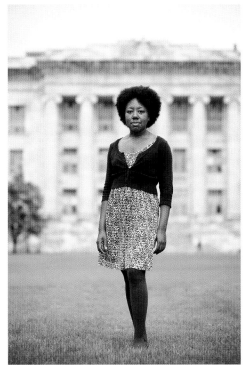

zero2sixty
creative.com

JARED
LEEDS
JAREDLEEDS.COM

508 533 4600
hello@zero2sixtycreative.com

363

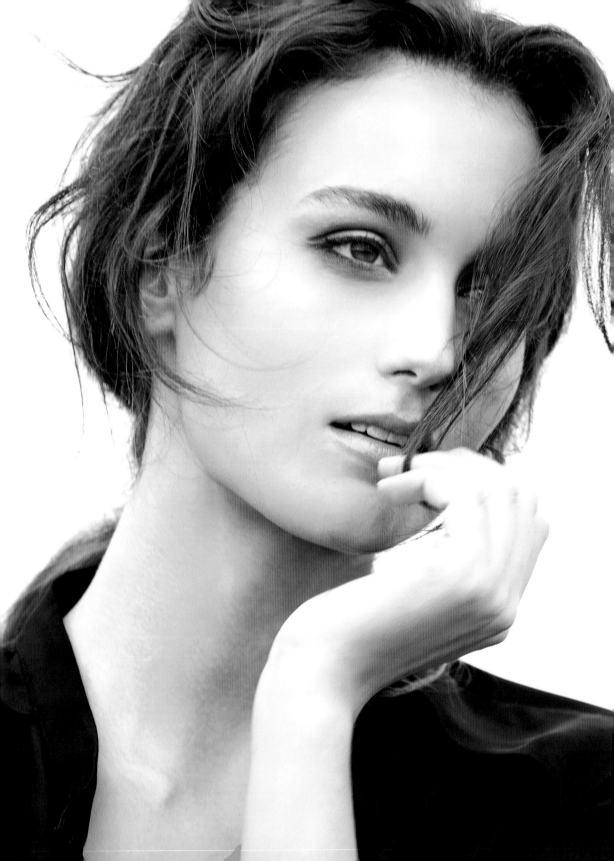

BOB
PACKERT
BOBPACKERT.COM

508 533 4600
hello@zero2sixtycreative.com

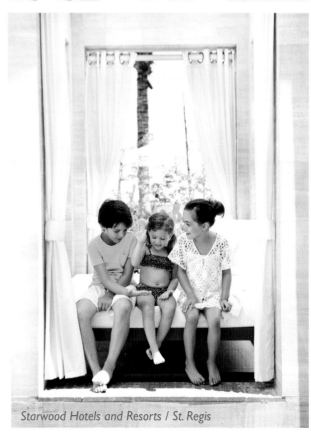

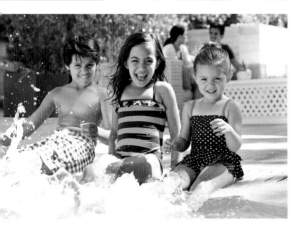

Starwood Hotels and Resorts / St. Regis

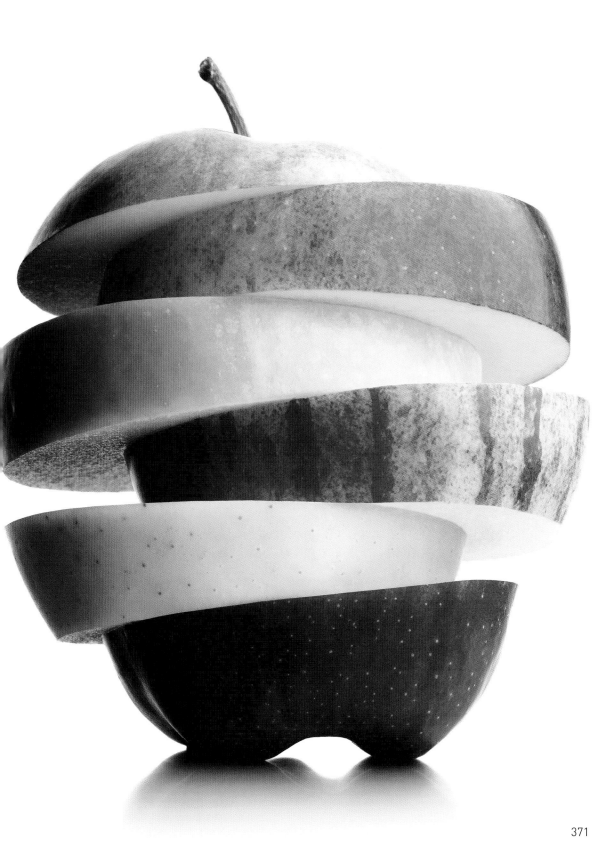

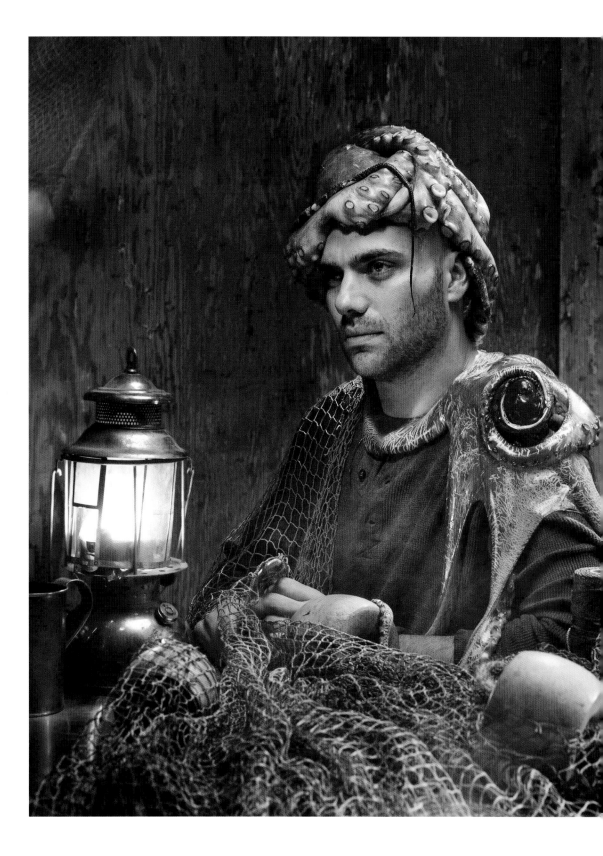

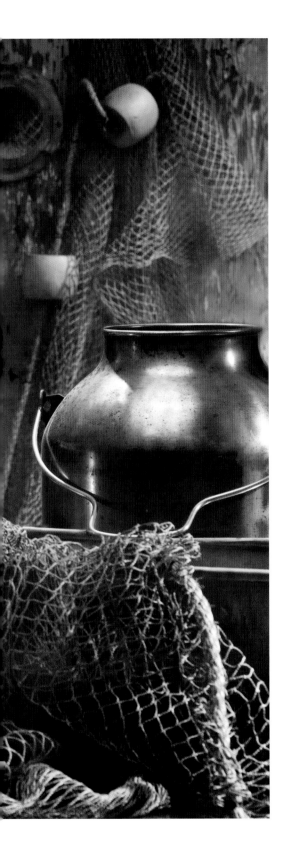

SCIORTINO

Jeff Sciortino Photography
764 N. Milwaukee Ave.
Chicago, IL 60622
312.829.6112
www.jeffsciortino.com

Represented by: Jodie Zeitler
312.467.9220
www.jodiezeitler.com

SCIORTINO

Jeff Sciortino Photography
764 N. Milwaukee Ave.
Chicago, IL 60622
312.829.6112
www.jeffsciortino.com

Represented by: Jodie Zeitler
312.467.9220
www.jodiezeitler.com

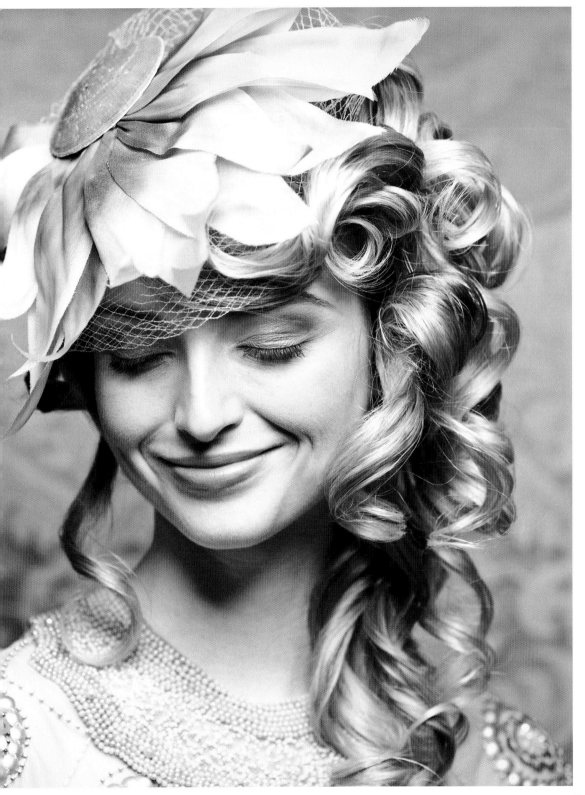

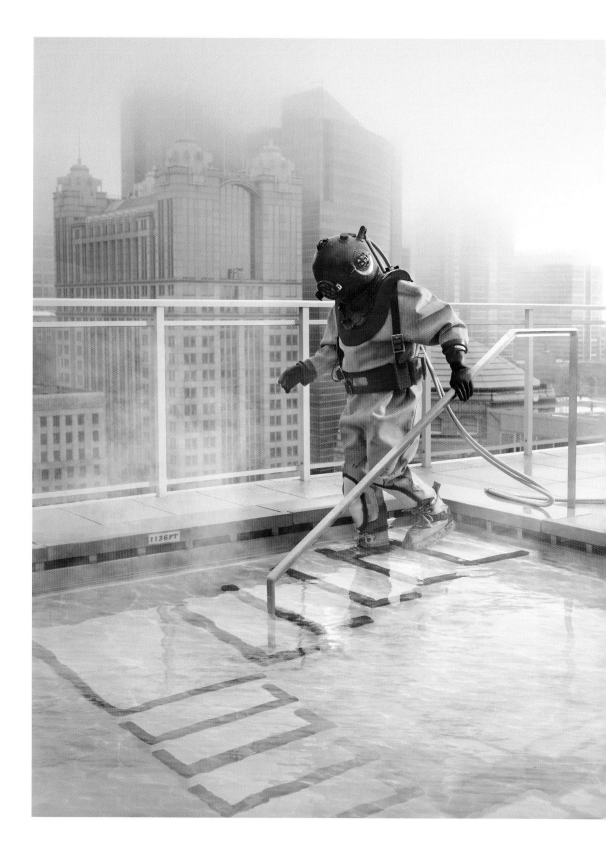

SCIORTINO

Jeff Sciortino Photography
764 N. Milwaukee Ave.
Chicago, IL 60622
312.829.6112
www.jeffsciortino.com

Represented by: Jodie Zeitler
312.467.9220
www.jodiezeitler.com

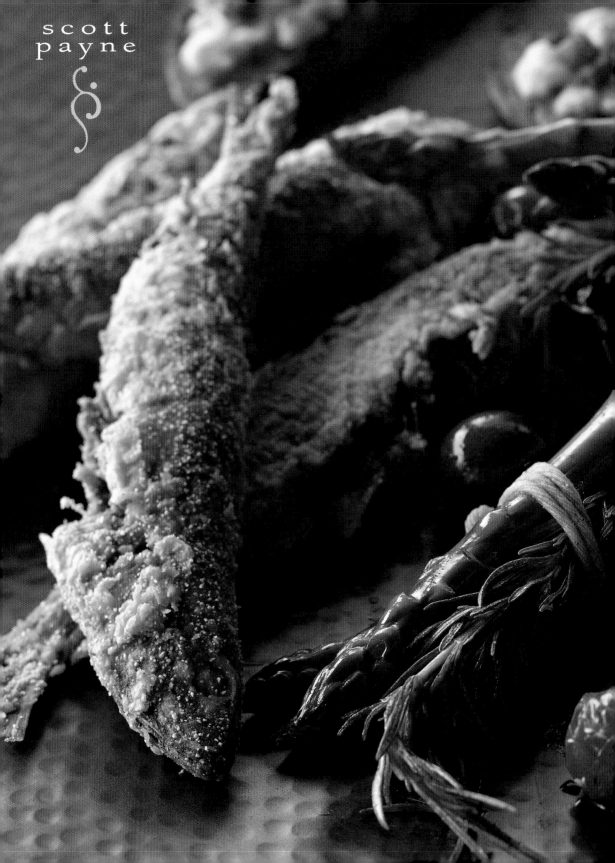

scott
payne

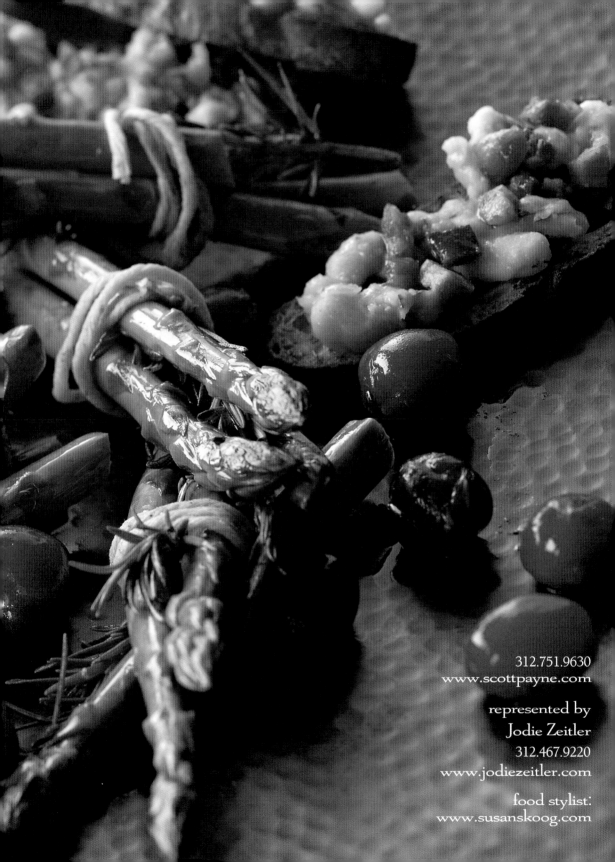

312.751.9630
www.scottpayne.com

represented by
Jodie Zeitler
312.467.9220
www.jodiezeitler.com

food stylist:
www.susanskoog.com

colin mcguire photographs

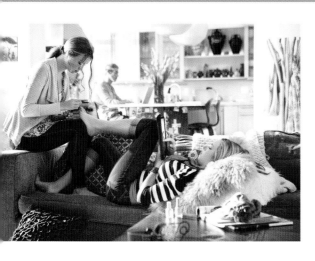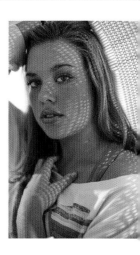

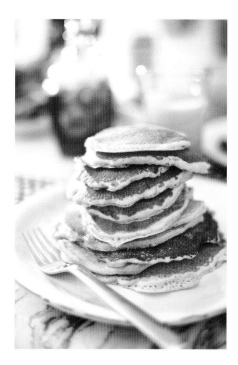

www.colinmcguire.com

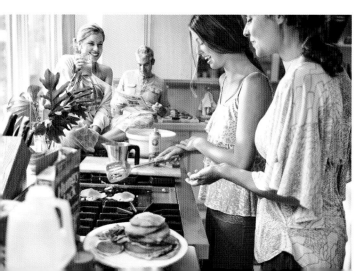

t 614.975.0025

e info@colinmcguire.com

Represented by Jodie Zeitler
312.467.9220
jodie@jodiezeitler.com

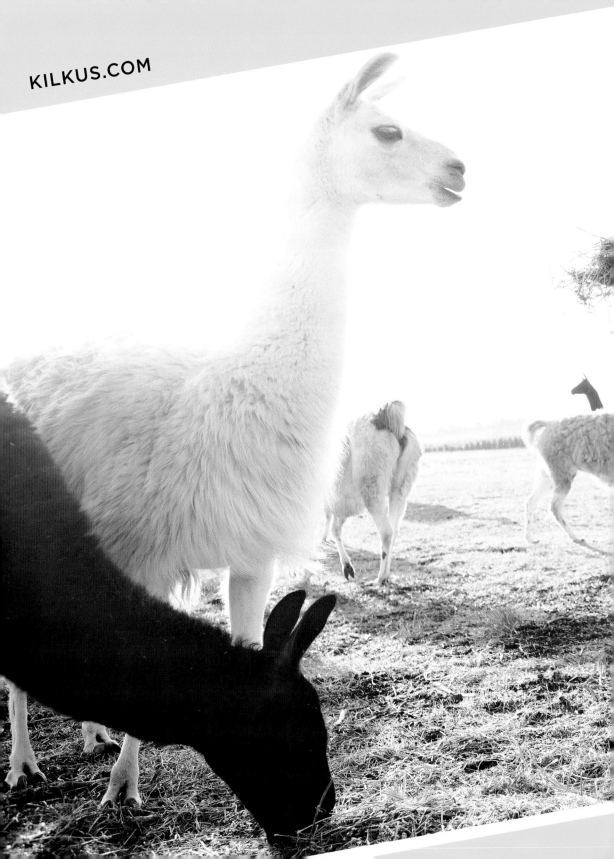

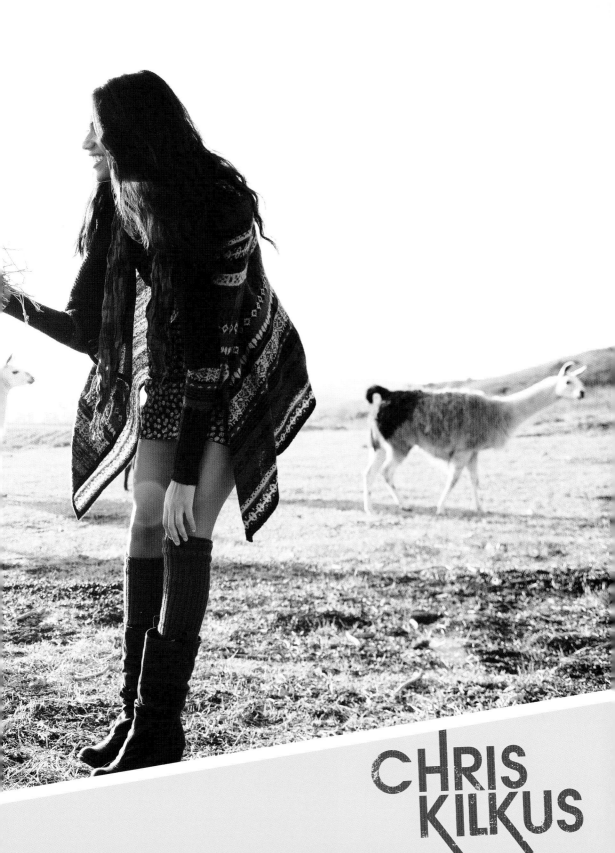

clor

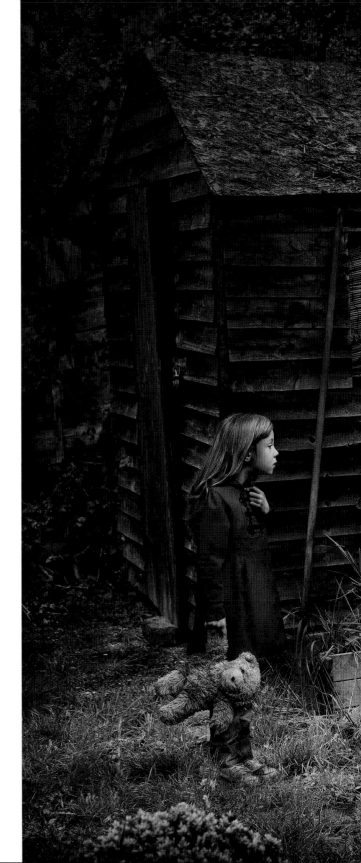

Dovis-Bird Agency
info@dovisbird.com
P 646.652.9118

www.clorimages.com

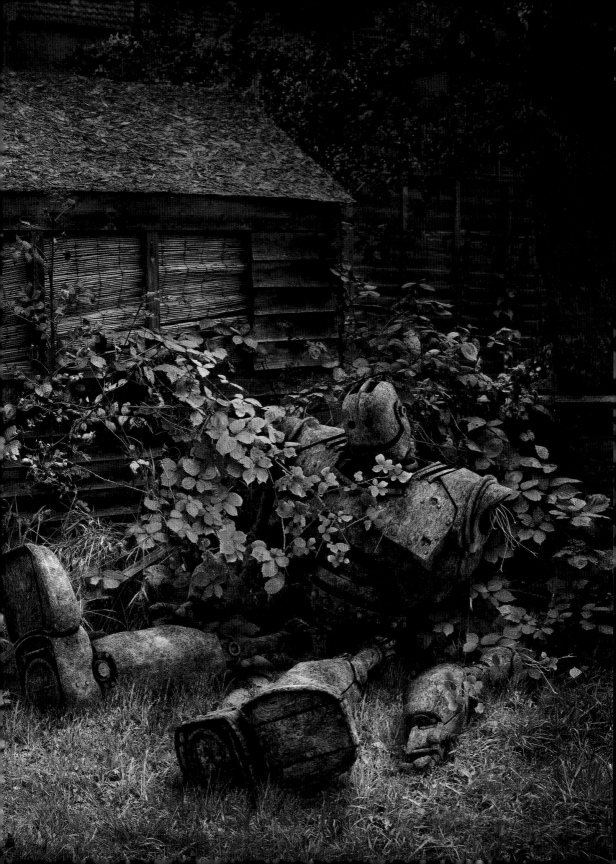

 Norman Maslov Agent Internationale 415 641-4376 maslov.com micheleclement.com

micheleclement.com Norman Maslov Agent Internationale 415 641-4376 maslov.com

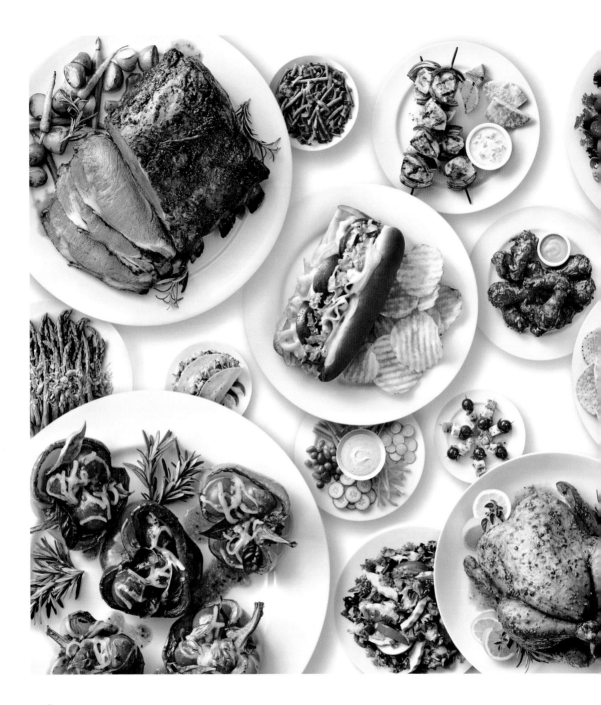

Norman Maslov Agent Internationale 415 641-4376 maslov.com suetallon.com

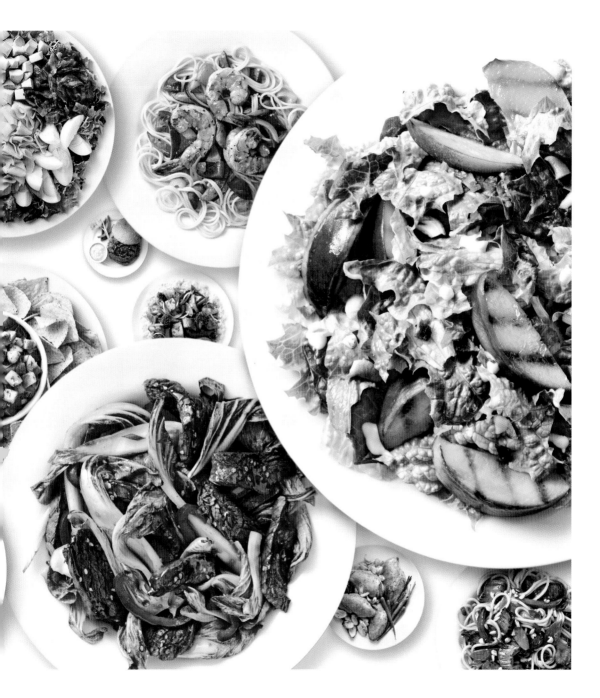

suetallon.com Norman Maslov Agent Internationale 415 641-4376 maslov.com

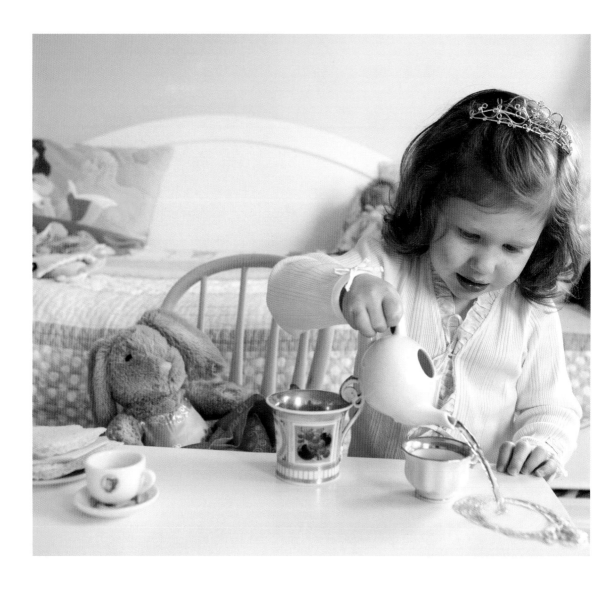

Norman Maslov Agent Internationale 415 641-4376 maslov.com emilymerrill.com

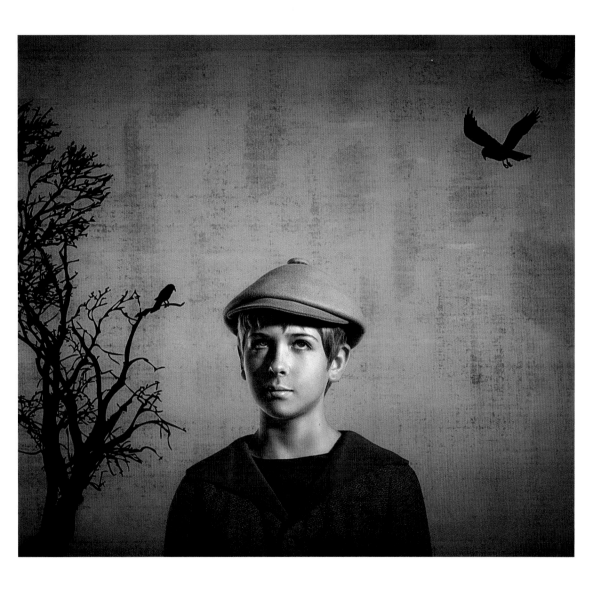

cristianaceppas.com Norman Maslov Agent Internationale 415 641-4376 maslov.com

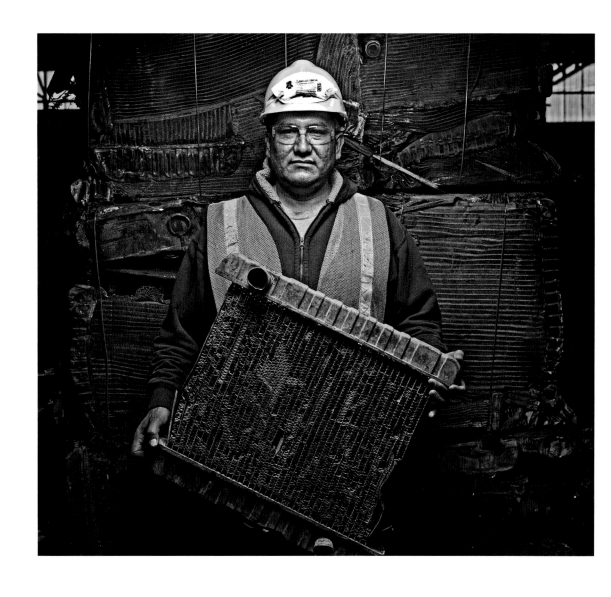

Lisa Button 312 399-2522 Mid & Southwest buttonrepresents.com

Norman Maslov Agent Internationale 415 641-4376 maslov.com haroldleemiller.com

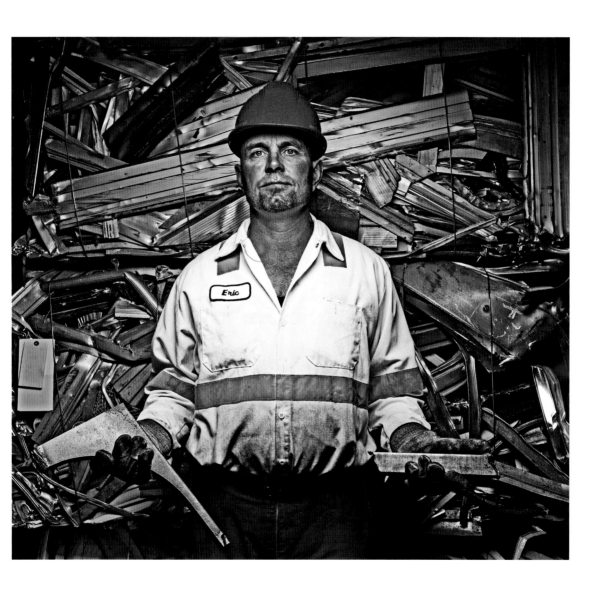

Lisa Button 312 399-2522 Mid & Southwest buttonrepresents.com

haroldleemiller.com Norman Maslov Agent Internationale 415 641-4376 maslov.com

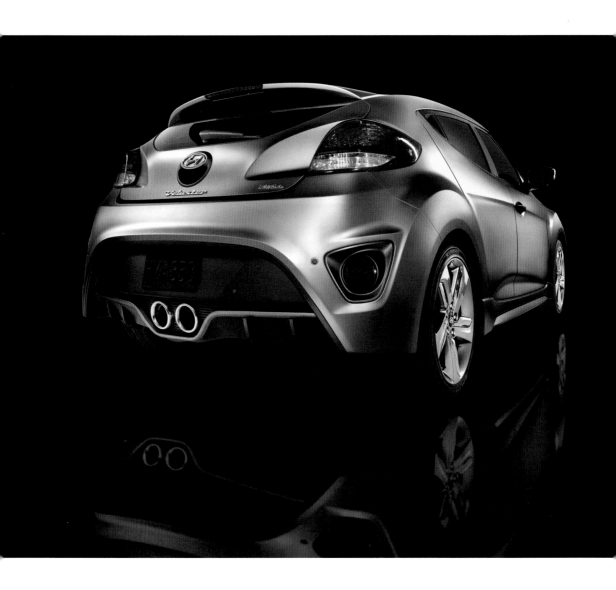

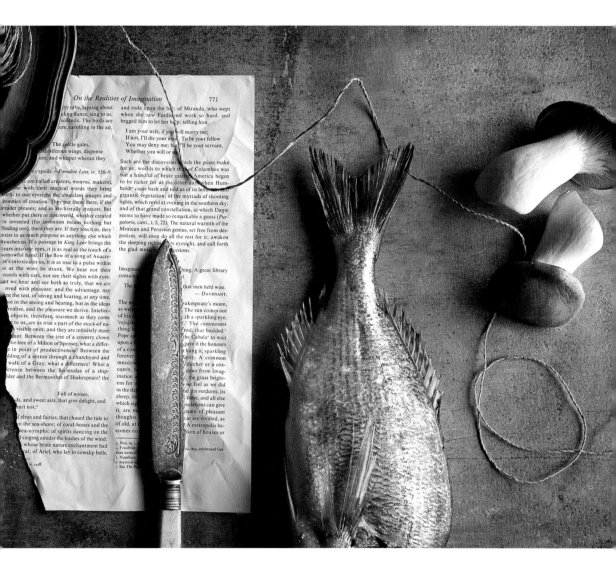

DAVID ALLAN BRANDT

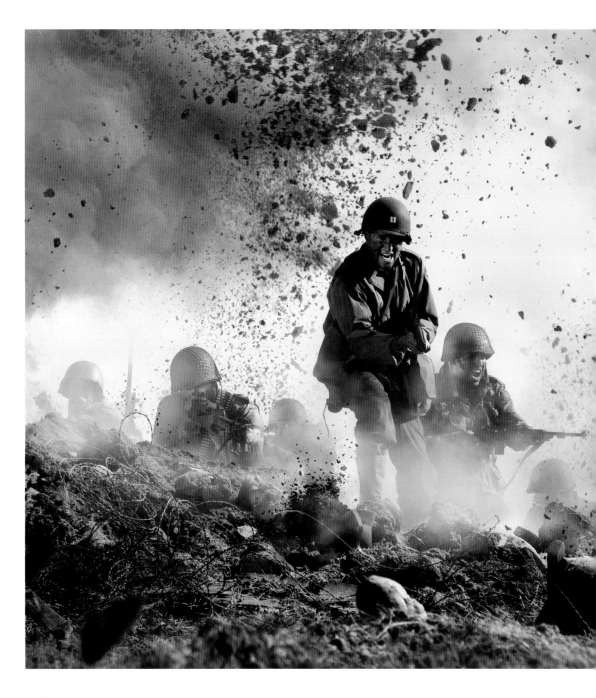

 Norman Maslov Agent Internationale 415 641-4376 maslov.com davidallanbrandt.com

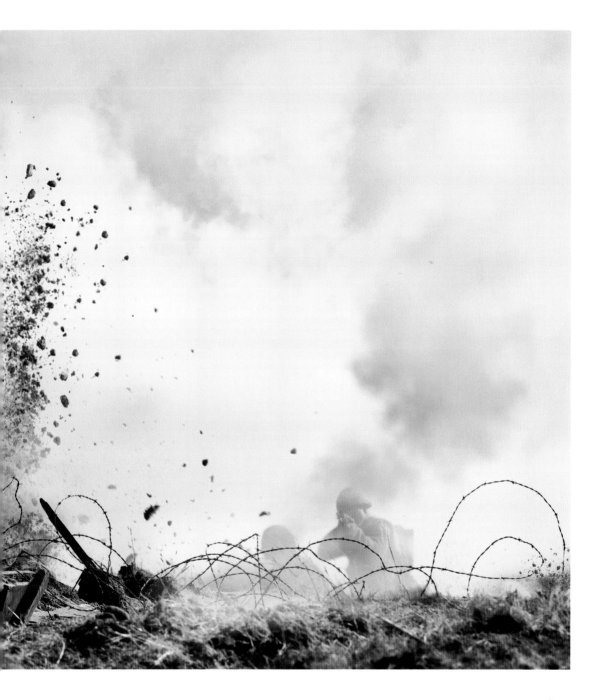

davidallanbrandt.com Norman Maslov Agent Internationale 415 641-4376 maslov.com

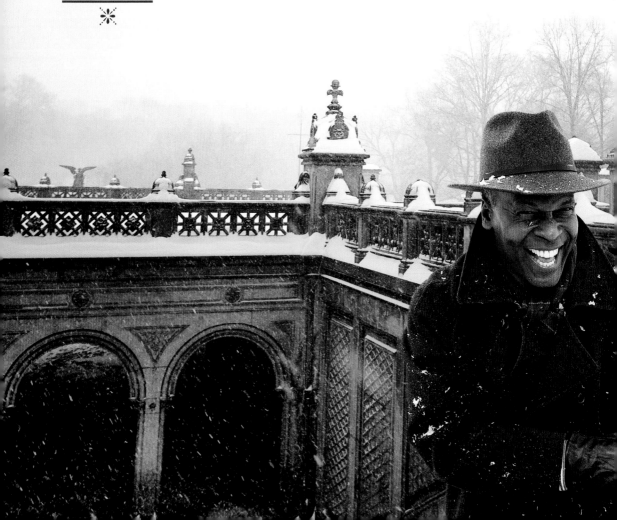

SCOTT
MONTGOMERY
Photography
SMONTGOMERY
·COM·

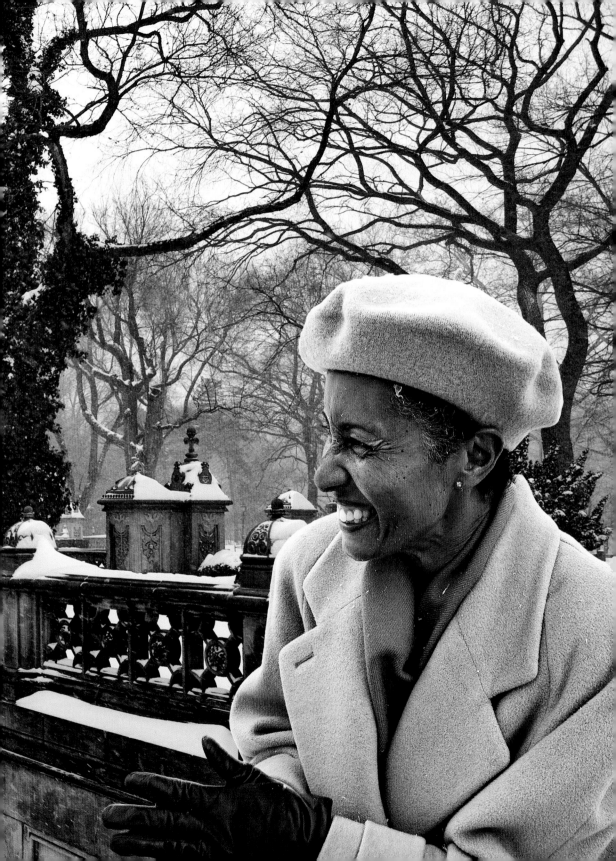

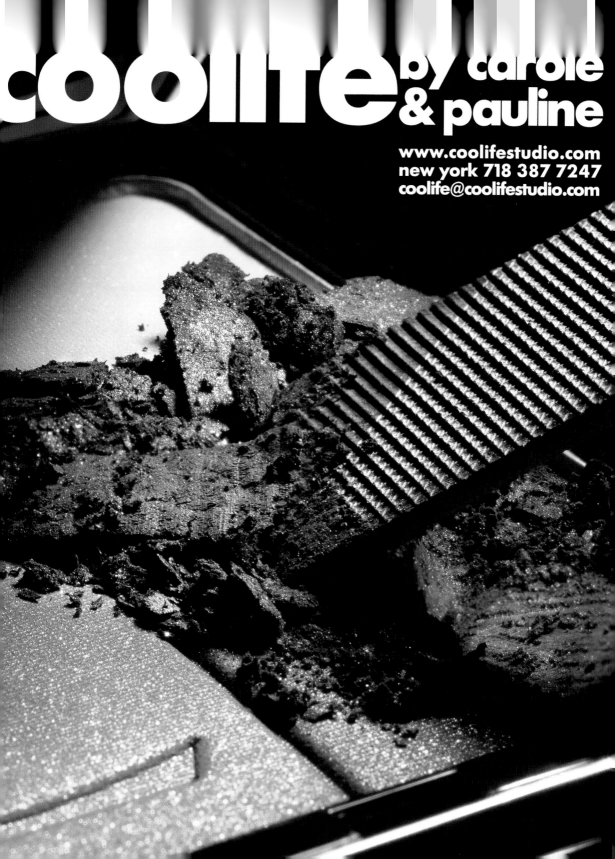

coolife by carole & pauline

www.coolifestudio.com
new york 718 387 7247
coolife@coolifestudio.com

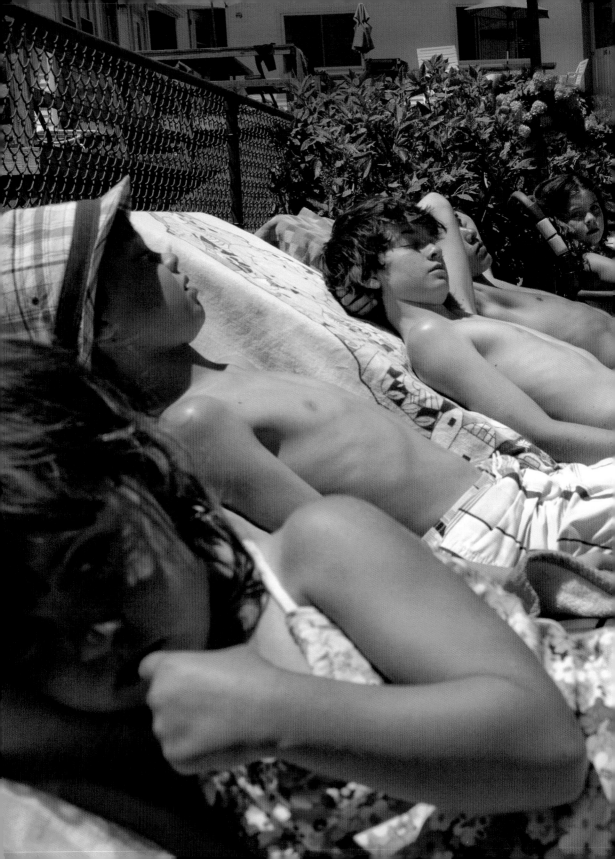

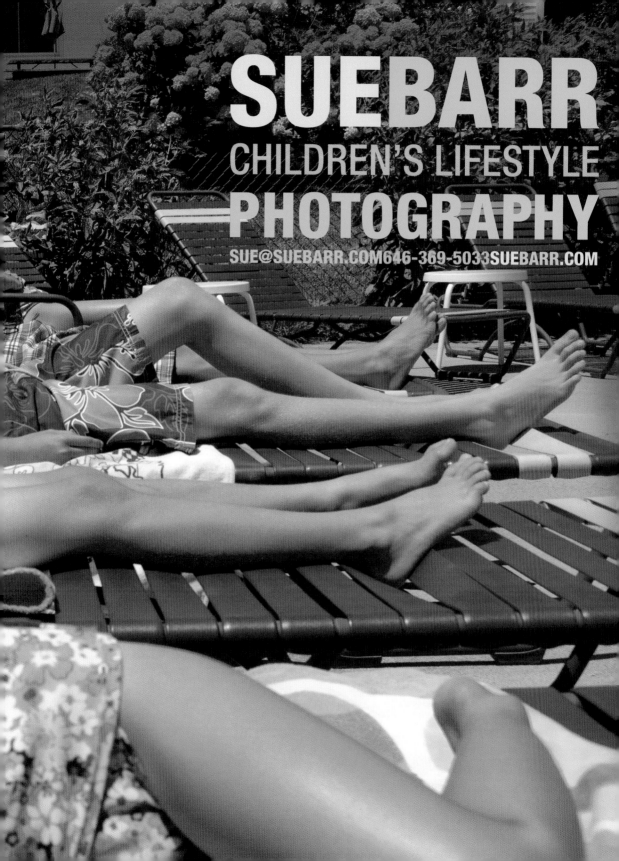

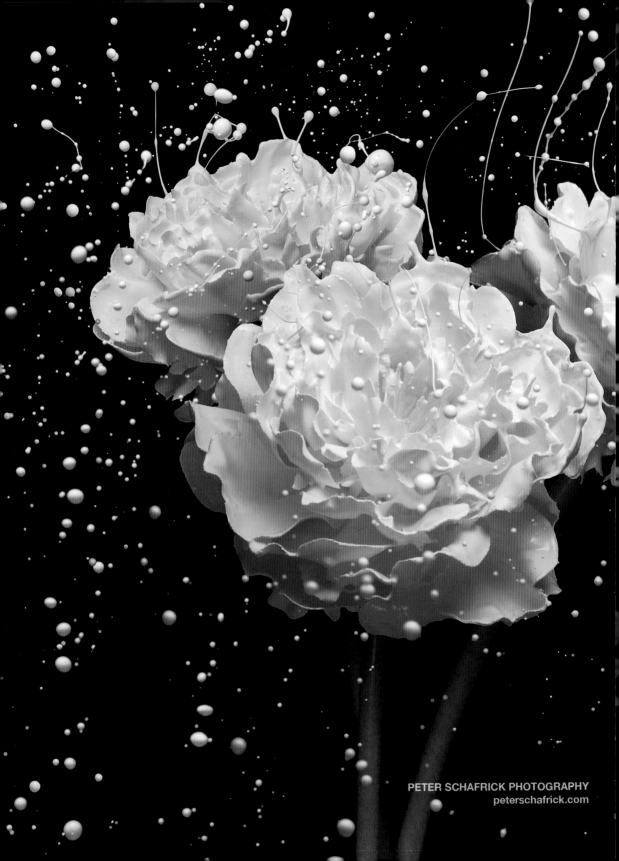

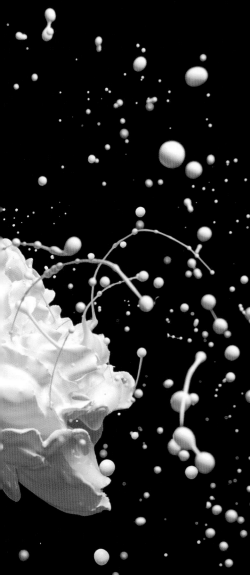

schafrick

U.S.A	CANADA	EUROPE			
ray brown	REP	arlene evidente	REP	bogna brock	REP
+1 212 243 5057	+1 416 823 1713	+49 (0) 211 325 780			

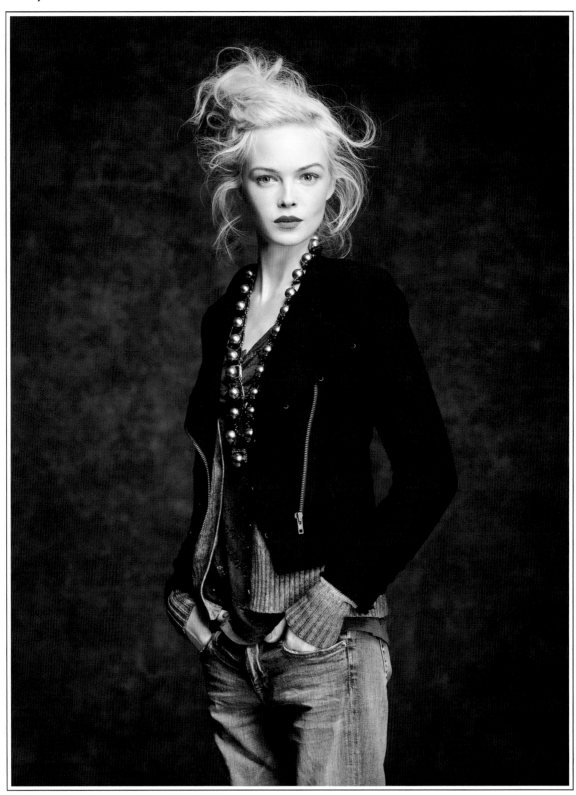

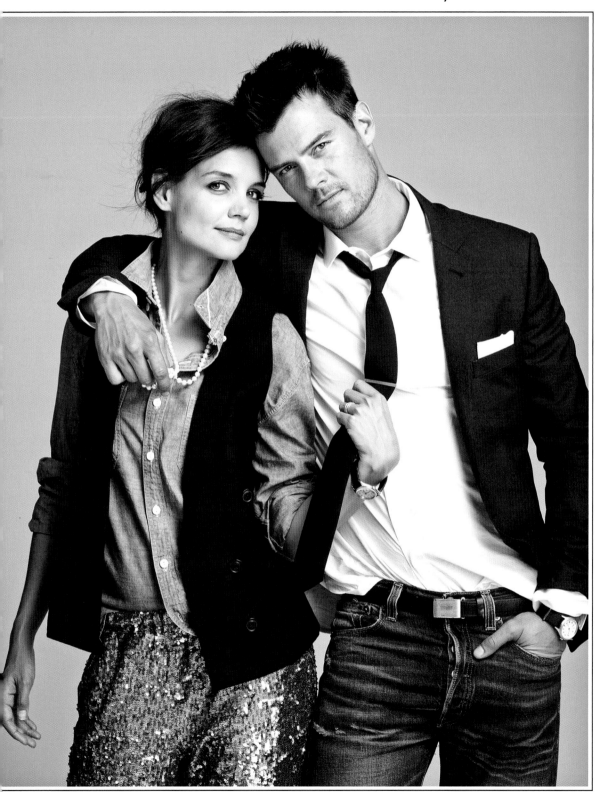

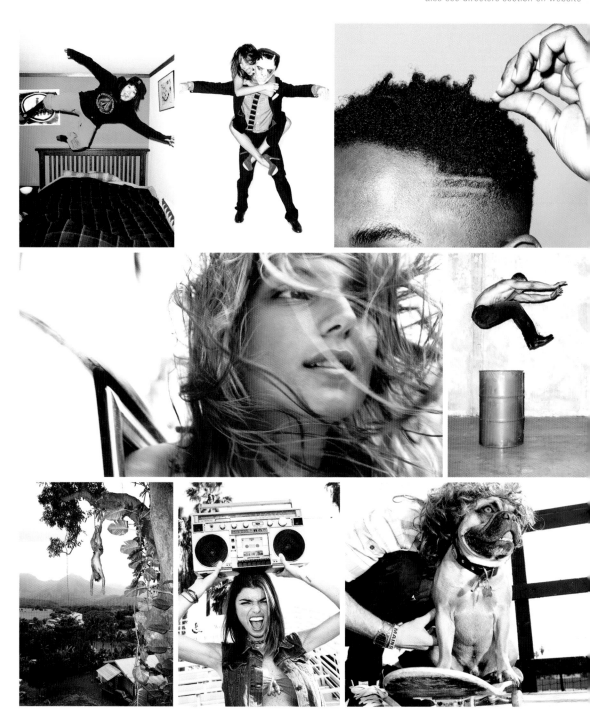

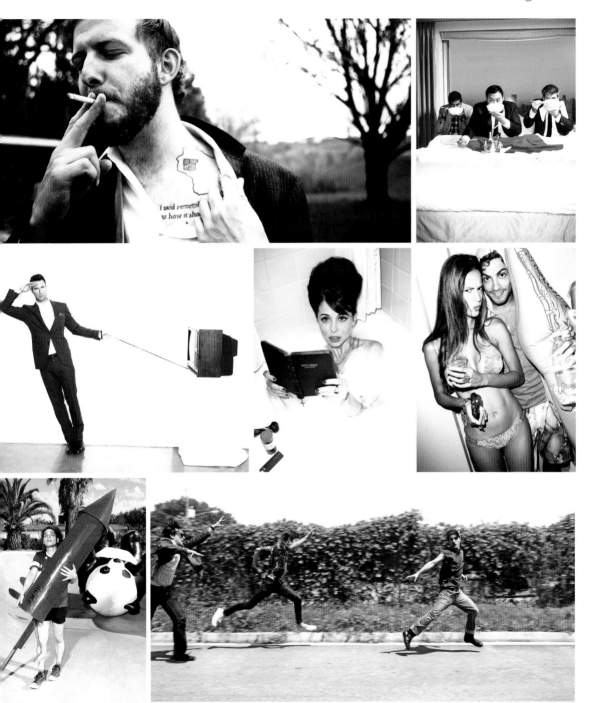

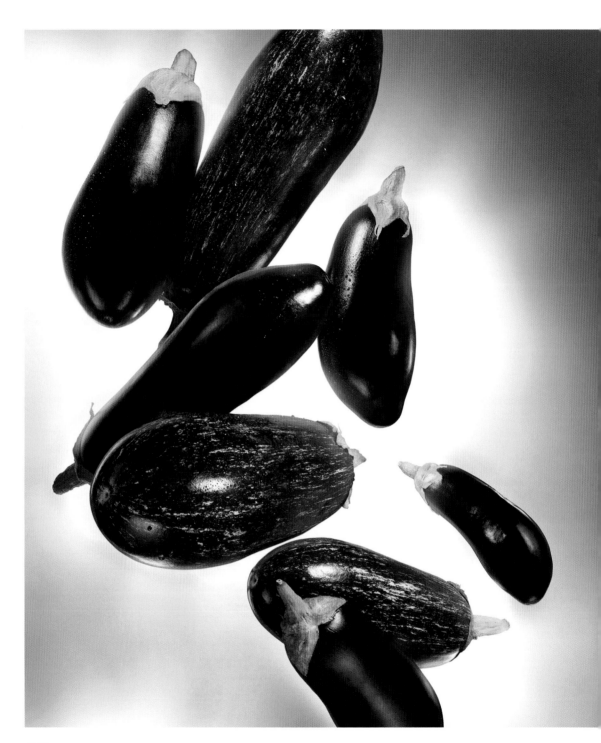

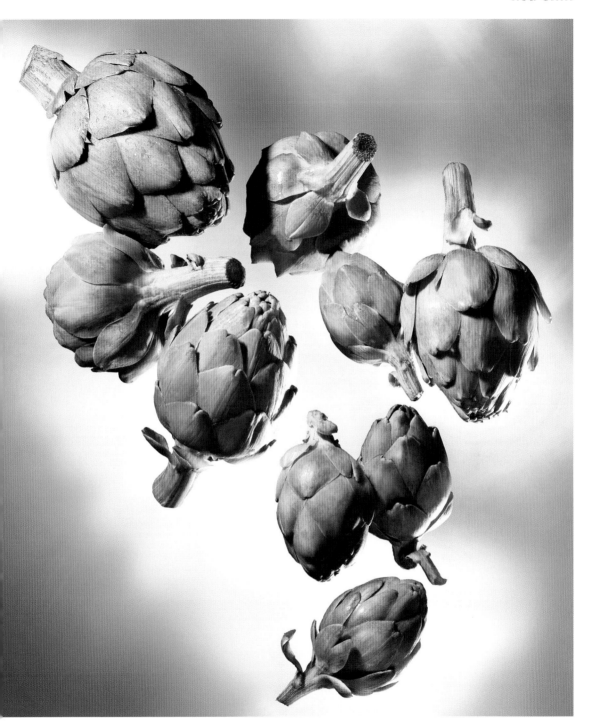

also see directors section on website ▶

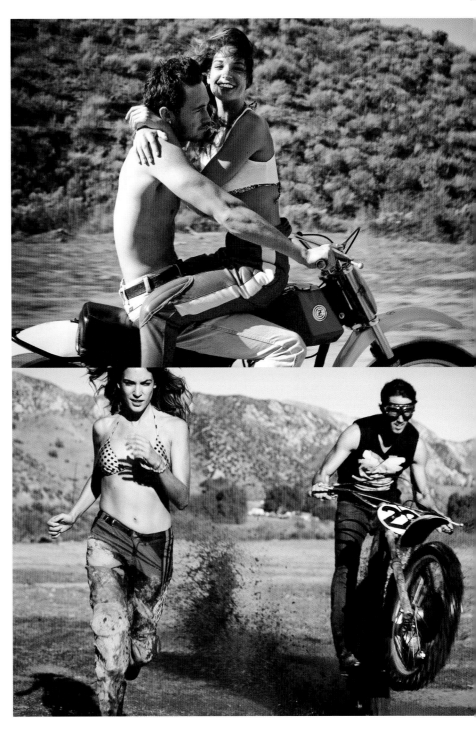

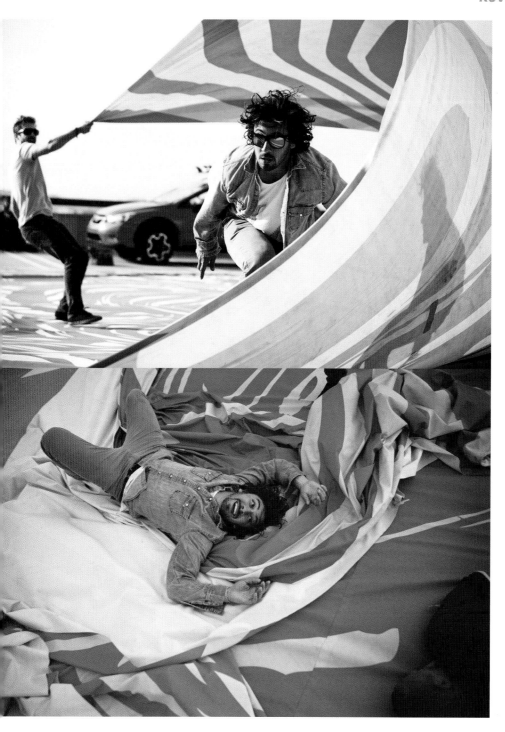

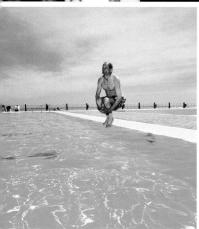

AH 212.431.5117 **www.andersonhopkins.com** blog.andersonhopkins.com

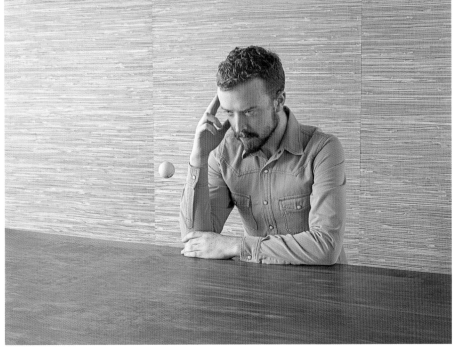

also see directors section on website

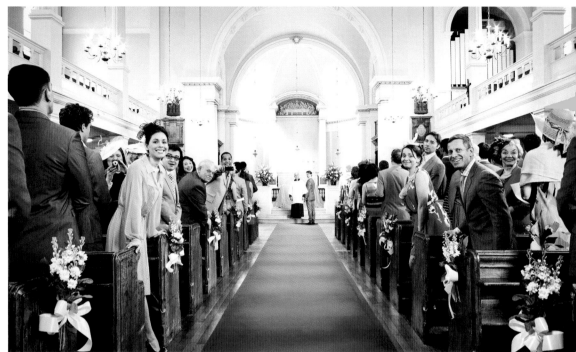

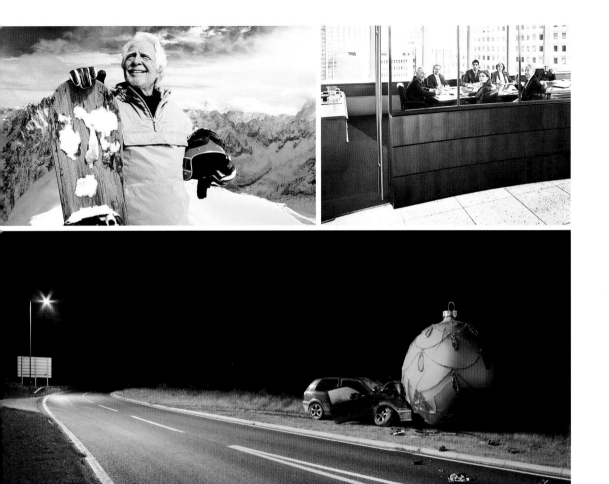

LESS IS *More* MORE OR LESS.

FIAT
500
Simply More

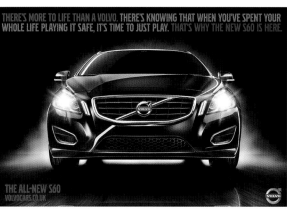

THERE'S MORE TO LIFE THAN A VOLVO. THERE'S KNOWING THAT WHEN YOU'VE SPENT YOUR WHOLE LIFE PLAYING IT SAFE, IT'S TIME TO JUST PLAY. THAT'S WHY THE NEW S60 IS HERE.

THE ALL-NEW S60
VOLVOCARS.CO.UK

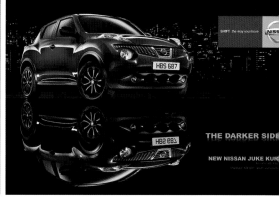

SHIFT the way you move

NISS

HBS 687

THE DARKER SIDE

NEW NISSAN JUKE KUR

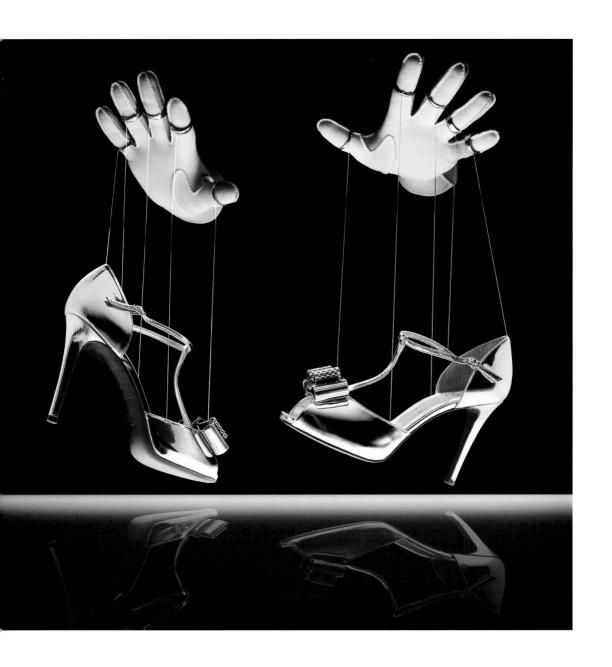

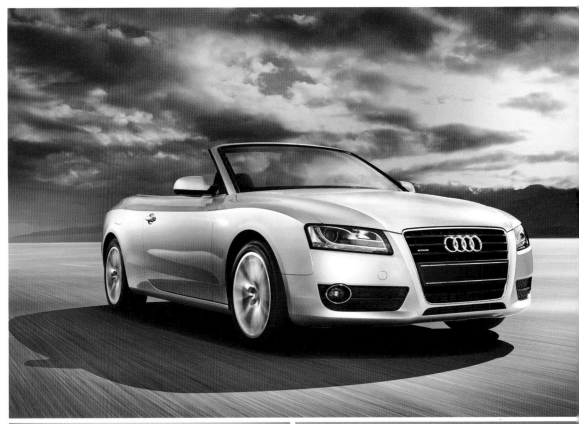

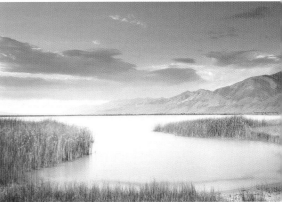

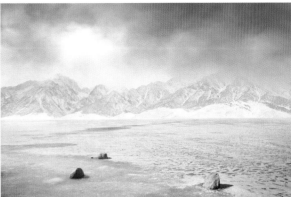
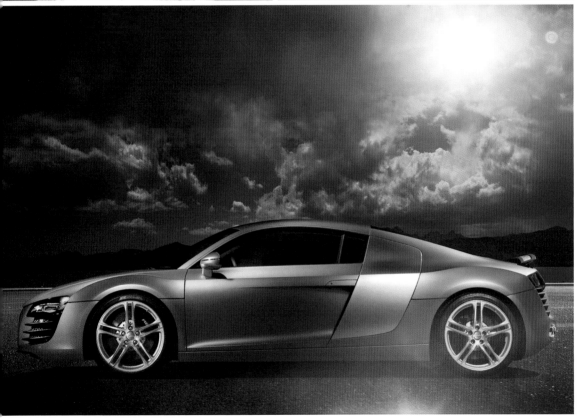

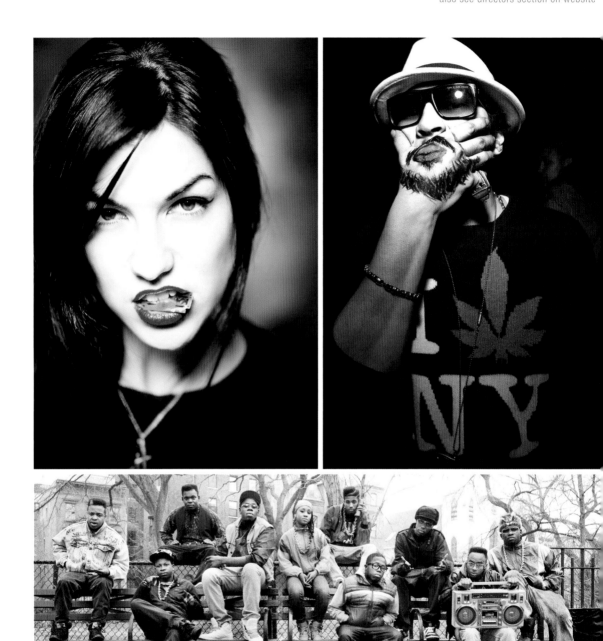

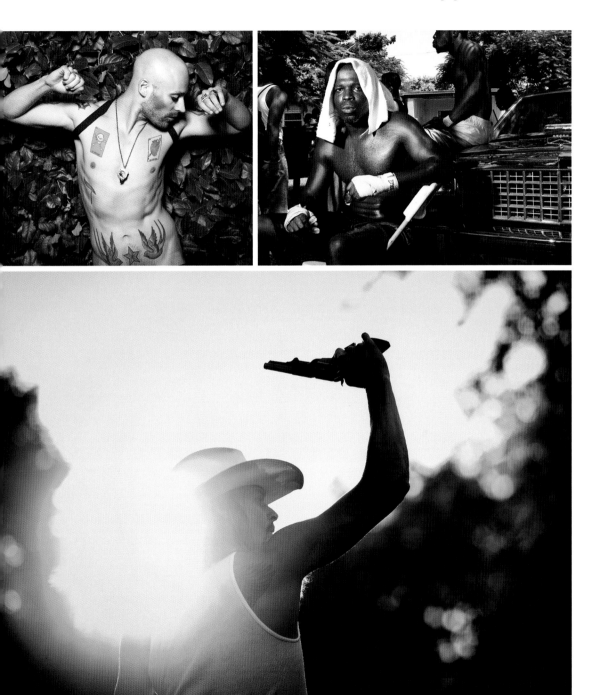

artists represented by **ANDERSON HOPKINS**

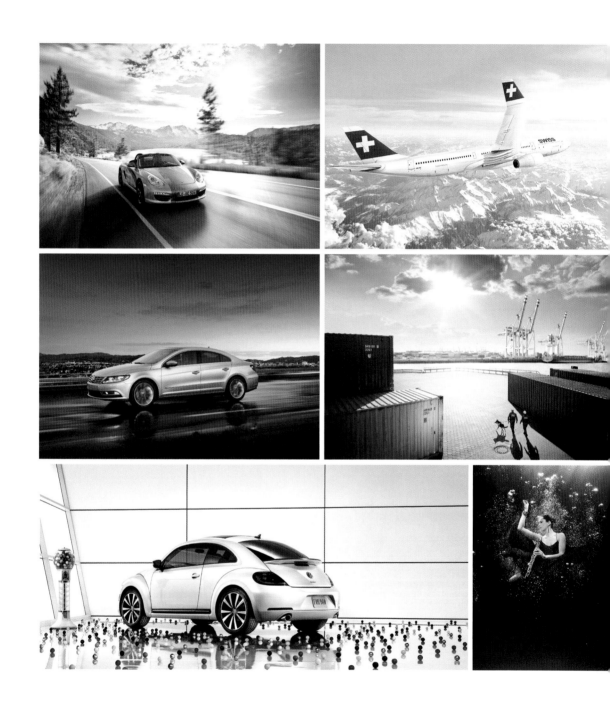

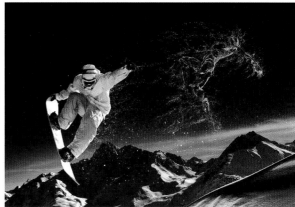

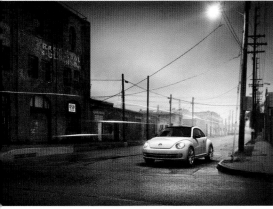

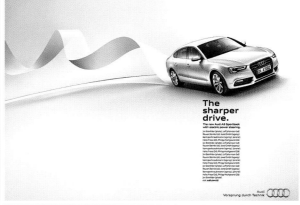

The sharper drive.

The new Audi A5 Sportback with electric power steering.

Audi
Vorsprung durch Technik

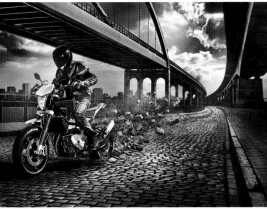

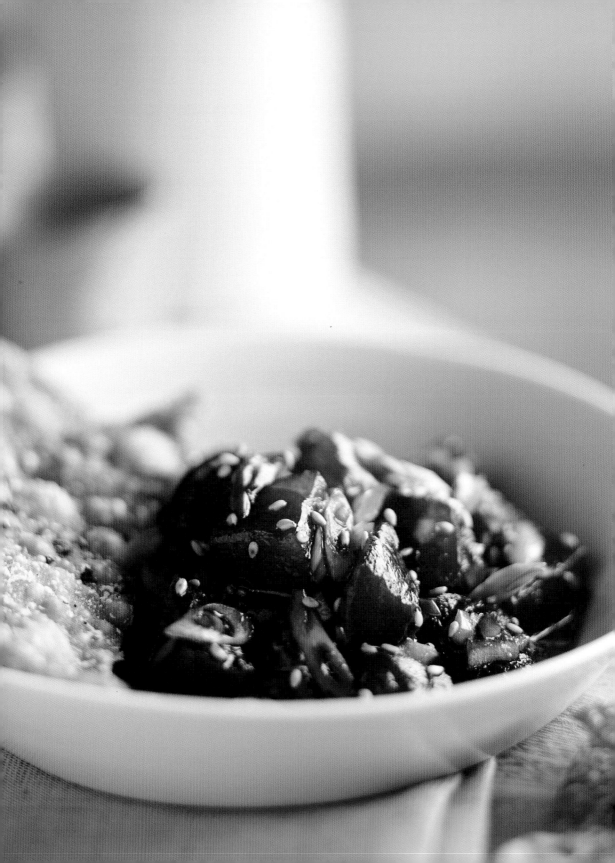

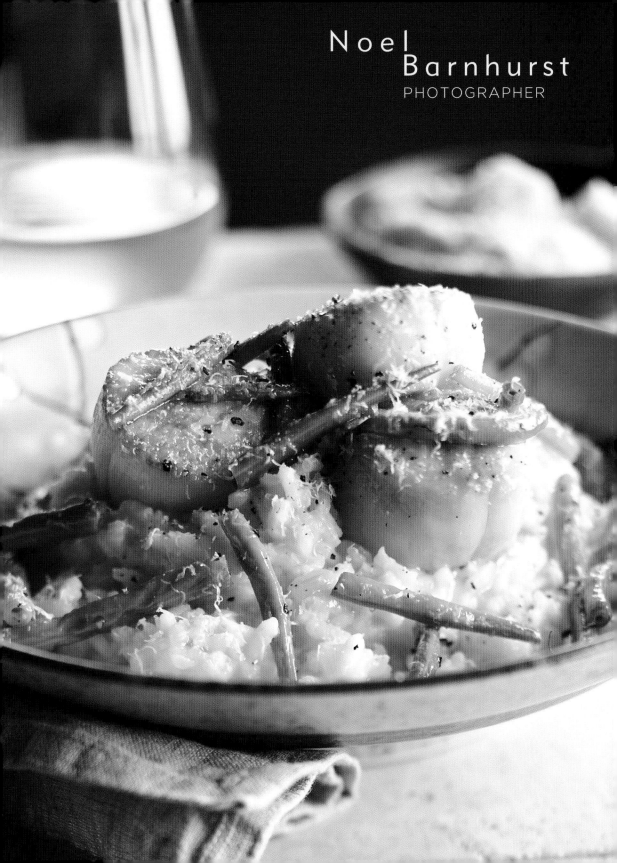

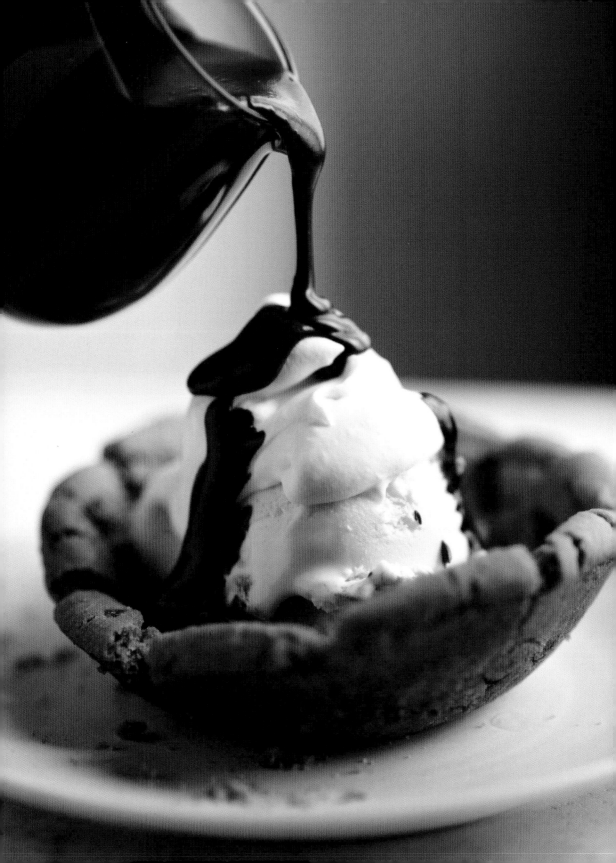

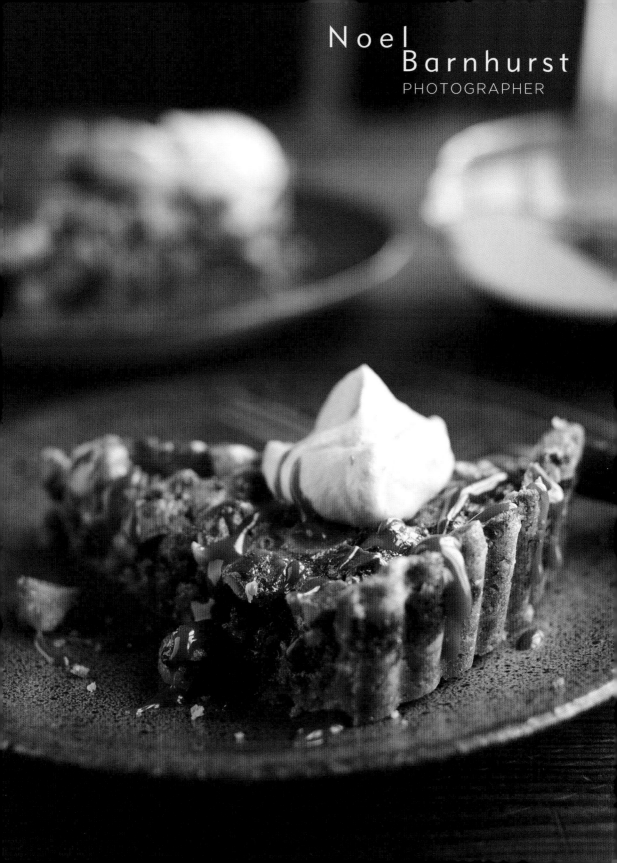

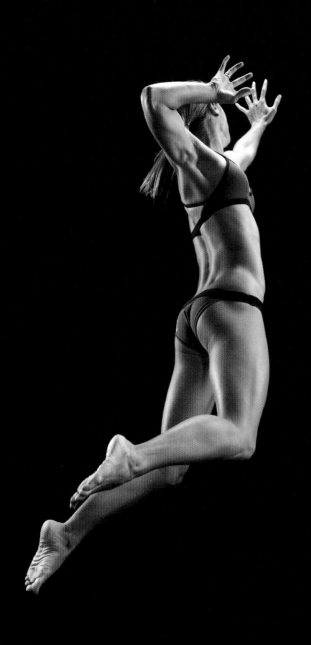

www.nagelphoto.com

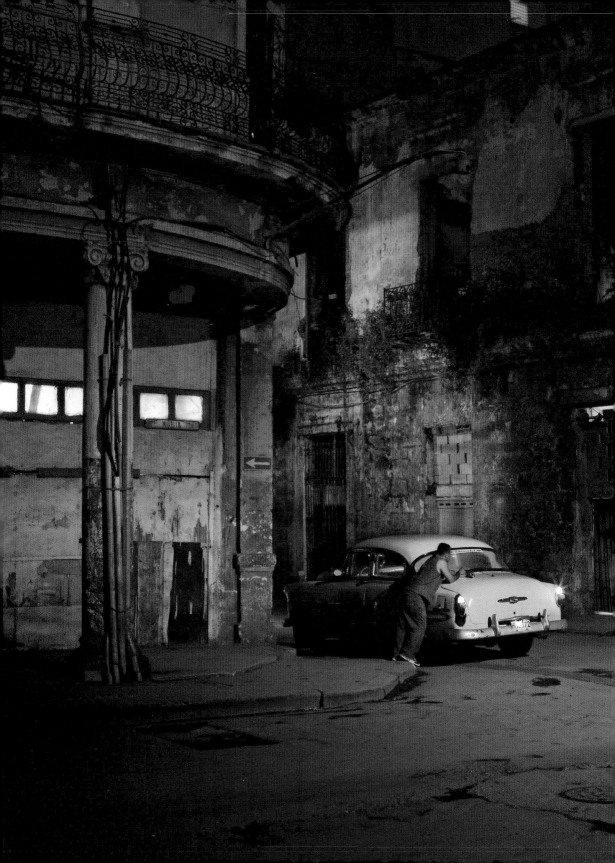